THE WHITSUNDAYS BOOK

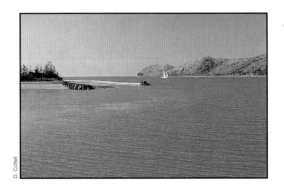

D. Colfelt

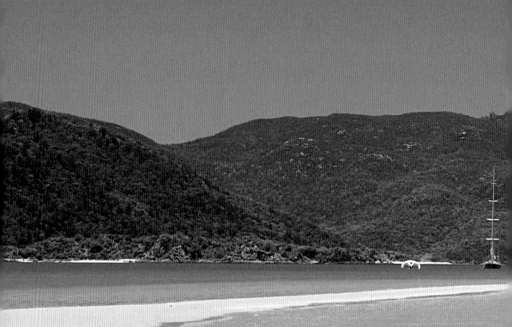

First published in 1995 by
Windward Publications Pty Ltd
464 Woodhill Mountain Road
Woodhill Mountain, via Berry, NSW 2535
© David and Carolyn Colfelt 1995

National Library of Australia
 Cataloguing-in-Publication data
Colfelt, David, 1939–
 The Whitsundays book.

 Includes index.
 ISBN 0 9590830 9 X
 ISBN 0 646 23039 5 (pbk.).
 1. Whitsunday Group (Qld.) – Description and travel. 2.
 Whitsunday Group (Qld.) – History. I. Title

919.436

Produced and printed in Australia.
Design and typesetting by Windward Publications Pty Ltd.
Printed by Griffin Press Pty Ltd, Plympton, SA 5038

THE
WHITSUNDAYS
BOOK

David Colfelt

Illustrations by Carolyn Colfelt

Windward Publications Pty Ltd

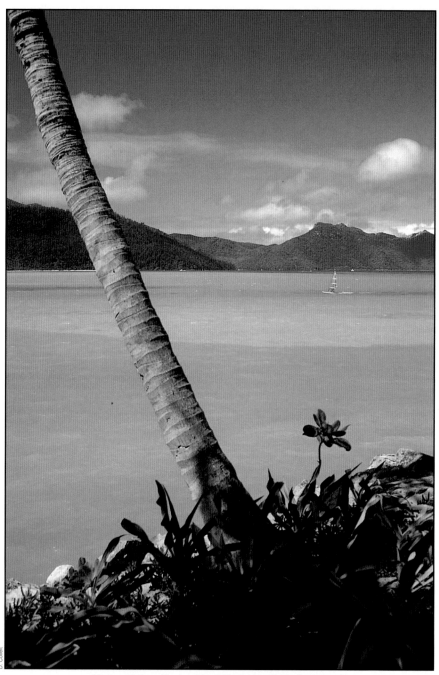

View south from Hayman Island, Hook Island in the background

Contents

Introduction
Introducing the Whitsundays _____ 8

The Whitsunday environment
The marine and national parks _____ 23
The Great Barrier Reef Marine Park and the Queensland marine
and national parks

Geology of the Whitsundays _____ 31
A violent tumultuous birth

Coral waters _____ 41
The Whitsundays and the Great Barrier Reef

The Whitsunday landscape _____ 51
An introduction to the flora of the Whitsundays

Whitsunday wildlife _____ 61
Highlights of Whitsunday fauna

What to do in the Whitsundays
Boating _____ 73
Camping _____ 79
Fishing _____ 87
Diving and snorkelling _____ 97
Visiting a coral reef _____ 112

History of the Whitsundays
The Ngaro _____ 125
The Aboriginal people of the Whitsunday islands

European discovery _____ 137
From James Cook to the present

The principal islands
Island highlights _____ 150
Highlights of the principal islands between Gloucester Island
and Brampton Island – access, description, historical notes, points of interest

General notes
Tips for tropical travellers _____ 183
Avoiding tropical hazards

General index 188

5

Acknowledgements

I have been given a lot of help in bringing this book together, and the text represents a broader knowledge and experience than I have or, I suspect, any one person has. Ray Blackwood, who has a formidable understanding of the islands and their past, wrote the chapters on geology, Aboriginal and European history, and he provided historical notes about individual islands. Dr Richard Schön and Scott Bryant of the Department of Earth Sciences at the University of Queensland, and Mark Mabin of the Geography Department at James Cook University, also helped with questions of geology. Tony Fontes, the senior PADI Course Director in Queensland and a member of the Great Barrier Reef Consultative Committee, has shared his long experience of diving around the Whitsunday islands and outlying reefs; he provided the backbone and much of the flesh for the chapter on diving and snorkelling. Dr Peter Lavarack, Senior Botanist with the Queensland Department of Environment and Heritage (Q.DEH), has an encyclopaedic knowledge of the islands and their vegetation, which he has generously shared. Eddie Heggerl, Director of the Australian Littoral Society, has a fervent love for and deep understanding of the Whitsundays, and his ability to simplify science was a help to me in gaining some perspective on island vegetation and habitats. Barry Nolan of Q.DEH provided notes on Whitsunday wildlife. Peter Valentine's familiarity with the islands and his knowledge of butterflies helped to flavour the notes on wildlife. Terry Done of the Australian Institute of Marine Science gave some helpful criticism of the discussion on coral reefs. Thanks to Robert van Woesik, expert on Whitsunday corals, for providing background information for the same chapter. Also, thanks to Bryce Barker of the University of Queensland for his help with the archaeology and Aboriginal antiquities of the area, and to Mike Rowland of Q.DEH, who has made a significant contribution to the general understanding of this aspect of Whitsunday history.

Dr Wendy Craik of the Great Barrier Reef Marine Park Authority (GBRMPA) provided support and guidance. Thanks to GBRMPA, too, for its contribution and also for its moral support in getting the whole project underway. Margot Warnett, Senior conservation Officer with Q.DEH, kept an eye on the developing text, and her advice and comments were important in shaping the final outcome. Many others from Q.DEH have shared their time and knowledge, particularly the dedicated group who work at the Whitsunday regional office; thanks to Artie Jacobson and his team, including Sandy Williams and Jim Cruise.

Carolyn Colfelt, my partner in all things, has done some beautiful illustrations, and in her other roles as subeditor and design consultant she has helped keep things on the rails. Avery Colfelt, an environmental science graduate, made some sharp-eyed comments on the manuscript, and these prompted me to tear up and rewrite several chapters that Carolyn had already told me were 'turgid' and which, hopefully, no longer are. Thanks to Anthony Colfelt for his contribution to design, and to Andrew Colfelt, whose consultancy on the computer technology employed in this production has spared me a few more grey hairs. Another member of the team who has again made an invaluable contribution, far beyond her brief, working under difficult circumstances (my fault), is our proofreader, Ella Martin.

David Colfelt

Foreword

I first met David Colfelt in 1978, in the Whitsundays, in the days of the fledgling bareboat charter industry. He was putting together what has evolved into *100 Magic Miles* – arguably the most comprehensive and popular book about the Whitsundays and a must for all Whitsunday sailors. *100 Magic Miles* has now been updated five times, and each time David and his wife, Carolyn, have assiduously, painstakingly and tenaciously sought input from Great Barrier Reef and island managers to ensure that the information was accurate, up to date, and that it conveyed the best available advice on how to enjoy sailing the Whitsundays without damaging the natural beauty of the area.

The Whitsundays Book, the latest contribution of the Colfelts, is a natural companion volume to *100 Magic Miles*, a wonderfully comprehensive treatment of the Whitsundays aimed at all who have any interest in the area.

The Whitsundays have always been a popular Great Barrier Reef destination, and the area today rivals Cairns in the number of tourists who appreciate its beauty and grandeur. Since 1978 tourism has grown enormously – the bareboat charter fleet has multiplied many times, high-speed, large-capacity catamarans, floating pontoons, semi-submersibles and helicopter access have changed the face of Whitsunday tourism. Island resorts have been expanded and upgraded and their capacity increased significantly; mainland infrastructure has also been upgraded.

The important and overriding aim of all who have an interest in the Whitsundays must be to ensure that human activities do not damage the quality, charm and beauty of the area. Those who use the area regularly are already working in conjunction with the Great Barrier Reef Marine Park Authority and the Queensland Department of Environment and Heritage to see that it is managed both for our children and our children's children. *The Whitsundays Book* has the potential to greatly enhance one's enjoyment of the Whitsundays and, perhaps most of all, it makes its own contribution to conservation.

The Colfelts' dedication to revealing the Whitsundays in a highly readable and wonderfully illustrated manner, underpinned throughout by their concern for its long-term future, is an elegant example of individual commitment to the Great Barrier Reef. The Great Barrier Reef Marine Park Authority, charged with the preservation of the Great Barrier Reef, strongly supports and appreciates the production of this book.

Wendy Craik
Executive Officer
Great Barrier Reef Marine Park Authority

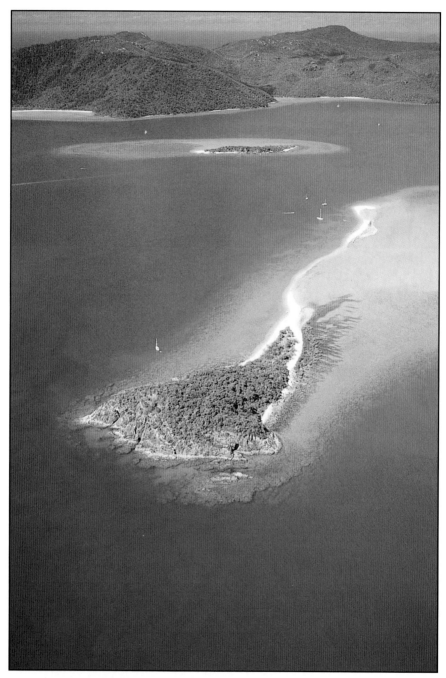

Langford Island (foreground), Black Island, and Hook Island (background)

Introducing the Whitsundays

A particular shade of blue

The Whitsunday islands were 'discovered' by Europeans in the year 1770, but they were favoured hunting and fishing grounds of Australia's Aboriginal people many thousands of years before that. They are officially the 'Cumberland Islands', from the name they were given by the English explorer, James Cook, when he sailed through on June 3, 1770. Today, they are usually referred to simply as 'the Whitsundays'*.

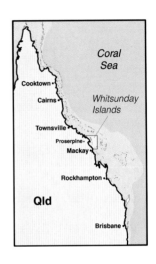

The Whitsundays lie close off the Queensland coast, east of the sugar-farming town of Proserpine. Viewed from the mainland on a clear day, they seem to perch on a shimmering horizon, like pyramids belonging to a beckoning paradise. The tropical waters surrounding them are a particular shade of blue – a vibrant turquoise, caused by very fine particles of sediment in the water which scatter the sunlight as it penetrates the surface – that imparts a special magic to the Whitsunday scene. The same phenomenon gives the sky its brilliant blue. From above, the islands have a jewel-like appearance, with iridescent margins 'glowing' beneath the shallow water over their fringing coral reefs. They are cloaked in eucalypt and pine, with an occasional swathe of vivid green grassland, or an occasional shadowy gully of rainforest. Patches of exposed granite betray the islands' essentially rocky character.

The mainland adjacent to the Whitsundays is sugar country. One-third of Australia's crop is produced in the district surrounding Mackay, the principal town on this part of the coast and the southern gateway to the islands. At Proserpine, 120 kilometres north of Mackay, traffic headed for the Whitsundays turns right, and the road meanders through kilometre after kilometre of canefields, with volcanic mountains always present in the background. At Cannonvale, about 23 kilometres on, travellers get a first glimpse of ocean, and just a little further is the resort town of Airlie Beach, overlooking Pioneer Bay. The road then enters Conway National Park, and it climbs jungle-clad hills and winds through tropical bushland for 10 kilometres to the coast, where it terminates at Shute

* The origin of 'Whitsunday' is discussed on page 138.

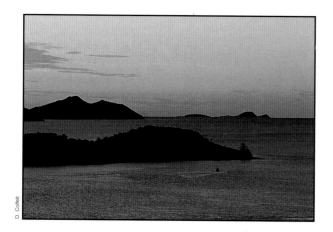

The Whitsunday scene seldom fails to impress travellers. James Cook referred to these sheltered waters as 'one continued safe harbour', and on more than one occasion those who have passed through have returned to the Whitsundays to settle, which is how some of the island resorts got started.

Located in warm waters between 20° and 21° south latitude, the shores of the Whitsundays are skirted by fringing coral reefs, giving the islands a mixed character – part continental, part coral reef. This is probably why they are sometimes referred to as 'Barrier Reef islands', which isn't strictly correct, as Barrier Reef islands are made entirely of coral and grow on top of coral reefs.

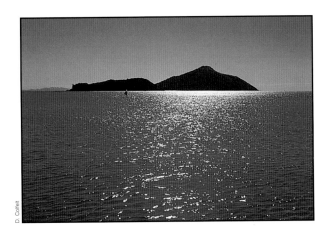

D. Cofelt

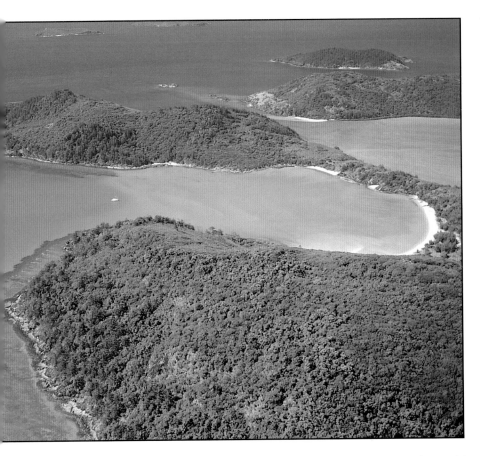

Introducing the Whitsundays 11

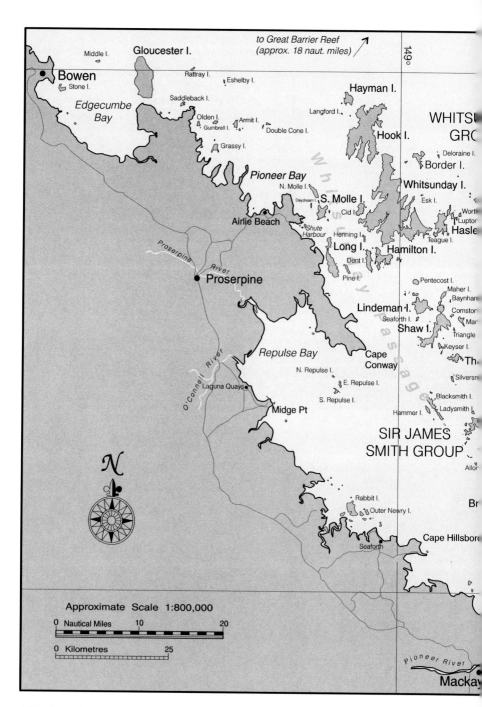

to Great Barrier Reef
(approx. 18 naut. miles)

149°

Middle I.

Gloucester I.

Bowen

Stone I.

Rattray I.

Eshelby I.

Hayman I.

*Edgecumbe
Bay*

Saddleback I.

Langford I.

WHITS
GR

Olden I.

Armit I.

Gumbrell I.

Double Cone I.

Hook I.

Grassy I.

Deloraine I.

Border I.

Pioneer Bay

N. Molle I.

Whitsunday I.

Daydream I.

S. Molle I.

Esk I.

Wort
Luptor

Cid I.

Airlie Beach

Hasle

*Shute
Harbour*

Henning I.

Teague I.

Long I.

Hamilton I.

Dent I.

Proserpine

River

Pine I.

● **Proserpine**

Pentecost I.

Maher I.

Baynhan

Lindeman I.

Comstor

Seaforth I.

Mar

Repulse Bay

Shaw I.

Triangle

Keyser I.

N. Repulse I.

Cape
Conway

Th

Silversn

O'Connell River

Laguna Quays

E. Repulse I.

S. Repulse I.

Blacksmith I.

Hammer I.

Ladysmith

Midge Pt

SIR JAMES
SMITH GROUP

Allor

Rabbit I.

Outer Newry I.

Br

Cape Hillsbor

Seaforth

Pioneer River

Mackay

Approximate Scale 1:800,000

0 Nautical Miles 10 20

0 Kilometres 25

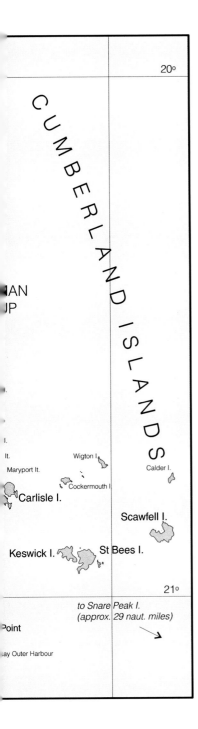

20°

CUMBERLAND ISLANDS

AN
JP

I.

It. Wigton I.
Maryport It. Calder I.
 Cockermouth I.
Carlisle I.

 Scawfell I.

Keswick I. St Bees I.

 21°

 to Snare Peak I.
 (approx. 29 naut. miles)
Point

ay Outer Harbour

What constitutes the Whitsunday islands?

There is some argument about what constitutes the Whitsunday islands, and the issue will never really be resolved. Their European discoverer, James Cook, did not name the islands but rather 'Whitsunday's Passage'. The Passage began at Cape Conway and was bounded by the mainland on the west and the islands to the east, which he named 'Cumberland Isles'. On Cook's chart, however, the words 'Cumberland Isles' extended well to the south of Cape Conway.

Cook actually named only one of the islands – Pentecost. Successive naval surveyors in the 1800s gave names to most of the rest, and the 'Cumberland' tradition was carried on, with many names from the old county of Cumberland in England being put on our map.

Today's charts show a 'Whitsunday Group', but there is no official definition of 'Whitsunday islands'. The term 'Whitsunday' is used by most people these days synonymously with 'Cumberland'.

There are some 150 islands, islets and rocks in the Cumberland Islands, which the hydrographic office considers to be all the islands from Snare Peak in the south (21°06' S, 149°56' E) to Hayman in the north (20°03' S, 148°53' E). Someone somewhere along the line seized upon the number '74' as being the number of 'Whitsunday islands', a figure often touted in promotion of the area, but it has no basis.

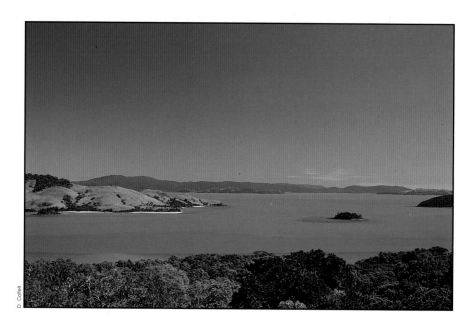

D. Collelt

Harbour, a beautiful natural harbour beside the Conway Range.

Enlightened thinking in the 1930s saw most of the Whitsunday islands become national parks. There are tourist resorts on seven of them, but mostly the islands are unspoiled and give every appearance of being uninhabited.

Yesterday's mountains

The Whitsundays are, geologically, the tops of a mountain range that was cut off from the mainland when the rising sea level at the end of the last ice age flooded the continental shelf. The drowning of the coast produced many natural anchorages that have been admired by mariners ever since European discovery. There is archaeological evidence that Aboriginal people have hunted and fished in the area for at least the last 8500 years.

The islands are termed 'continental islands' because they have the same geological make-up as the continental mainland. They are given a 'Barrier Reef' character by the fringing coral reefs growing around their shores, some of which rival the reefs of the Great Barrier for impressive coral growth. The fringing reefs produce beaches and beach vegetation that is reminiscent of true coral islands.

The nearest reefs of the Great Barrier lie about 34 nautical miles (63 kilometres) north-east of the Whitsunday main-

land. The Barrier Reef protects the islands from oceanic swells, and the tranquillity of the Passage obviously impressed James Cook. However, at times of brisk trade winds and spring tides, Whitsunday waters can become quite choppy.

The climate

The Whitsundays have a warm subtropical climate with mild winters and warm to very warm summers. Much of the annual rainfall occurs in the 'wet season', which is usually January–March, when a considerable portion of rain falls at night. The water is a swimmable temperature year round, and the Queensland sun creates shirt-sleeve weather most of the time.

The nearest coral reef of the Great Barrier – Bait Reef – lies about 16 nautical miles (30 kilometres) to the north-east of Hook Island. This view is looking south-west from Bait Reef to the dominant profile of lofty Hook, with Hayman Island on its right, Whitsunday Island on its left.

Whitsunday weather

	Jan.	Apr.	July	Oct.
Av. daily high (°C)	31	28	23	28
Av. daily low (°C)	25	23	17	21
Days rain (over 0.2 mm)	13	14	5	5
Normal rainfall (mm)	203	115	36	16
Mean sea temp. (°C)	27	26	22	24
Normal annual rainfall – 1445 mm				

The southern tropics are very occasionally visited by

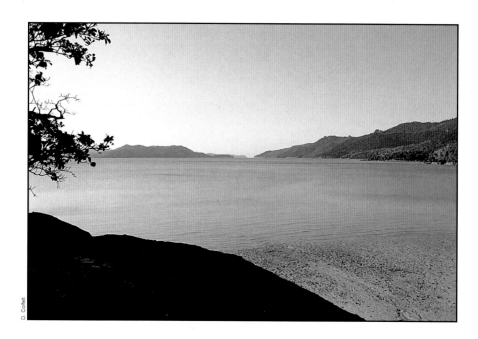

Whitsunday waters are protected from oceanic swells by the offshore reefs of the Great Barrier system as well as by the many islands spread out over one degree of latitude (20–21°). The sheltered bay (above) is on the north-west side of the largest of the islands, Whitsunday Island, which is 18 kilometres long and rises to a height of 435 metres.

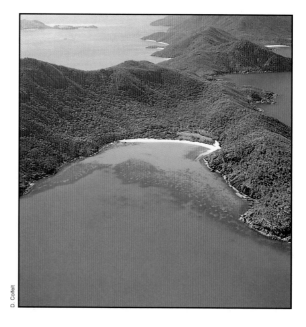

The Whitsundays offer an abundance of sheltered anchorages, the area having the reputation of being the finest cruising grounds in Australia.

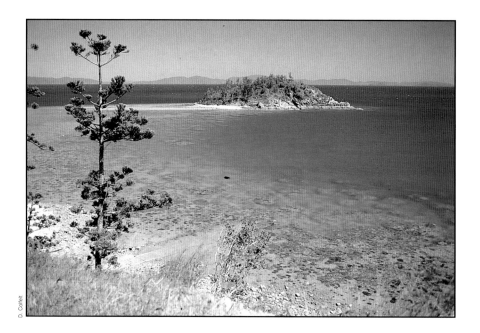

D. Colfelt

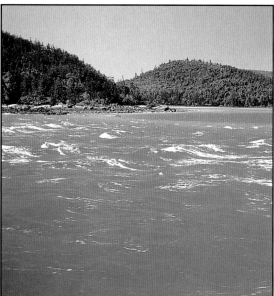

D. Colfelt

A symbol of the Whitsundays is the hoop pine (*Araucaria cunninghamii*), a tree of ancient origin that is seen throughout the islands, sometimes as a lone tree clinging to a rocky slope, sometimes as a dense forest capping a steep ridge. The islands have many rocky outcrops that provide places for raptors and sea birds to perch and to nest.

Brisk trade winds that fan the Queensland coast often combine with strong tidal currents to whip up Whitsunday waters and create exhilarating sailing conditions. Disturbed waters may be encountered, particularly in restricted passages and around some headlands.

Introducing the Whitsundays 17

cyclones, which can occur in the Whitsundays from November to May, but if they happen at all, they are most likely to come in February and March.

Lusty winds and huge tides

From April to September the whole of the Queensland coast is fanned by south-east trade winds that blow in fairly constant bursts, sometimes for days on end. The trade winds are driven by global differences in atmospheric pressure, namely a band of equatorial low pressure that draws in cooler air from the higher latitudes. Winds of 15 knots (28 kilometres per hour) and more are not uncommon during the trade winds season, and they persist until mid- to late spring. Then, days with lighter easterly and north-easterly winds become increasingly common.

Broad Sound, which is just south of Mackay, experiences the biggest tides on the Australian east coast, with a

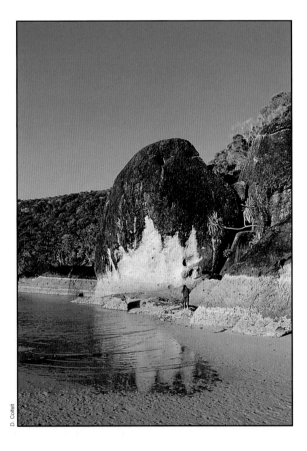

Evidence of the high tides in the Whitsundays can be seen on the rocks of western Whitsunday Island. A number of species of birds take advantage of the expansive sand and mud flats that uncover when the tide is down; beach thick-knees, oyster catchers, herons, gulls and others may be seen fossicking along the shores.

D. Colfelt

maximum range of about 10 metres in some estuaries. The high tides are due to a combination of factors, including the conformation of the local sea floor and the shape of the continental shelf east of Broad Sound. Mackay experiences a maximum tidal range of 7 metres; as one moves northwards through the islands, this range becomes smaller, until at Hayman Island, for example, the maximum range is about one half that of Mackay. Tides to the south of Broad Sound diminish, too.

The tides flow swiftly through restricted passages among the islands, and when they are flowing in the opposite direction to the wind, the sea can become quite lumpy. Sailors need to consider this when planning the day's itinerary. Campers need to be mindful of tides in making landings on islands as, when the tide is down, the exposed fringing coral reefs make some beaches impossible to land and walk on. Spring tides (tides with high ranges that occur at the time

D. Collett

South-east trade winds that fan the Queensland coast from about April through September–October create exhilarating sailing conditions. From late September and into the summer months the winds become progressively lighter and more easterly and north-easterly.

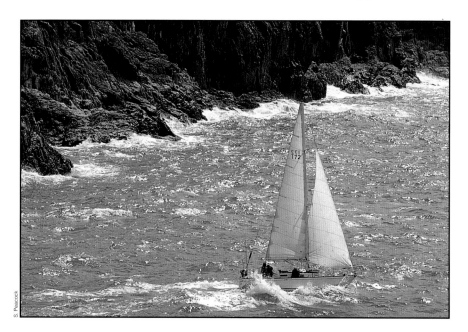

S. Peacock

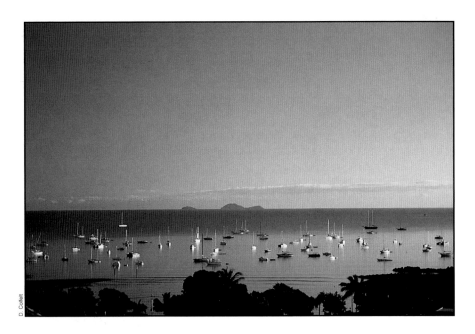

D. Colfelt

The view north from Airlie Beach over Pioneer Bay surveys a peaceful expanse of blue, the horizon broken by an occasional distant cone-shaped island.

of the full and the new moon) can affect visibility in the water because they stir up sediment, and this will affect conditions for snorkellers and scuba divers.

The Whitsunday mainland

The town of Whitsunday incorporates the mainland villages of Cannonvale, Airlie Beach and Shutehaven. Cannonvale was the earliest coastal settlement in this area and continues to be a residential centre with a growing interest in tourism.

Three kilometres to the east of Cannonvale is Airlie Beach, Whitsunday's resort town and business centre, with holiday accommodation, nightlife, restaurants, tourist booking agencies, and shops. At Abell Point, a short distance back towards Cannonvale, is the Abell Point marina, a boating centre and point of embarkation for the islands and the Reef.

Ten kilometres down the road to the south-east of Airlie Beach is Shute Harbour, the best natural harbour for many kilometres up or down the coast. Historically it has been the principal jumping-off point for the islands. Shute Harbour has two busy public jetties from which depart island ferries, cruise vessels and water taxis.

Getting to the Whitsundays

Two commercial airports serve the Whitsunday area, one at Proserpine and the other at Hamilton Island. From Proserpine regular bus services go to the coast throughout the day. A water taxi based at Shute Harbour meets flights landing at Hamilton Island, and ferries passengers to other destinations.

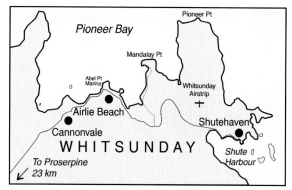

The town of Whitsunday, incorporating Cannonvale, Airlie Beach and Shutehaven, is about 14 hours by car from Brisbane, 3½ hours from Townsville and about 8 hours from Cairns. The Whitsunday airstrip is used by small aircraft and is the base of the local air taxi service.

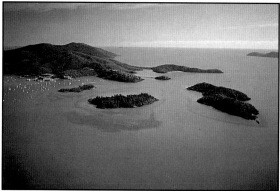

Shute Harbour (middle) is the best natural harbour in the Whitsunday area and has traditionally been the principal jumping-off point for the islands.

Abell Point (below), the site of the first marina to be built on the Whitsunday mainland, also serves as a point of embarkation for the islands and the Great Barrier Reef.

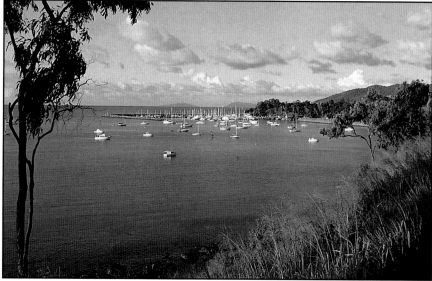

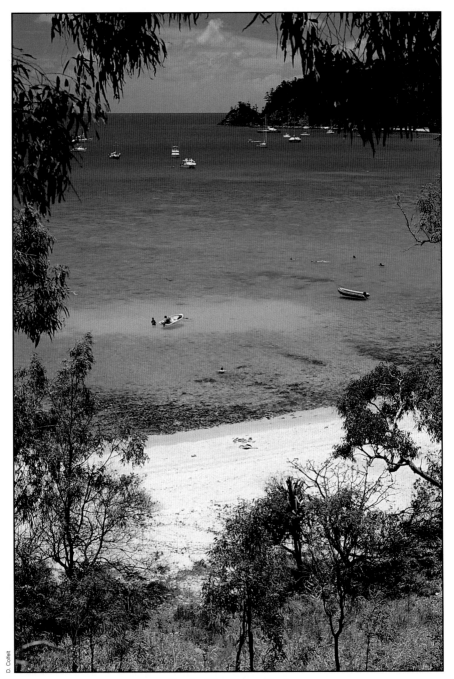

Blue Pearl Bay, Hayman Island

The parks

The Great Barrier Reef Marine Park and State Marine Park

The Great Barrier Reef Marine Park was created to protect and preserve the largest and richest system of coral reefs in the world. It incorporates most of Australia's north-eastern continental shelf, including the Whitsunday islands and their magnificent fringing coral reefs. The Great Barrier Reef Marine Park extends up to low water mark, while the intertidal waters, that is, those between low and high water, belong to the Queensland State Marine Park. Most of the islands within the marine parks are State national parks.

The Great Barrier Reef Marine Park is based on a concept of multiple use, where some areas are totally protected while in others a range of different activities may take place. In some respects it resembles a town, where different types of activities are allowed in different parts of the town. In place of a town plan there are zoning plans that allow for reasonable use of park resources provided that the uses are sustainable. A map showing the various park zones in the Whitsundays is found on the following pages, along with an explanation of the types of activities permitted in each zone.

The Queensland national parks

Most of the Whitsunday islands and portions of the adjacent mainland are Queensland national parks. National park boundaries extend above high water. No animal or plant may be interfered with, killed or taken from these areas. Domestic animals are prohibited; certain activities, such as camping, require a permit.

Park management

The Great Barrier Reef Marine Park Authority (GBRMPA), a federal agency with headquarters in Townsville, and the Queensland Department of Environment and Heritage (Q.DEH), a State body with headquarters in Brisbane and which has regional offices all along the Queensland coast, jointly manage the Great Barrier Reef Marine Park. Day-to-day supervision and management is in the hands of Q.DEH park rangers. The regional office of Q.DEH and an information centre for the Whitsundays is located about 2 kilometres from the centre of Airlie Beach, on the Shute Harbour Road at Mandalay Road.

Continued on page 26

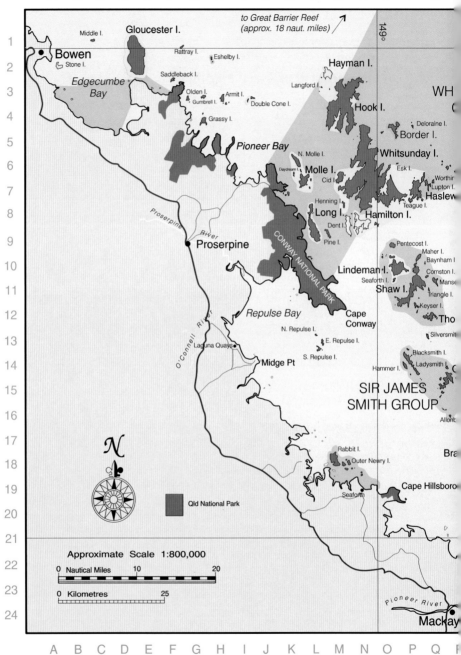

Map labels:

A B C D E F G H I J K L M N O P Q

Middle I.

Gloucester I.

to Great Barrier Reef
(approx. 18 naut. miles)

149°

Bowen

Stone I.

Rattray I.

Eshelby I.

Hayman I.

Saddleback I.

WH

Edgecumbe
Bay

Langford I.

Olden I.

Armit I.

Gumbrell I.

Double Cone I.

Hook I.

Grassy I.

Deloraine I.

Border I.

Pioneer Bay

N. Molle I.

Whitsunday I.

Daydream I.

Molle I.

Esk I.

Cid I

Worthir

Lupton I.

Haslew

Henning I.

Teague I.

Long I.

Hamilton I.

Dent I.

Proserpine

River

Pine I.

Proserpine

CONWAY NATIONAL PARK

Pentecost I.

Maher I.

Baynham I.

Lindeman I.

Comston I.

Seaforth I.

Manse

O'Connell River

Shaw I.

Triangle I.

Keyser I.

Repulse Bay

Cape
Conway

Tho

N. Repulse I.

Silversmit

Laguna Quays

E. Repulse I.

S. Repulse I.

Blacksmith I.

Midge Pt

Ladysmith I.

Hammer I.

SIR JAMES
SMITH GROUP

Allonb

Rabbit I.

Bra

Outer Newry I.

Cape Hillsboro

N

Seaforth

Qld National Park

Approximate Scale 1:800,000

0 Nautical Miles 10 20

0 Kilometres 25

Pioneer River

Mackay

Summary of marine park zones and activities

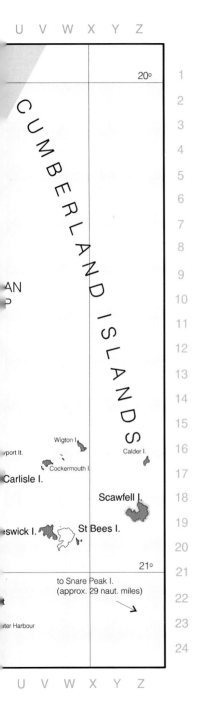

	Bait netting and gathering	Trawling	Collecting (recreational – not coral)	Crabbing and oyster gathering	Diving, boating, photography	Line fishing (bottom fishing, trolling, etc.)	Spear fishing
General Use 'A' Zone	Yes	Yes	Limited	Yes	Yes	Yes	Yes
General Use 'B' Zone	Yes	No	Limited	Yes	Yes	Yes	Yes
Marine National Park 'A' Zone	Yes	No	No	Limited	Yes	Limited	No
Marine National Park 'B' Zone	No	No	No	No	Yes	No	No
Preservation Zone	No	No	No	No	No	No	No

General Use 'A' Zone (light blue)
An area where you can do just about anything, within reason, consistent with conservation of the Reef. Spear fishing with scuba is prohibited throughout the Park, as are commercial drilling, mining and littering. The taking of estuary or greasy cod, or giant gropers over 1200 millimetres in length is also prohibited anywhere in the Park without a permit. Commercial trawling, shipping and limited collecting are allowed.

General Use 'B' Zone (darker blue)
Basically the same as General Use 'A' but with no trawling or commercial shipping.

Marine National Park 'A' Zone (yellow)
This zone is similar in concept to a national park on land, that is, natural resources protected; but it is different in that some fishing activity is permitted, e.g. trolling (for pelagic fishes, such as mackerel, line fishing (with one hand-held rod or line used with one hook or lure), and bait netting. This zone has been applied to protect significant areas from intensive extractive activities; for example, netting, collecting and spear fishing (without scuba) conflict with many tourist activities and have been excluded adjacent to resort and camping islands.

Marine National Park 'B' Zone (light green)
This is a 'look but don't take' zone; fishing of any sort and collecting are prohibited. The purpose of this zone is to protect areas of special value so that people may appreciate and enjoy them in a relatively undisturbed state.

Preservation Zone (pink)
The objective of this zone is to preserve areas of outstanding value in a totally natural state, undisturbed by man except for purposes of scientific research which cannot be carried out elsewhere. Important breeding and nesting grounds may be given this status.

The marine and national parks 25

Queensland Marine Park rangers patrol the islands regularly, making contact with park users, answering questions about the environment and ensuring that park use is consistent with preserving the natural resources of the Whitsundays.

Whitsunday Information Centre

Q.DEH's information centre is well worth a visit. It has static and dynamic displays interpreting the local ecology, pamphlets and other free literature and books for sale. Park rangers are frequently on hand and willing to answer questions.

General notes about the parks

Permits

Permits are required for camping anywhere in the mainland or on island national parks. These may be obtained from the Q.DEH information centre. Camping permits help to control the numbers of campers in any given site at one time, thus enhancing the quality of the experience for all. (For more information about camping, see page 79.)

Rubbish

The park rangers use the expression 'Ship it in, ship it out'. All rubbish, including tins, bottles, food scraps, plastics, packaging, fishing line, etc. must be removed from the marine park and island national parks. Fish and food scraps should not be left on beaches or at the water's edge, and rubbish should never be buried on the islands, as it will invariably be dug up by animals.

Fires

Fires pose a risk to the flora and fauna and are discouraged. The use of gas for cooking is preferable to an open fire. For one thing, there is no firewood on the islands other than the rare piece of driftwood. All wood in island national parks is protected – even dead wood and leaves, which play a role in the natural ecology, providing food and homes for a number of species. Where fires are permitted they must be below high water mark. They are to be used for cooking only, with a maximum diameter of 0.5 metres. Total fire bans are sometimes in force; check before lighting a fire.

Fishing

Line fishing, using one hand-held rod or handline per person, used with one hook, is permitted in most areas.

Fishing is strictly prohibited:

● in green zones, and in the area around the underwater observatory on Hook Island;

● in the pink zone that extends 500 metres around Eshelby Island, where *all* activities are prohibited (a Preservation Zone).

Fishing is discussed in more detail on pages 87–95.

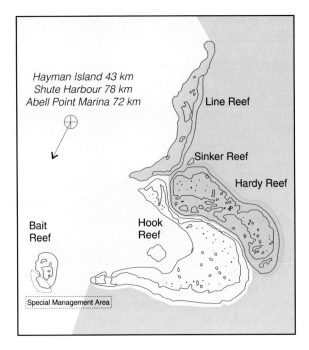

Hayman Island 43 km
Shute Harbour 78 km
Abell Point Marina 72 km

Line Reef

Sinker Reef

Hardy Reef

Bait
Reef

Hook
Reef

Special Management Area

The map shows marine park zones at the area's most visited outer reefs, Bait, Hook, Hardy and Line. In addition to the park zones listed on page 25, Special Management Areas are employed in some areas to give additional flexibility to park managers to respond to conservation problems. The western side of Bait Reef is one such area, which has become a very popular scuba diving and snorkelling site. By virtue of its Special Management Area status, a large part of Bait Reef has the same degree of protection as a Marine National Park 'B' Zone (a 'look but don't take' zone), which is appropriate for an area which is widely used for reef and wildlife appreciation and where fishing, for example, would be inconsistent with that use.

Spear fishing

Spear fishing is permitted in blue zones except for the eastern, south-eastern and southern sides of Hook Island. Spear fishing is prohibited in yellow and green zones.

● Spear fishing using scuba equipment is not sporting and is strictly prohibited throughout Queensland.

● Spear guns and hand spears (Hawaiian slings) are not allowed on island national parks.

Shell collecting

In General Use (blue) zones, shell collecting is limited to taking no more than five shells of any unprotected species. Collecting shells (dead or alive) in yellow and green zones is prohibited. Clams, helmets, and tritons are totally protected.

Coral collecting

The collecting of corals, dead or live, is totally prohibited throughout the Great Barrier Reef Marine Park.

Oyster gathering

Oysters may be taken for immediate consumption on the spot, except in the green Marine National Park 'B' zones, where oysters (and everything else) are totally protected. Smaller oysters should be left to mature.

Anchoring

Damage to coral from boat anchors has become a significant problem in some of the Whitsunday island bays. Coral can be damaged by the weight of an anchor and its chain falling directly onto it, or by the chain wrapping around and breaking sections off, or by the ploughing effect of an anchor or chain dragging through coral. When anchoring:

- Try to anchor in sand or mud, away from coral (the dark patches on the bottom are usually coral, the lighter areas sand).
- When hauling an anchor in, motor towards the anchor to avoid dragging it through coral.
- Anchor well away from the edge of fringing reefs, as there are usually isolated off-lying lumps of coral for some 20–50 metres beyond the reef.
- When fishing, drift rather than anchoring over a reef.
- If it is absolutely necessary to anchor over a reef, use only a lightweight reef anchor ('reef pick') with plastic tubing over any chain that is tied to the anchor.

In some popular anchorages where anchor damage has occurred, white pyramid-shaped buoys have been placed to mark the edge of the fringing reef. Always anchor seawards of these buoys, and seawards of an imaginary line between adjacent buoys.

Diving and snorkelling

The islands offer many safe and interesting spots to dive, swim and snorkel. Visitors need to be aware of strong currents around the islands. When in the water, the best attitude to adopt is that of a 'guest' in a foreign environment. Some marine organisms can deliver a painful and, in some cases, dangerous sting if handled. The best policy is to 'look but don't touch'.

Beware of marine stingers in areas adjacent to the mainland from November to May (see 'Tips for tropical travellers', pages 183–188).

Fish feeding

Fish feeding is not a good idea, for several reasons.

- Fish normally eat a wide variety of natural foods and may not receive adequate nourishment if their main source of food is artificial. Foods fit for human consumption are not generally suitable for fish – for example, red meats, manufactured meats, chicken meat and bones, fruit peelings, breads, pasta, cooked prawns and shells.

- Fish feeding may change the natural behaviour of fish and cause them to rely on food that will not always be available.

- Fish feeding may attract animals that may not occur naturally in an area, disrupting the balance of the local ecology. For example, seagulls attracted to the nesting area of other sea birds may prey on the chicks and eggs.

- Fish feeding may induce undesirable aggressive behaviour, such as biting swimmers, in some fish.

- Fish feeding may attract potentially dangerous species, such as sharks, to areas used by swimmers, snorkellers and divers.

Avoiding disturbance to nesting birds

Many sea birds and raptors nest in the Whitsundays at various times of the year. October to March is an especially busy season. In some cases the Whitsundays are the final refuge for these birds, and if nesting is disturbed, the whole population is threatened. Sea birds are easily disturbed by human presence, and if adult birds leave their nests, eggs and young become vulnerable to predators, such as silver gulls and reptiles, or they may simply be cooked by overexposure to the intense heat of the sun. When approaching islands, rocky outcrops or mainland beaches, be aware of sea birds behaving in an alarmed manner overhead, such as swooping, and continuous noisy squawking. These are usually nesting signs.

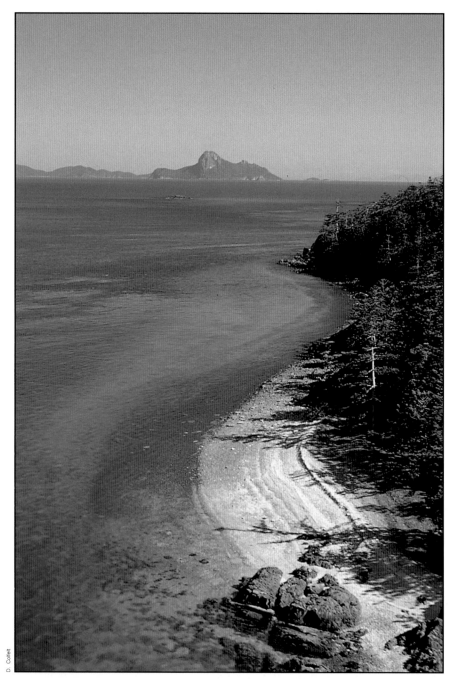

Pentecost Island (centre on the horizon) viewed from the southern end of Haslewood Island

Geology of the Whitsundays

A violent tumultuous birth

RAY BLACKWOOD

An observer looking today at the tranquil scene presented by the Whitsunday islands may never realise that their birth was a violent and tumultuous one. The Whitsunday landscape is the result of millions of years of volcanic activity; with a few exceptions, the topography consists either of the outpourings of volcanoes or the remnants of the molten rock which underlay them and which, now solidified, has been exposed by countless years of erosion.

This activity occurred about 110 million years ago when the region passed through a volcanic stage lasting about 37 million years, the main activity in the Whitsundays being concentrated in a 15-million-year period. Geologists say this was the result of a rifting process engendered by what was for a time known as 'continental drift' but which today is explained in terms of the theory of plate tectonics.

Plate tectonics

Plate tectonics proposes that the outer crust of the earth is divided into a number of large rigid plates 'floating' on the partly molten mantle of the earth. In the billions of years since the planet was created, the earth's land masses have been rearranged extensively by the movements of these plates, of which there are two types: continental plates carrying the continents (such as Eurasia, Australia, the Americas); and oceanic plates (for example, the Pacific plate). The plates move relative to each other, some colliding, some moving laterally against a neighbour, others drawing apart and thus tearing themselves away to form separate plates, this latter process being known as rifting. As the plates slide past each other, collide or rift, their interaction results in earthquakes, volcanoes and deformation along the boundaries between the plates. One of the most famous of these boundaries is the San Andreas Fault in California, where the Pacific plate is sliding northward past the North American plate at a rate of a few centimetres a year. It is this activity that has caused the infamous quakes of San Francisco, for example. The Himalayas reflect the ancient collision of India with the Eurasian

(a) Australia has not always occupied its present position on the globe. 200 million years ago all of the continents were united in a single land mass that was dubbed Pangaea ('all earth') by a German meteorologist, Alfred Wegener, who first put forth the theory of 'continental drift'. Gondwana was the name given to the amalgam of southern continents, including South America, Africa, India, Australia and Antarctica. Gondwana began to break up about 180 million years ago. Africa and the Arabian Peninsula moved northwards towards the European and Asian continents and eventually closed the ancient Tethys Sea. India took the long trek north, its collision with Asia resulting in the creation of the Himalayas. Australia started to separate from Antarctica some 65 million years ago and became an island continent 45 million years ago, moving north-eastwards into the Pacific.

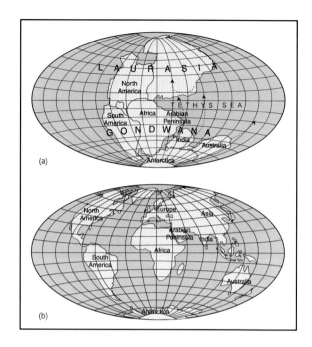

(a)

(b)

(b) The position of the continents is explained today in terms of the theory of plate tectonics, which suggests that the continents are carried on rigid plates that 'float' around the globe driven by the thermal dynamics of the planet's interior. Earthquakes and volcanism are common at the plate boundaries. Today Australia continues its north-easterly movement into the Pacific, at a rate of about 5 centimetres a year.

continent. The Andes result from the collision of oceanic plates with the South American plate, where the former sink beneath the continental plate in a process known as subduction.

The birth of Australia

The continent of Australia is a part of the process. It was once part of the continent of Gondwana, which slowly moved north from the more southern latitudes and, as it did, it shed various segments that were to become today's Australia, New Zealand, Papua-New Guinea and the island chains of the South Pacific Ocean.

The Whitsunday region of those days lay on a rift boundary where, eventually, the north-east coast of Australia was to emerge. This rift boundary suffered its share of tectonic activity in the form of earthquakes, volcanoes and deformation. As rifting proceeded, a shallow freshwater inland sea may first have appeared, later to evolve into the Coral and Tasman seas.

Slow-motion volcanoes

The volcanoes of the Hawaiian islands are an example of what may be called the less destructive type; most people have seen films of their eruptions, with streams of red-hot lava running down their flanks. However inexorable and all-consuming the advance of the lava, anyone in its path has

ample time to move to safety, and the fireworks of the eruption may be viewed in safety from comparatively close quarters. These volcanoes are fed by a basalt magma, which is very fluid and flows freely. When it reaches the surface, spectacular releases of gases fling incandescent sprays into the air. The fluidity of the magma allows internal gas pressures to be released frequently, and disastrous pressure build-ups are averted.

'Soda-pop' volcanoes

The Whitsundays, however, were host to a more terrifying type of volcano characterised by a thick, sticky magma that tends to clog its own progress through vents and fissures. This allows enormous gas pressures to build up until all is released in one or a series of explosions of awful magnitude, hurling high into the air millions of tonnes of broken rock, ash and dust, burying the immediate area under the debris. Lava flows as such may be minimal, the magma being blasted into small, sometimes tiny, fragments (volcanic ash) by the explosive forces of the gases it contained before the immense pressures were suddenly released. Some geologists refer to this as the 'soda-pop' effect.

Mount Pinatubo in the Philippines is a recent example of one such volcano where a towering eruption column bellowed ash and other material into the atmosphere, much of it to

The volcanoes of the Hawaiian islands are characterised by a fluid, freely flowing basaltic lava that permits pressure within the volcano to be released without a sudden, devastating explosion. The lava travels in relative 'slow motion'. The volcanoes of the Whitsundays were of a much more violent kind.

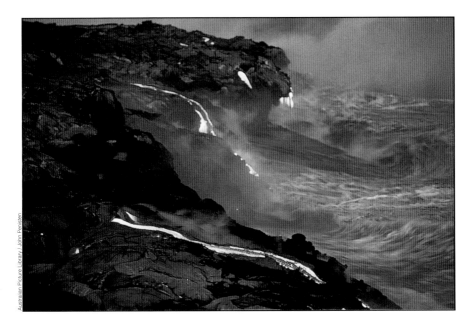

Australian Picture Library / John Penisten

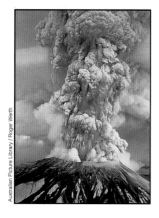

Mount St Helens in the United States is a relatively recent example of a deadly pyroclastic flow such as would have emanated from the volcanoes that played a part in the evolution of the Whitsundays. On 18 May 1980 it 'blew its cork', releasing steam and gas under such pressure that much of its northern face was completely blown away, and the blast levelled the surrounding forest for a distance of 20 kilometres.

rain back to earth in what geologists call 'pyroclastic airfall deposits'. Mount Vesuvius in Italy buried the cities of Pompeii and Herculaneum in this manner.

An even more vicious phenomenon of these explosive eruptions is what is called a 'pyroclastic flow' where there is an outward flow of superheated gas and particles that can travel at hundreds of kilometres an hour away from and down the slopes of a volcano, totally devastating the region in its path. Mount Pelée in Martinique in 1902 (which killed 30 000 people in a matter of minutes) and Mount St Helens in the USA in 1980 both produced pyroclastic flows – travelling at well over 100 kilometres an hour, in the case of Mount St Helens. Films of that eruption amply demonstrate the terrible forces involved.

A violent and spectacular beginning

Such was the scene in the Whitsundays during its volcanic phase when a long series of explosive eruptions built up a bed of ejected material over one kilometre thick, which, over the centuries, fused into solid rock, by no means homogenous in nature but reflecting various volcanic stages. Thus it is possible to find rock comprised of volcanic ash, of shattered fragments cemented together with finer material, of shattered rock now fused into solid rock, or a multitude of combinations of these elements. Whitsunday and Hook islands are good examples of this primary bedrock.

Another factor that may have contributed to the structure of the Whitsunday islands is the phenomenon known as a 'caldera collapse'. In such circumstances a volcanic eruption evacuates an underground chamber, undermining its walls which collapse into the chamber below, sometimes allowing the sea to rush in with a devastating explosion as the water meets molten lava.

Krakatoa in Indonesia was a classical example of this process. It is possible the northern Whitsunday islands are the remnants of the western rim of one such collapse.

A gentler volcanic adolescence

However, Mother Nature, forever restless, did not pause there. Subsequent volcanic activity continued, much of it of the quieter, basaltic nature, and lava intruded the bedrock by forcing its way through cracks and fissures. Today it is easy to find a multitude of 'dykes'* where this has happened. These present themselves as vertical bands of dark rock contrasting with the lighter host rock from the earlier volcanoes and sometimes standing proud like a wall where the host rock has been weathered away. Many examples of dykes can be found at the northern end of Hook Island, the southern tip of Shaw Island and at Thomas Island. More general lava flows are evident at South Molle and Lindeman islands but, overall, such flows are relatively few among the Whitsunday islands.

Meanwhile, throughout and after the volcanic phase, tectonic activity twisted, folded and faulted the terrain. Some areas were thrust upwards while others subsided. The Conway Range is a good example of an up-thrust accompanied by a subsidence on either side which produced the Bowen–Proserpine lowland corridor on the west and the Whitsunday Passage on the east.

Volcanism was not continuous over the 37 million years, and a common feature was dormant periods during which the freshly deposited volcanic rock was eroded by water with sediment deposited in shallow freshwater lakes. The best example of these sediments is found at Cape Conway where they are up to 550 metres thick, with some evidence therein of coal deposits containing fossils, indicating there was a

* A dyke is a near-vertical sheetlike body of volcanic rock that, when molten, was pushed up through the overlying host rock.

D. Collett

The 'Wood Pile' is the local name for a prominent rock formation on the northern side of Hook Island. Technically known as a 'dyke', it is the result of molten magma that forced its way between cracks in the original rock and then solidified into granite with horizontal columnar segments giving the appearance of a stack of wood.

Dykes are very common throughout the Whitsunday islands but mostly they are of dolerite (a medium-grained igneous rock) and display themselves as vertical dark-coloured bands intruding the lighter-coloured host rock.

relatively wet environment during the volcanic phase, not too dissimilar to the present climate.

The scene 100 million years ago

So what did the Whitsunday islands region look like 100 million years ago? Firstly, the region would have been part of the mainland, but there were no high-standing volcanoes, such as Mount St Helens, Mount Pinatubo or those in Hawaii. The area was of predominantly low relief, containing a number of small valleys produced by the rifting process, and scattered around were probably a number of large circular craters with gentle slopes of ejected material. There were also probably a number of small active volcanoes and 'domes' (bulges produced by magma forcing its way upwards but not achieving an eruption) with shallow lakes in between. Overall the scene probably looked most like today's Taupo region of the North Island of New Zealand.

The volcanoes are long gone, and their actual locations can be only a matter of speculation. Pentecost Island has in the past been considered to be the site of one, but modern thought is that it is not a volcanic plug (the solidified lava core of the volcano exposed by erosion of the outer volcanic cone) but a dyke composed of a rock known as porphyry. This porphyry contains iron sulphide, which has stained the north-east face of the island orange.

The erosive forces of wind and water continued their moulding of the terrain in the long years after the volcanoes, inexorably weathering away the primary rock and in some parts eventually exposing what lay beneath the volcanic rock – the solidified magma which had thrust itself towards the surface in its fluid state, which had fed the various volcanoes but which mostly had remained deeply buried and cooled over millions of years, hidden below the volcanic rubble it had spawned.

Gloucester, Hayman, Shaw, Mansell, and Derwent islands are all excellent examples of granite masses exposed by erosion, suggesting that above them stood the volcanoes of ancient times. All these islands are notable for the homogeneity of their structure, being composed entirely of granite, grey in the case of Gloucester Island, pink in the case of all the others. (An exception to this statement is the northern end of Shaw Island, beyond Neck Bay, but that segment is a separate mass of volcanic rock, now joined to the remainder of Shaw Island by a sedimentary isthmus.)

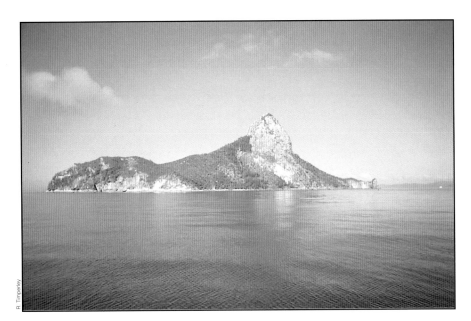

R. Timperley

The mature years

In the near-final scene of geological evolution of the area we have a chain of mountains or hills of volcanic or plutonic origin surrounded by a plain of sediment derived from erosion of the ancient landform. In all probability the scene would have been similar to that evident during a road trip today from Whitsunday to Townsville, where isolated hills and mountains rise abruptly from wide plains.

At some time in the later stage, the eastern coast of Australia was lifted upwards, and the Eastern Highlands were created. The crest of these highlands is marked in places by the Great Dividing Range, while towards the coast is the impressive drop-off known as the Great Escarpment. Over the last 80 million years or so this escarpment has been slowly eroding its way westwards into the Eastern Highlands, leaving behind a landscape of residual hills and mountains (rocks too hard to be easily eroded), surrounded by a coastal plain. The Coral Sea has flooded in and drowned the landscape leaving only a narrow strip of coastal plain in the Whitsunday area. The peaks and hills of the mountains on that plain remain above water and form the islands of the area, so-called 'continental' islands because they are part of a drowned mainland.

Pentecost Island's distinctive profile (from the east) attracted James Cook's attention on Whit Sunday, 1770. It is the only island he named. For some years it was referred to as 'Lion Island' because of a supposed likeness to a crouching lion, which requires some imagination. The island is thought to be a dyke of porphyry.

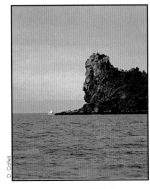

D. Collett

The northern tip of Pentecost Island (viewed here from the west) has a craggy face that, some say, looks like an Indian head.

The islands come and go

The final scene was dictated by the various ice ages as the polar icecaps waxed and waned under little-understood climatic influences. As the icecaps expanded, water was abstracted from the oceans of the world and sea levels fell. As the caps melted, the seas rose again. Thus the continental shelf in the Whitsunday area has seen a series of strandings and floodings, and the position of the coastline has varied widely. At one stage it is calculated to have lain at the very edge of the shelf, some 200 kilometres east of the present coast.

During the strandings, the islands would again have been a part of the mainland, with limestone girdles around their bases, the remains of coral reefs that had grown during periods of inundation. The Barrier Reef was a chain of limestone islands or hills further to the east; the seas rose again, and the coral polyps resumed their building on the carcases of the old reefs.

At the present time the world is in a period of postglacial high water, which peaked about 6000 years ago.

Nonvolcanic landforms

Among the preponderance of volcanic and plutonic islands in the group there are several isolated exceptions worthy of mention. Blackcombe Island is an isolated outcrop of conglomerate rock sitting atop a massive base of granite below water level.

The Repulse islands, along with the adjacent coastline north and south of Midge Point, have the distinction of being the oldest landforms in the area, being largely composed of sedimentary rock. East Repulse Island is particularly interesting because it contains a deposit of high-grade limestone, the remnant of a coral reef over 500 million years old.

Another exception is Whitehaven Bay and adjacent islands. Here there is a deposit of high-grade silica sand, estimated to be about 800 million tonnes, which forms the beaches of the area giving them their dazzling white appearance. The sand is composed of minute grains of quartz and is the product of what is known as longshore drift; that is, it has been transported from some unknown source by ocean currents running parallel to the coast.

Behind Whitehaven Beach the sand is piled in distinct terraces now covered with vegetation, and it is these terraces which, along with other factors in that area, point to some uplifting of the land in comparatively recent times.

The Whitsunday islands we see today are, with very few exceptions, either consolidated masses of ejectamenta from explosive volcanoes (in what must, at times, have been a scene worthy of the most adventurous of Hollywood movie versions) or are of the granite that lay in molten form beneath the area and fed its volcanoes. The time scale of the evolution of the topography defies the ordinary person's imagination. Therefore, it might be easy to assume that during the whole of the volcanic phase the area was a desolate, smoking earthquaky ruin, but this would not necessarily have been the case. Dormant periods of perhaps some millions of years would have resulted in a normal vegetated landscape where anyone present may, with justification, have asked: 'What volcanoes?'.

Hill Inlet and Whitehaven Beach, on the eastern side of Whitsunday Island, have dazzling white quartz sand beaches of a geological origin different from the local surroundings.

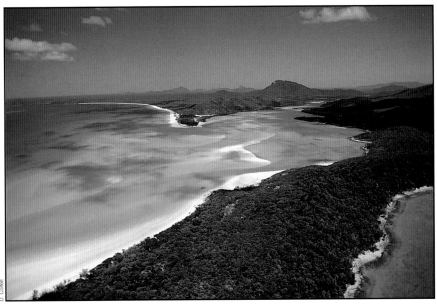

D. Colfelt

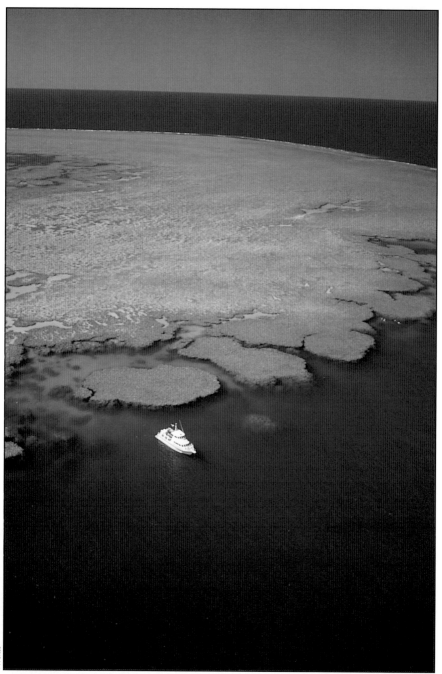

Bait Reef, 34 nautical miles (63 kilometres) from the mainland, a popular scuba-diving destination

Coral waters

The Whitsundays and the Great Barrier Reef

The Great Barrier Reef is a vast complex of coral reefs (almost 3000) that lies on the Queensland continental shelf. The world's largest coral reef system, it makes a formidable barrier to any ship approaching the Australian coast (and to any ship wishing to leave coastal Queensland waters for the Coral Sea), which is why Matthew Flinders coined the name 'Great Barrier Reef' during his surveys of the Australian coast in the early 1800s.

The Reef was built by tiny, calcium-secreting marine animals, coral polyps, and is said to be the largest structure on earth built by living creatures. The individual coral polyp is typically about 1–20 millimetres in diameter but, together, polyps can build colonies that ultimately become reefs, sometimes many square kilometres in area.

Corals have built many reefs in the tropical waters of northeastern Australia including those that fringe the continental islands and the mainland itself. The Whitsundays are renowned for fringing reefs that display great coral diversity, providing a laboratory for marine scientists as well as recreation for snorkellers, scuba divers and reef fossickers.

Where coral reefs grow

Coral reefs are almost always found in warm, relatively shallow, clear waters where the maximum/minimum temperature year round remains in a range of about 20°–30°C, generally between the tropics of Cancer (23° north latitude) and Capricorn (23° south latitude). Coral reefs do not flourish in waters much deeper than 50 metres, nor do they tolerate too much freshwater and sediment. Their development is, therefore, restricted in areas close to rivers. This is one reason why fringing reefs are less well developed in the southern Whitsundays, an area relatively more affected by the influences of major mainland river systems, such as the Pioneer, Proserpine and O'Connell, and where a very high tidal range keeps sediments stirred up.

The coral animal

Corals are members of the phylum Cnidaria (from the Greek *cnidos* meaning 'nettle'), which also contains jellyfishes, anemones, hydroids, sea fans, and sea whips. All members

Plant or animal? It was a vexing question for centuries and put more than one scientific reputation at risk. Corals are today classified as animals, but in some respects they also function very much like plants.

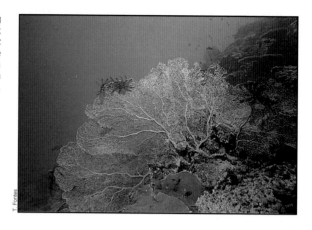

of this phylum use stinging cells (nematocysts) in capturing prey. Corals are carnivorous (meat-eating) animals, although for a long time they were considered to be plants. They feed on zooplankton, the minute animal life, abundant in the oceans, which includes the eggs and larval forms of millions of sea creatures. But they also derive nutrition from another source, which is the secret of their success as reef-builders.

The reef builders

Corals that build reefs have a close association with algae – minute, single-celled algae, called zooxanthellae (pronounced zoo–zan–thell–ee), that actually live within their tissues. The relationship is a mutually beneficial one, a so-called *symbiotic* relationship. Like all plants, the algae manufacture food from light by photosynthesis, and the corals obtain the lion's share of this food, enabling them to grow (by building skeleton) much more rapidly than would otherwise be possible – two to three times faster. The algae benefit in that they obtain the waste products of coral metabolism and respiration, nitrogen and carbon dioxide, which they use for their own nourishment. Corals are born with their symbiotic algae or acquire them very early in life.

The coral–algae partnership is why coral reefs around the world exist in relatively shallow waters (less than 50 metres deep): algae need light in order to manufacture food, and corals need algae in order to reproduce and build reefs.

Reef-building corals form a relatively thin living veneer on top of the consolidated substrate of the reef, which is composed of dead coral skeletons and other calcareous reef debris which have been cemented together by another kind of algae found on coral reefs, encrusting coralline algae.

The polyp
Tentacles
(with stinging cells and cilia)

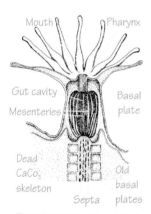

Mouth — Pharynx
Gut cavity — Basal plate
Mesenteries
Dead CaCo₃ skeleton — Old basal plates
Septa

The polyp is essentially a little bag (stomach) with a mouth (that is also the anus) at one end. The mouth is surrounded by tentacles equipped with stinging cells to immobilise prey. The gut cavity is partitioned by vertical mesenteries that increase its area of absorption. The cuplike skeleton (corallite) is secreted at the base and has multiple vertical partitions called septa. The skeleton grows upwards pushing the polyp up with it (that is, the skeleton grows but the polyp remains the same size).

How reef-building corals reproduce

Coral polyps reproduce sexually and asexually. They can multiply asexually by several means, but the principal method is by simply growing another polyp genetically identical with the first, and then doing it again and again – a process known as 'budding'. The pattern of budding governs the ultimate shape of the coral.

Sexual reproduction occurs two ways. A male polyp issues a sperm that is ingested by a female polyp, and her egg becomes fertilised within her body; or, male and female polyps issue sperm and eggs that become fertilised while free-floating in the water. The result of sexual reproduction is a fertilised larva, called a planula, that is free-swimming and capable of migrating to a new location, from a few metres to thousands of kilometres away.

Coral polyps are connected to each other laterally by a layer of tissue. Asexual reproduction is principally by budding – one polyp simply grows another.

A coral orgy

Over a period of several nights in late spring, about three to five nights after a full moon, a large proportion of the corals on the Great Barrier Reef have a sexual orgy. In what has been described as an 'upside-down snowstorm', the corals simultaneously release their multicoloured eggs and sperm into the sea. A phenomenon that was confirmed only relatively recently, the mass spawning of corals is a strategy of immobile animals that cannot move into sexual contact with each other and which live in an environment of continuous water movement. It may also serve to 'overwhelm' predators, thus improving their survival rate.

How a reef begins

After a coral egg is fertilised, it becomes a mobile coral planula, and it joins the zooplankton community, drifting in the ocean

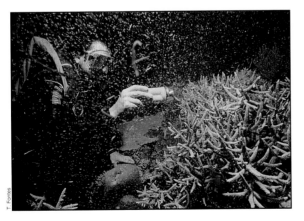

Staghorn corals spawning at Bait Reef

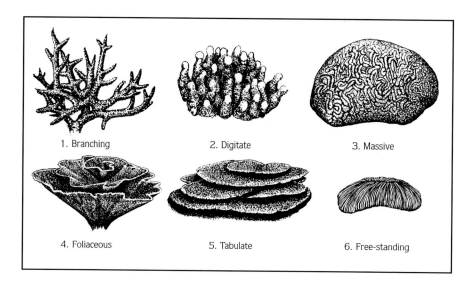

1. Branching 2. Digitate 3. Massive

4. Foliaceous 5. Tabulate 6. Free-standing

Principal growth forms of reef corals

Reef-building corals take on a number of shapes, but shape is not necessarily a guide to a particular species, as some species adopt different shapes depending on where they are growing. The basic growth forms are shown in 1–5 above (these are also commonly referred to as 'staghorn', 'brain', 'leaf', 'plate', 'table', and so forth). They are built by colonial polyps, most of which are individually not much bigger than a few millimetres.

Some polyps exist as individuals, such as the genus *Fungia*, referred to as 'mushroom' or 'slipper' coral (see 6 above). These can grow to as much as 25 centimetres.

Some other corals are encrusting and assume the shape of whatever they grow over.

The different shapes allow corals to succeed in different physical environments – for example, the platelike (tabulate) forms expose maximum surface which enhances their light-gathering ability in deeper water.

for a period anywhere from several hours to several weeks. If it survives predation by any of the many plankton feeders, for example small fish, clams and other molluscs, and even the corals themselves, it may find a clean substrate on which to make a home. It then begins to secrete a cuplike skeleton at its base, into which it can retreat for protection; it can then get on with the business of budding and expanding itself.

The individual coral is referred to as a colony; the structures that communities of colonies form are called reefs. Colonies grow upwards and outwards seeking the optimum amount of light for the benefit of the resident algae. Zooplankton, little fishes and other creatures seek protection among the growing branches of the colony and in the spaces between colonies. Algae become established here and there, and soon bigger fishes arrive looking for algae to graze on or for little creatures to eat. Some of the zooplankton grow up into shells and crabs and fishes. And so the newborn reef is underway.

The reef continues growing upwards until it reaches the surface and can grow up no more (this is at low tide level, at which point the colonies on the reef top will die) and further growth continues outwards. The reef is shaped by the forces of the water that impinge upon it. On the windward side it is pounded by waves, and bits of coral are broken off and tossed back to leeward where they accumulate in piles of rubble. Slowly the rubble is pulverised into sand and small fragments. Much reef sand is also produced by 'bio-erosion', the result

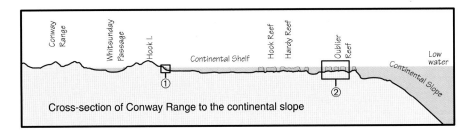

Cross-section of Conway Range to the continental slope

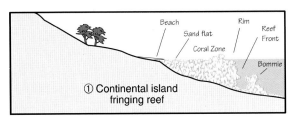

① Continental island fringing reef

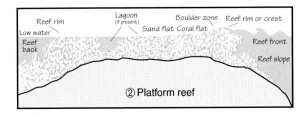

② Platform reef

of fish and invertebrates that scrape, bite and burrow into living and dead coral skeletons. Algae take over where the coral has died. Calcareous algae flourish in surf-battered conditions where they cement the living and dead corals, shells, and other debris into a solid mass. Pounded by the sea it becomes a smooth ledge sometimes referred to as the 'algal rim' which, along with a rubble zone immediately behind it, is the highest point of the reef. This zone dissipates the energy of the waves, and behind it corals may again flourish. Various physical conditions exist at various locations on the reef, producing zones that suit many different kinds of animals. A physical and biological pattern is established.

Algae – less obvious reef builders

Tropical reefs would not exist were it not for their algae. The microscopic symbiotic algae that dwell within coral tissues are very important, but other algae play a significant role.

Almost any sunlit surface of a reef that is not occupied by coral is potentially covered by a fuzzy green or brown carpet

Whitsunday reefs

The profile (above) represents the the Whitsunday continental shelf with the islands and the off-lying reefs of the Great Barrier Reef.

Fringing reefs (①) formed on the rocky shores of the continental islands when the sea level rose after the last ice age. They have parallels with offshore reefs, but being adjacent to land masses and subject to terrestrial runoff, usually have wide mud/sand flats and expanses of algae-covered coral rubble between the beach and the edge. They also lack the deep pools or lagoons found in the leeward areas of some platform reefs on the continental shelf. The best coral growth is at the edge and reef slope of a fringing reef.

The platform reefs (②) of today's Barrier Reef formed on top of ancient sedimentary structures. Depending upon their particular circumstances and their age, some may have a lagoon; in others the lagoon has become filled with sand. All reefs have distinctive physical and biological zones, different parts suiting different corals, other animals and algae. Particularly on offshore reefs, the reef front, for example, is a high-energy zone where corals must be robust to survive.

of algae called turf. This is the food of the fish, snails, crustaceans, and other animals that inhabit the reef. Fish graze by day and most others by night. The sheer numbers of grazers keeps the turf closely cropped, and therefore the algae is not always apparent to the casual viewer.

Other types of algae assist in reef construction as 'cementers' and 'sand formers'. They grow over the reef structure forming a hard skin and they also consolidate reef debris. Without these algae the reef would be pounded to pieces by the waves.

The spaces between coral skeletons on the reef are filled with the smaller skeletal remains of many other calcareous organisms, but a large proportion of the sand comes from algae – disclike and needlelike deposits from calcareous green and red algae.

Algae play such an important role on coral reefs that some scientists have suggested that reefs should be called 'biotic' or 'algal' reefs.

A dynamic balance

Corals and algae are in a dynamic balance, and if that balance is upset, the health of the reef may be threatened. When corals are killed by storms, or by an outbreak of the crown-of-thorns starfish, algae grow over the dead coral skeletons. Algae can also gain the upper hand if they are not cropped by the grazers of the reef. If a reef is overfished, removing some of its grazers, algae may gain advantage to the ultimate detriment of the reef.

Corals in the Whitsundays

The Whitsunday islands are renowned for their fringing coral reefs, which can be found throughout the islands and along the mainland shores, where it has been estimated that there are over 400 species of corals. The best-developed reefs are where there is good circulation of relatively clear water. Generally speaking, these are among the northern islands, where the tidal range is less than it is further south (and, therefore, less of the reef becomes exposed at low tide), and where the islands are bathed in clear oceanic waters twice each 24 hours as tidal currents sweep in from the north. Viewed from the air, Hayman, Langford, Hook, Border and Haslewood islands all exhibit very broad expanses of reef flat, a sure sign that conditions for reef development are good in that area. Among these islands are some of the best diving and snorkelling sites to be found in this region, and they rival the Barrier Reef itself for interest and variety. Further south in the Whitsundays, the tidal range increases,

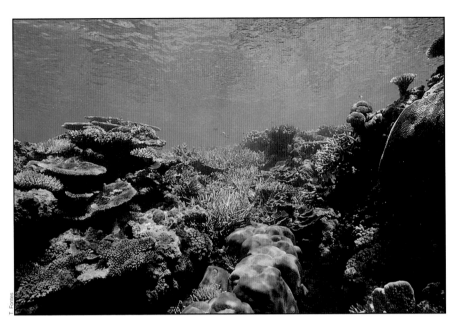

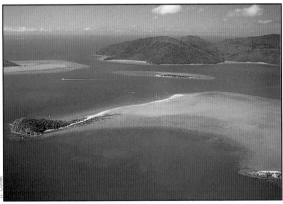

Corals are more spectacular than reef algae and therefore attract more attention, perhaps obscuring the importance of algae, which is a primary food source as well as the principal consolidator of the reef structure. The photograph above illustrates some of the many different forms of coral growth – staghorns (branching), leaflike whorls (foliaceous), 'brain' corals (massive), tablelike plates (tabulate), and fingerlike species.

Some of the most prolific growth of coral reefs in the Whitsundays area is among the northern islands, where the rising tide brings clear oceanic waters swiftly through the narrow passages. Langford Island (left, foreground) has developed a long kidney-shaped reef, moulded by the strong currents that sweep the area.

the water generally carries a higher sediment load from the Pioneer, Proserpine and O'Connell rivers, and coral growth is, as a general rule, less spectacular.

The nearest reef of the Great Barrier system, Bait Reef, is about 16 nautical miles (30 kilometres) north-east of Hook Island. Bait is one of a group of reefs that the chartmakers, in the late 1800s and early 1900s, named after the angler's basic equipment – Bait, Hook, Line and Sinker – the reason for which is apparent when looking at a map. Bait is a pristine

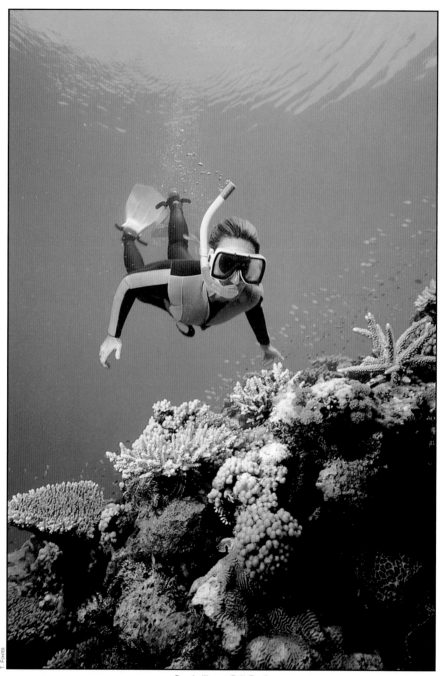

Snorkelling at Bait Reef

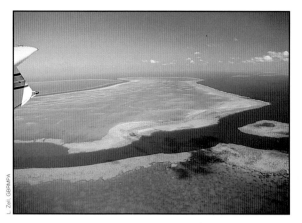

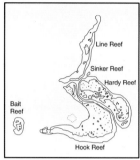

The reefs of the Great Barrier system that lie closest to the Whitsundays suggested a fishing theme to hydrographic surveyors early in the 20th century – Hook, Line, Sinker and Bait Reefs. Hardy Reef (above, left) is a large platform reef with lagoon and is the principal destination for outer reef visits in the Whitsunday region. Bait Reef is a popular destination for scuba divers and snorkellers (opposite), with a range of sites that offer good opportunities for both.

reef with excellent scuba-diving sites, and many student divers experience their first taste of diving on the Barrier Reef at the 'Stepping Stones', a series of large coral heads on its western side. Hook Reef probably got its name because it is the nearest sizeable reef to Hook Island, but its shape, and the position and conformation of the surrounding reefs, obviously made the fishing analogy difficult to resist for those who named them. Hardy Reef was probably named after Norman A.C. Hardy, second-in-command of HMAS *Moresby*, which conducted surveys in the Whitsundays in the 1920s.

Hardy Reef lies immediately east of Hook Reef, separated by a deep channel through which the flow of tidal currents is swift. Coral development in the channel is good, and Hardy has become the centre for outer reef activities in the area. Large pontoons moored in the channel are the base of operations for large motorised catamarans that bring reef visitors from the island resorts and the mainland.

Enjoying a coral reef

The best way to enjoy a coral reef is right in the water with it. Reef walking provides an opportunity to view another dimension of a reef, along with the many animals that inhabit the intertidal zone. Diving, snorkelling, reef walking and visiting the outer reefs are discussed in later sections.

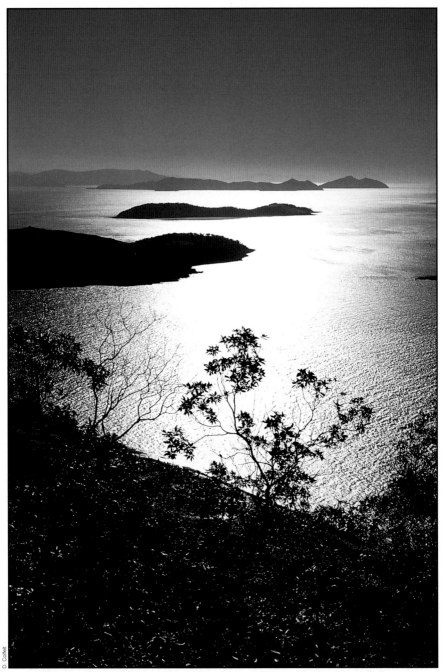
Vista from Hamilton Island, looking north-west towards Henning Island and the Molle Group

The Whitsunday landscape

A sea eagle soaring above the Whitsunday Passage today surveys a mosaic of dark green islands mortared together in a silvery latticework of waterways. Ten thousand years ago these islands were part of the mainland, linked by a sandy coastal plain. The climate had emerged from a very dry period associated with the climax of the last ice-age, 18 000–15 000 years ago, at which time trees were absent from 85 per cent of the Australian continent and the sea level was 130 metres lower than it is today. When the ice melted, the sea level advanced rapidly. Ten thousand years ago saw the beginning of a 'greenhouse' period of several thousand years, with increasing rainfall, and from that time the seas were to rise about another 35 metres until they reached the current level about 6500 years ago. Aboriginal hunter-gatherers roamed the area, taking advantage of seasonal resources of food.

Today the islands and adjacent high mainland enjoy greater rainfall than does the countryside immediately to the south (of Mackay) or to the north. Rainfall varies considerably from island to island and even from place to place on some islands. The high peaks are frequently shrouded in mist and the sheltered gorges run with water from the surrounding hills after rain. Exposed rocky slopes are scoured by the trade winds, and narrow beach strands provide a bare toe-hold for salt-tolerant plants. This variety of habitats gives rise to a rich vegetation, possibly 1000 species of plants. Although the islands have not had time to evolve a distinctive flora, there is evidence that evolution is underway, with a few species being endemic to the islands and others showing adaptations from island to island.

Evolution of the flora

Over its long history the Australian continent has been far from stationary and has had anything but a uniform climate or uniform sea level at its shores. And, as noted in a previous chapter (see page 32), Australia has not always been a separate continent, nor has it always occupied the same position on the globe.

During its travels the Australian continent has experienced, at one time or another, periods of complete inundation by water, periods when it was largely covered by rainforest and populated by dinosaurs, and periods of extreme aridity when it was all but a desert.

The Whitsunday coastline 10 000 years ago was further east than it is today; the sea level at that time was about 35 metres lower. The islands were lofty hills on a coastal plain.

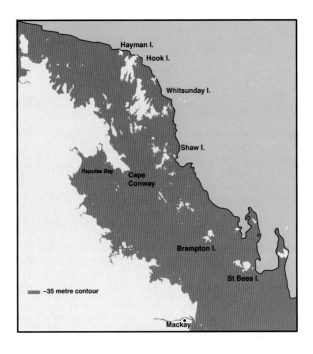

About 45 million years ago, Australia broke away from Gondwana and started a north-easterly migration, at a rate of 6–7 centimetres a year, to its present position. Since that time the continent has been an island ark, evolving a unique flora and fauna. The major pressure for evolution in the Australian flora has come from the changing climate that occurred after the breakaway, which caused a major change in the circulations of oceanic currents.

When Australia and South America were still connected to Antarctica, warm currents ran down the eastern sides of the great continents in the southern hemisphere, transferring heat from the equatorial latitudes. The temperature of the globe was more uniform than it is today, and at that time there was no ice at the poles. The climate in Australia was warm and wet, and the continent was mostly covered by rainforest. The breakaway of Australia and South America allowed a new oceanic current to flow unobstructed along southern latitudes, creating a weather regime characterised by much less even global temperatures and setting the stage for the formation of polar ice. Cycles of glaciation ensued

that caused wild fluctuations in the level of the sea and periods of intense aridity.

Australia is made up of some of the oldest rocks on Earth. The continent has been left with a legacy of relatively poor soils, largely unrenewed by volcanic upheaval, leached of nutrients by long periods of inundation. Climatic changes have transformed the continent from being one largely covered by rainforest to being the driest vegetated continent on earth. The transition to a drier, more fire-prone environment saw the evolution of a sclerophyll flora, dominated by eucalypts and acacias, with hard, leathery, oily leaves that helped them to withstand dry conditions in poor soils. Plants developed a number of strategies to cope with the increasing frequency of fire as the rainforests receded. In fact, they have evolved to the point where many Australian plants today actually need fire to regenerate.

Fire

Fire caused by lightning played an important role in shaping the Australian flora. An increasing incidence of fire was brought to the continent by the Aboriginal people, who arrived at least 60 000 years ago and possibly as long as 140 000 years ago.

Joseph Banks recorded in his journal after his visit to Australia in 1770:

> We guessd also that the fires which we saw so frequently as we passd along shore, extending over a large tract of countrey and by which we could constantly trace the passage of the Indians who went from us in Endeavours river up into the countrey, were intended in some way or other for the taking of the animal calld by them *Kanguru*, which we found to be so much afraid of fire that we could hardly force it with our dogs to go over places newly burnt. They get fire very expeditiously with two pices of stick ...

During their however-long pre-European occupation, the Aborigines employed fire widely in their hunter-gatherer occupation. They set fires at various times of the year, at various times of day, across a variety of habitats, burning with varying frequencies, which had an influence on a broad spectrum of plant and animal species.

In the Kakadu region of northern Australia, for example, Aboriginal people divined six major seasons, observing their onset not by a rigid calendar but by such events as the swarming of dragonflies, the flowering of various trees, the arrival of bird species, and by seasonal storm patterns. Fires were lit at specific times to control their spread and intensity.

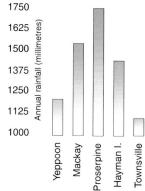

Annual rainfall on the Whitsunday coast
Rainfall varies among the islands and even from one locality to another on individual islands, governed principally by topography. The effect may be seen in the vegetation, which ranges from lush rainforest in protected gullies to eucalypt woodlands and scrub on drier rocky slopes.

Patterns of burning resulted in mosaics that had the effect of controlling the extent of burns and protecting some habitats from damage by uncontrolled fire. Aboriginal fire regimes employed in the Whitsundays may have differed from those used further north, but the general principals were probably the same. Fires were used to drive out large macropods – kangaroos – or to promote the growth of fresh green shoots which attracted certain game, or to maim or to stun small animals, or to conserve plant food sources (such as burning to protect closed forests or to control scorch height in open forests).

The Whitsunday landscape is typically characterised by 'bush-covered' islands that support a wide variety of vegetation ranging from closed tropical rainforests to parched beach communities that eke out an existence in a harsh, salty environment. A characteristic feature of many rocky promontories and ridges, where fire is not a factor, are tall stands of hoop pines (*Araucaria cunninghamii*), such as on the peninsula at the south-western entrance to Macona Inlet, Hook Island.

Aboriginal people of the Whitsunday islands no doubt had a marked effect on the vegetation. Selective burning probably resulted in an increase in grasslands (the 'lawns' on which James Cook remarked in 1770) such as those on North and South Molle, Haslewood and Lindeman islands. Europeans arrived in the latter part of the last century with their grazing animals and were attracted by these grasslands, but their appreciation and use of fire was different. Some grasslands are no longer grazed and, as they are also no longer burned, are now showing a tendency to revert to savanna and will, eventually, become forest. In other areas, the absence of a regular fire regime, or fires that have been set accidentally, have led to the invasion of rainforests by open forest species.

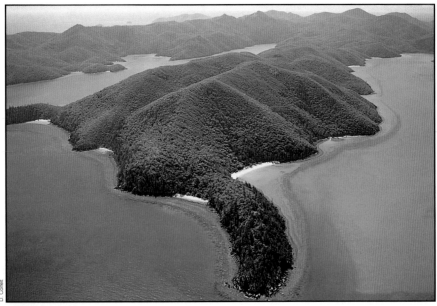

D. Collet

Features

The islands and much of the adjacent mainland today are national parks and, to the visitor, present an appearance of being largely unspoilt and 'bush-covered'. The varying topography of the islands gives rise to vegetation ranging from lush, closed tropical rainforest to low, dry, windswept heaths. The green of the islands changes where increased moisture and better soils foster rainforests, and where the distinctive hoop pines (*Araucaria cunninghamii*) raise their heads above other forest vegetation. The tall native tropical grasslands, the lowland vine forests and the woodlands featuring the beautiful white-trunked poplar gums (*Eucalyptus platyphylla*) represent ecosystems that are becoming less common on the adjacent mainland.

Hoop pine (*Araucaria cunninghamii*)

Along the beaches

The most evident and often the first vegetation encountered at the top of many beaches in the Whitsundays is the vine-like goat's-foot convolvulus (*Ipomoea pes-caprae*), with its long runners and bilobed leaf resembling a cloven hoof (*pes* = foot, *caprae* = goat). At times it shows attractive purple-pink funnel-shaped flowers, which has earned it the title 'beach morning glory'.

Among some attractive littoral species are the Burdekin plum (*Pleiogynium timorense*), octopus bush (*Argusia argentea*), silver bush (*Sophora tomentosa*), Cardwell cabbage (*Scaevola sericea*), *Guettarda*, and the Tanjong tree (*Mimusops elengi*). Several of these have both pretty leaves and flowers and may provide the visitor with welcome shade in what is a very hot environment. The line of strand plants is a feature of many Pacific Ocean and Indian Ocean shores and surprisingly the species are the same in many remote places.

The first trees to colonise the shoreline are often the she-oaks (*Casuarina equisetifolia*). These graceful trees with bark that is suggestive of the oak, and pinelike 'needles' that whisper in the wind (actually these are branchlets that have taken on the function of leaves) are able to subsist in apparently the most inhospitable conditions partly due to specialised roots that contain a bacterium that enables them to convert nitrogen into food.

Another 'tree' of the shore (and sometimes elsewhere) is the palm look-alike *Pandanus* (it is not a palm). It is also called the 'screw-palm' because of the spiral arrangement of the leaves as they grow out of the trunk, and it is sometimes called the 'screw pine' for reasons that defy the imagination, as surely no pine ever looked like this. It is also referred to by some as the 'breadfruit' because its fruit somewhat resembles the pineapple. In any of its many aliases, the *Pandanus* has a

The landscape 55

Coral tree (*Erythrina variegata*)

Burdekin plum (*Pleiogynium timorense*)

Golden orchid (*Dendrobium discolor*)

Tanjong tree (*Mimusops elengi*)

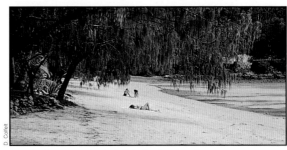

She-oak (*Casuarina equisetifolia*) (Palm Bay, Long Island)

Screw-palm (*Pandanus* sp.)

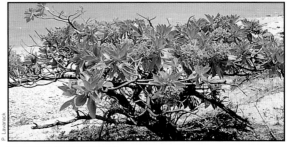

Octopus bush (*Argusia argentea*)

Pandanus sp. fruit

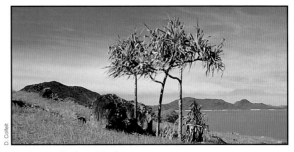

Pandanus sp. (Lindeman Island)

56 The Whitsunday environment

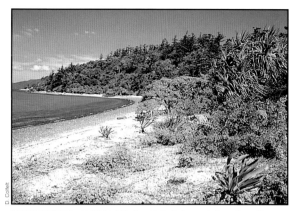

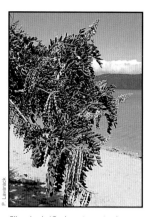

Some typical beach vegetation, including goat's-foot convolvulus, crinum lily, screw palm, octopus bush and others

Silver bush (*Sophora tomentosa*)

tightly packed crown of long, tapering leaves that have a latticelike minute cell structure that makes them very suitable for weaving into mats and baskets, as has been practised throughout the Pacific. Mature trees of some species have prop roots (roots that appear to 'prop it up'). The *Pandanus* fruit, which grows to about the size of a pineapple, contains oily seeds. The fleshy part is evidently edible but requires some amount of boiling.

Just behind the strand line and a common sight on the shores of Cid Harbour, Hamilton Island and in other locations is the coral tree (*Erythrina variegata*). None is more spectacular in spring and early summer, when its cone-shaped, 7-centimetre long red-flowering heads open progressively over a period of several weeks. A deciduous tree, the coral tree loses all its leaves during the dry months of late winter and spring, at which time the trunk is shiny and has a grotesqueness about it, causing some to mistake the tree for dead.

Probably the most common plant encountered on the strand line of Whitsunday beaches is the octopus bush (*Argusia argentea*), an attractive shrub that is usually low-growing (about 1–1½ metres tall) and spreading. The fleshy leaves are covered with hairs that give the whole plant a silvery appearance. The flowers are borne in twisted, contorted heads, which accounts for the name.

To many people orchids are delicate plants requiring the most sheltered and favourable conditions possible. This makes the golden orchids of the Whitsundays, *Dendrobium discolor*, something of a marvel. Rock faces covered with golden orchids are truly one of the features of the Whitsundays. These

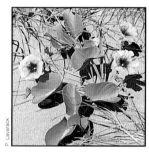

Goat's-foot convolvulus (*Ipomoea pes-caprae*)

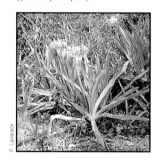

Crinum lily (*Crinum pedunculatum*)

Rainforest gully, Cid Harbour

Solitaire palm (*Ptychosperma elegans*)

Throughout the islands, but particularly on the lofty Whitsunday and Hook islands, patches of rainforest occur in many protected gullies. Particularly on Whitsunday Island, in Cid Harbour, Gulnare Inlet and in some of the bays on the south and east sides of the island, exploration of creeks occasionally reveals a brief profusion of the elegant solitaire palm (*Ptychosperma elegans*).

beautiful flowering plants cling to exposed rocks, bake in the searing tropical sun with no shade, only just above the reach of salt water where, during cyclones, many are washed off to their death. They are also found growing in the upper branches of trees, where they reach out to the sun with their long stems. *Dendrobium* flowers vary in colour from a chocolate brown to clear gold to light yellow. The flowering spikes are up to 60 centimetres long and bear numerous weirdly twisted, long-lasting flowers, each about 5 centimetres across. They can grow into huge clumps metres across and produce masses of blooms from late July to October. 'You can't kill them with an axe' the locals say, but they can be killed by goats. On islands where there have been goats, golden orchids are noticeably absent from the rocks.

On higher ground

A feature of exposed slopes of a number of islands are the unique Australian native grass trees (*Xanthorrhoea* sp.), which used to be commonly referred to as 'blackboys' because of a supposed resemblance to an Aborigine holding a spear. There are about thirty-three different kinds of grass trees which are distinguished by whether or not they grow a trunk, by the leaves and by the 'spear' which consists of a flowering section and a stalk (which can make an excellent spear shaft). *Xanthorrhoea* is derived from the Greek *xanthos* = yellow, and *rhoea* = flowing, which describes a yellow resin that comes from the trunk and which the Aborigines used, among other things, as an adhesive to attach axe heads and spear tips. They are relatively slow-growing plants and take six to ten years developing a root system, then gradually developing a trunk and growing about 10–25 millimetres a year (a 2-metre tree might, therefore, be well over 100 years old). Grass trees are part of the hard-leaved Australian sclerophyll flora, fire-adapted and able to exist in relatively poor soils. The treelike species are well insulated from fires and they are among the first plants to resprout after fire.

A symbol of the Whitsundays is the hoop pine, a stately, symmetrical tree that adorns the ridges and high-water marks of many of the islands. Hoop pines add an almost Scandinavian feel to the fjord-like inlets such as Gulnare, Nara and Macona and they attracted timber-getters in the latter half of the 19th century. Sometimes regarded as relics of the ice ages, the origin of this species is Gondwanan, when Australia lay in much cooler latitudes joined to Antarctica, South America and Africa. The trees seen today are no more than a few hundred years old. Hoop pines are susceptible to fire, particularly in the seedling stage, and this susceptibility is evident in their distribution; they do not occur in areas where grass is long

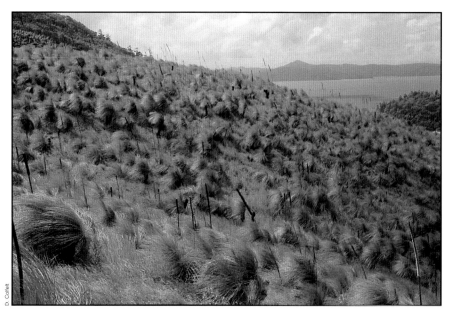
Grass trees (*Xanthorrhoea* sp.) on South Molle Island

and able to support a good fire. Along with other rainforest and fire-sensitive plants, they generally occur on rocky hillsides where grass has never gained a foothold. Creek lines and the rocky areas just above high tide are other places where these elegant trees eke out a living. The name hoop pine comes from the tendency of the bark to outlast the inner part of the trunk; when the tree dies and falls to the forest floor, it leaves large hoops.

Mangroves

Anyone travelling through the Whitsundays cannot fail to see patches of mangroves along the shorelines anywhere where fresh water runs from island streams or mainland creeks enter the sea. Australia has more than thirty species of mangroves, about thirteen of which can be found in the Whitsundays. Mangroves are flowering plants that have learned to survive in conditions that would prove fatal to most species. They occupy an ever-changing environment at the interface between land and sea. Their roots and lower branches are inundated by the tide twice every 24 hours (along most of our coast where diurnal tides exist), and when the tide goes out, much of their roots remains submerged in a soft bog of oxygen-starved mud. They have thus evolved a variety of modified roots – pencil roots, knee roots, blade-shaped roots, prop roots, stilt roots – which they can raise

Grass tree (*Xanthorrhoea* sp.)

Mangrove (*Rhizophora stylosa*) at May's Bay, Whitsunday Island

Mangroves have historically been accorded a relatively lowly status as 'muddy, swampy breeding places for mosquitoes'. They are frequently a target for reclamation and seaside development. Mangroves are very productive biologically and are extremely important as nurseries for a number of species of immature fishes, some of which are vital to the commercial fishery. The organic matter that mangroves contribute, primarily as of leaf litter, is the beginning of a complex food web involving micro-organisms and fungi and a host of animals that participate in food recycling. Mangroves are important to many terrestrial species as feeding areas, and they play a significant role in stabilising the shoreline by trapping silt.

above the muck and which have small openings (lenticels) through which mangroves can take up oxygen. Mangroves deal with the excess salt of their environment by filtering it out at the roots or by excreting it through glands in their leaves, or by shedding leaves that become salt laden.

All along the mainland coast, from Repulse Bay to Bowen, there are significant areas of mangroves, and some of the richest development among the islands is found at Hill Inlet, Gulnare Inlet and parts of Cid Harbour on Whitsunday Island.

Seagrasses and algae

While perhaps not usually thought of as part of a 'landscape', algae are highly visible when the tide is down in the Whitsundays and the fringing reefs of the islands are exposed. Both algae and seagrasses play an important role in the ecology of the area.

Algae are nonflowering marine plants, often referred to as 'seaweeds'. Their origins date back billions of years. They come in a variety of colours – red, brown, green and blue-green – and exhibit a wide array of forms, from delicate branching plants to stony encrustations. They are of significance as a primary food source for animals associated with coral reefs. Some species have an important role in consolidating the reef structure by cementing reef debris together, others contributing calcareous material to the reef sediments.

Seagrasses, commonly referred to as 'eel grass' or 'turtle grass' (not to be confused with 'turtle weed', which is an alga (*Chlorodesmis fastigiata*), are marine flowering plants functionally similar to terrestrial grasses. They have leaves, stems, roots, flowers and fruit, and most reproduce by underwater pollination. All have rhizomes (horizontal underground stems) with roots that anchor them to the bottom and which absorb nutrients. Seagrass meadows support diverse fauna providing a sheltered, nutrient-rich habitat. They are of major importance as nursery grounds for commercial prawns and provide feeding refuges for juvenile pelagic and reef fishes. They are a major food source for detritus feeders and also for larger animals such as the marine mammal *Dugong dugon*.

The most significant seagrass areas of the Whitsundays are in Repulse Bay and along the north-western side of Whitsunday Island including Dugong Inlet in Cid Harbour, which undoubtedly got its name because dugongs, in quieter times, used to frequent the area.

Whitsunday wildlife

It was only a short while ago in geological time that the Whitsundays became islands, not long enough ago for a great deal to have happened in evolutionary terms. The wildlife is essentially the same as on the adjacent mainland. The islands do have special appeal for some species, such as sea birds, which use some of the more remote islands as roosts and rookeries. Fish-eating raptors (birds of prey), such as the osprey and white-bellied sea eagle, are a very notable feature of the Whitsundays, and little wonder, with such an abundance of good hunting grounds and so many ideal places to roost immediately adjacent to them.

The mangroves and intertidal sand flats on the islands are used seasonally by wading birds on their transequatorial migrations, and the bird population grows dramatically at certain times of year. But year round, at low tide, the shores and reef flats are scoured by the numerous fossicking birds of the Australian coast. The isolation of the islands, and their dramatic topography that causes rainfall to vary considerably from one island to another (and even from place to place on the same island), promotes environmental niches and, therefore, the existence of some wildlife that is unique.

The following section presents, in no particular order, brief highlights of wildlife commonly encountered in the Whitsundays – birds and other animals about which the national parks rangers are frequently asked – and some examples of a few noteworthy species that invariably stimulate the interest of visitors. Wildlife in the Whitsundays is also the wildlife of the Barrier Reef – too large a topic to be covered here; a few highlights of reef wildlife are given in 'Diving and snorkelling in the Whitsundays' and 'Visiting a coral reef'.

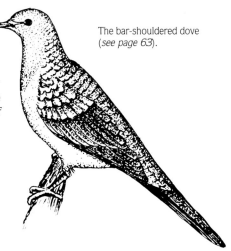

The bar-shouldered dove
(*see page 63*).

Raptors

Among the most noticeable birds of the Whitsundays are the white-bellied sea eagle and the osprey.

The raucous cries of sea eagles can often be heard in the early morning as they call out from their perches and nests. By day they are seen swooping over the water, deftly plucking fish from the surface with their large talons. During the mating season (April to June) sea eagles perform an aerial ballet, spectacular courtship flights where the male swoops towards the larger female, attempting to grab her talons and, after a number of passes, locking talons with her; then the two birds plummet in great cartwheels towards the ground. Sea eagle nests are an array of sticks, usually located in a hoop pine. Nesting occurs from May to August during which time these birds are sensitive to disturbance and shouldn't be approached too closely..

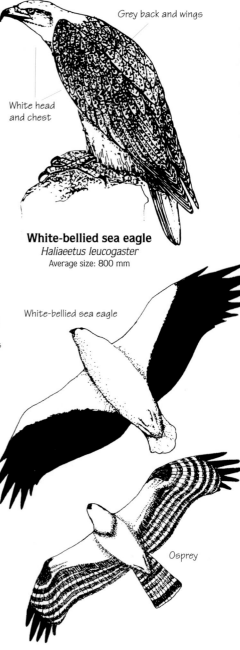

Grey back and wings

White head and chest

Osprey
Pandion haliaetus
Average size: 565 mm

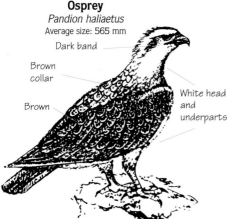

Dark band

Brown collar

Brown

White head and underparts

White-bellied sea eagle
Haliaeetus leucogaster
Average size: 800 mm

White-bellied sea eagle

Osprey

Ospreys sometimes swoop and pluck their prey from the water like sea eagles, and sometimes they plunge right into the water feet-first. Dark brown upper parts and white underparts, and a distinctive dark collar at the base of their neck, help distinguish them, along with bowed wings in flight. They also perform spectacular courtship aerobatics, climbing and diving together and performing various other aerial tricks. Osprey nests consist of a platform of sticks often in full view on an exposed rocky outcrop. These birds are sensitive to disturbance during nesting (at its peak during May to August), when nests shouldn't be approached closer than 150 metres.

Brahminy kite
Haliastur indus
Average size: 480 mm

The Brahminy kite is a beautiful bird that lives along mangrove inlets feeding mainly on fish and other marine animals that it finds on beaches at low tide.

Birds of the islands and coast

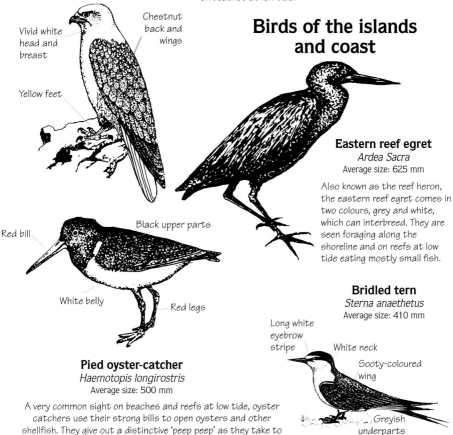

Vivid white head and breast

Chestnut back and wings

Yellow feet

Red bill

Black upper parts

White belly

Red legs

Eastern reef egret
Ardea Sacra
Average size: 625 mm

Also known as the reef heron, the eastern reef egret comes in two colours, grey and white, which can interbreed. They are seen foraging along the shoreline and on reefs at low tide eating mostly small fish.

Bridled tern
Sterna anaethetus
Average size: 410 mm

Long white eyebrow stripe

White neck

Sooty-coloured wing

Greyish underparts

Pied oyster-catcher
Haemotopis longirostris
Average size: 500 mm

A very common sight on beaches and reefs at low tide, oyster catchers use their strong bills to open oysters and other shellfish. They give out a distinctive 'peep peep' as they take to flight. Sooty oyster-catchers (*Haemotopus fuliginosus*), which are totally black, are also seen in the Whitsundays.

Bar-shouldered dove
Geopelia humeralis
Average size: 280 mm

Barred copper nape

Light brown barred wings

Grey head and neck

Red legs and feet

Also called the mangrove dove, or pandanus pigeon, the bar-shouldered dove's preferred territory is mangrove creeks and estuaries and is often observed feeding on beachfronts. It nests on a flimsy platform of twigs and sticks usually located on a horizontal branch of a tree.

Terns have narrow, pointed wings and (usually) forked tails (they used to be called sea-swallows). They hover and scoop their food from the surface of the water, where they hunt by day, returning to island roosts at night. Several of the Whitsunday islands are important tern rookeries, particularly for the bridled tern. They are sensitive to disturbance during the breeding season.

Birds of the islands and coast

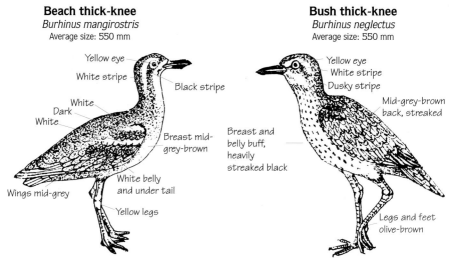

Beach thick-knee
Burhinus mangirostris
Average size: 550 mm

Yellow eye
White stripe
Black stripe
White
Dark
White
Breast mid-grey-brown
White belly and under tail
Wings mid-grey
Yellow legs

Bush thick-knee
Burhinus neglectus
Average size: 550 mm

Yellow eye
White stripe
Dusky stripe
Mid-grey-brown back, streaked
Breast and belly buff, heavily streaked black
Legs and feet olive-brown

Once called the beach curlew and bush curlew, thick-knees are a common sight and sound in the Whitsundays. Their eerie, mournful calls are reminiscent of anguished cries (which was no doubt responsible for the bush thick-knee being called 'neglectus'). Both thick-knees wail at night. The beach thick-knee has a heavier bill and more striking plumage; it is active in the daylight hours in the intertidal zone. Both species are threatened and easily disturbed.

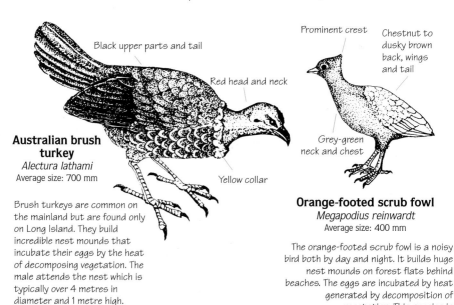

Black upper parts and tail
Red head and neck
Yellow collar

Australian brush turkey
Alectura lathami
Average size: 700 mm

Brush turkeys are common on the mainland but are found only on Long Island. They build incredible nest mounds that incubate their eggs by the heat of decomposing vegetation. The male attends the nest which is typically over 4 metres in diameter and 1 metre high.

Prominent crest
Chestnut to dusky brown back, wings and tail
Grey-green neck and chest

Orange-footed scrub fowl
Megapodius reinwardt
Average size: 400 mm

The orange-footed scrub fowl is a noisy bird both by day and night. It builds huge nest mounds on forest flats behind beaches. The eggs are incubated by heat generated by decomposition of vegetation. This species is sensitive to disturbance.

Birds of the islands and coast

Sulphur-crested cockatoo
Cacatua galerita
Average size: 475 mm

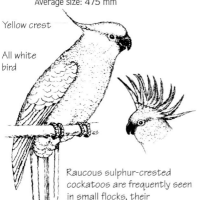

Yellow crest

All white bird

Raucous sulphur-crested cockatoos are frequently seen in small flocks, their discordant shrieks echoing from the hills and in the bays. In the heat of the day they sit in trees eating the leaves and stripping bark. They can raise and lower their yellow crest for display. Visitors to the Whitsundays can scarcely fail to see one.

Laughing kookaburra
Dacelo novaeguineae
Average size: 425 mm

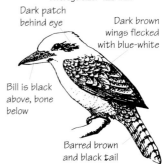

Dark patch behind eye

Dark brown wings flecked with blue-white

Bill is black above, bone below

Barred brown and black tail

The kookaburra is probably Australia's best-known bird, and because of its boisterous, laughing call, it is bound to be heard, if not seen, by every Whitsunday visitor. Kookaburras are the largest of the kingfishers; they feed principally on insects and other small invertebrates, although they sometimes eat snakes, lizards and small rodents. Their territory is eucalypt woodlands and open forest, where they perch, staring at the ground until swooping on their prey. 'Laughing' is their way of proclaiming their territory.

Torresian imperial pigeon
Ducula spilorrhoa
Average size: 375 mm

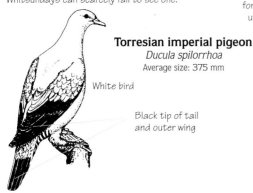

White bird

Black tip of tail and outer wing

A common sight in the breeding season, small flocks of these striking white-and-black birds, also called Torres Strait pigeons, are seen flying to and from their nesting and feeding sites across the inshore waterways of the Whitsundays. They begin breeding in September after migrating from New Guinea and other islands north of Australia. Nesting success depends upon the availability of food, weather conditions, and absence of disturbance. The biggest threat to their survival is hunting and the clearing of lowland rainforest on the mainland adjacent to their island nesting sites.

Silver gull
Larus novaehollandiae
Average size: 425 mm

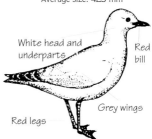

White head and underparts

Red bill

Grey wings

Red legs

A common bird of the Australian coast, silver gulls congregate to take advantage of easy food. It is not a good idea to feed them, as this gives them an advantage over less plucky species and may contribute to an artificial imbalance in nature.

Marine mammals

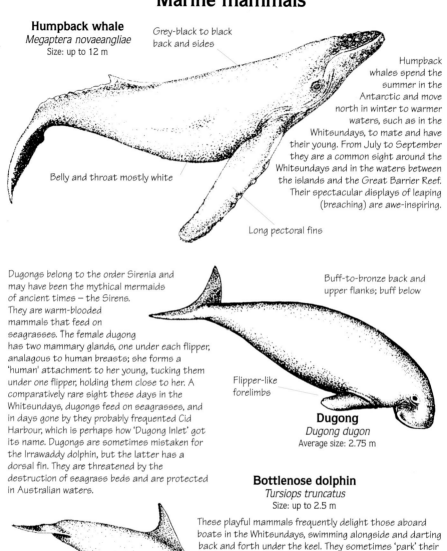

Humpback whale
Megaptera novaeangliae
Size: up to 12 m

Grey-black to black back and sides

Humpback whales spend the summer in the Antarctic and move north in winter to warmer waters, such as in the Whitsundays, to mate and have their young. From July to September they are a common sight around the Whitsundays and in the waters between the islands and the Great Barrier Reef. Their spectacular displays of leaping (breaching) are awe-inspiring.

Belly and throat mostly white

Long pectoral fins

Dugongs belong to the order Sirenia and may have been the mythical mermaids of ancient times – the Sirens. They are warm-blooded mammals that feed on seagrasses. The female dugong has two mammary glands, one under each flipper, analagous to human breasts; she forms a 'human' attachment to her young, tucking them under one flipper, holding them close to her. A comparatively rare sight these days in the Whitsundays, dugongs feed on seagrasses, and in days gone by they probably frequented Cid Harbour, which is perhaps how 'Dugong Inlet' got its name. Dugongs are sometimes mistaken for the Irrawaddy dolphin, but the latter has a dorsal fin. They are threatened by the destruction of seagrass beds and are protected in Australian waters.

Buff-to-bronze back and upper flanks; buff below

Flipper-like forelimbs

Dugong
Dugong dugon
Average size: 2.75 m

Bottlenose dolphin
Tursiops truncatus
Size: up to 2.5 m

These playful mammals frequently delight those aboard boats in the Whitsundays, swimming alongside and darting back and forth under the keel. They sometimes 'park' their broad tails on the bow wave and just hitch a ride, now and again turning on their side and staring upwards with a beady eye at spellbound observers on deck. Other dolphins sometimes seen in the Whitsundays are the spinner dolphin (*Stenella longirostris*) and the unusual Irrawaddy dolphin (*Orcaella brevirorostris*).

Dark or light grey above, grading to light grey or white below

Mammals of the forest

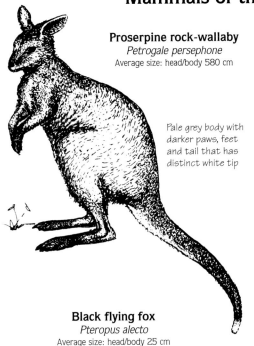

Proserpine rock-wallaby
Petrogale persephone
Average size: head/body 580 cm

Pale grey body with darker paws, feet and tail that has distinct white tip

A shy, elusive, large wallaby that inhabits boulder-strewn rainforest slopes and also feeds at adjacent margins of open forests, the Proserpine rock-wallaby is becoming rare on the mainland and is found only on Gloucester Island.

Another species of rock-wallaby found in the Whitsundays is the unadorned rock-wallaby (*Petrogale inornata*); it is smaller and distinguishable principally by its colour, which is sandy grey above and sandy white to rufous below. Found only on Whitsunday Island.

Brushtail possum
Trichosurus vulpecula
Average size: head/body 450 cm

Black flying fox
Pteropus alecto
Average size: head/body 25 cm

The most common of four species of flying foxes in the Whitsundays, this large fruit bat is an important pollinator of the forest. Flocks can be seen leaving their roosts late in the day, heading off for distances of 50 kilometres to forage for fruit and blossoms of eucalypts and rainforest trees. There is a large flock on Hamilton Island adjacent to the harbour and a smaller one on Lindeman Island immediately in front of the resort.

Probably the best known marsupial of the Whitsundays, this gregarious, cosmopolitan marsupial reaches nuisance proportions in popular camping areas and is a frequent visitor to campsites.

Fawn-footed melomys
Melomys cervinipes
Average size: 150 mm

The fawn-footed melomys is an agile, arboreal (tree-dwelling) native Australian rat belonging to a genus common throughout Melanesia (melomys means 'Melanesian mouse'). It has a distinctive, thin, mosaic-scaled tail which it uses to advantage in climbing. This species is common on the islands and befriends many an unwary camper, helping itself to any but the most secure of provisions – tents and backpacks proving no barrier.

Reptiles

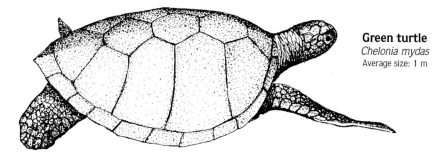

Green turtle
Chelonia mydas
Average size: 1 m

The two sea turtles most commonly seen in the Whitsundays are the green and the hawksbill. Green turtles have a disproportionately small head for the size of their body; hawksbills have pointed, narrow faces and are smaller.

Green turtles migrate long distances in the Pacific, and some nest in the Whitsundays while others just live and feed there and nest elsewhere. The mating season peaks around October, and nesting occurs from October to about February. Fertilised females come ashore onto a sandy beach, usually on a night when the tide is very high, scramble up above the high-tide mark, dig a hole and deposit their eggs. They then cover up the hole with sand, perhaps dig another shallow depression to disguise the real egg site, and then make the arduous journey back down the beach to the water. During the two months after mating, each female turtle may lay four to eight 'clutches' of eggs, each clutch consisting of a hundred or so ping pong ball-sized eggs. The eggs take about nine weeks to hatch.

Green turtles feed on seagrasses and are frequently seen adjacent to seagrass areas (such as Repulse Bay, and the western side of Whitsunday Island).

Hawksbills reside in the Whitsundays but don't breed there. They feed around rocky headlands and reefs, eating sponges and other encrusting animals.

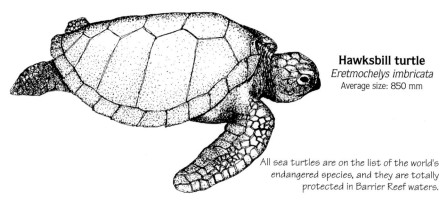

Hawksbill turtle
Eretmochelys imbricata
Average size: 850 mm

All sea turtles are on the list of the world's endangered species, and they are totally protected in Barrier Reef waters.

Reptiles

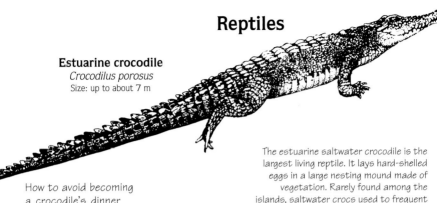

Estuarine crocodile
Crocodilus porosus
Size: up to about 7 m

The estuarine saltwater crocodile is the largest living reptile. It lays hard-shelled eggs in a large nesting mound made of vegetation. Rarely found among the islands, saltwater crocs used to frequent the mainland estuaries, and a degree of caution in these areas is warranted.

How to avoid becoming
a crocodile's dinner

● Dont swim or fish where warning signs are erected
● Don't approach a basking animal
● Don't interfere with nest mounds
● Don't clean fish by the water's edge near mainland estuaries
● Seek local advice about the presence of crocodiles
● Never dangle your feet in the water in croc territory

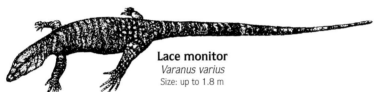

Lace monitor
Varanus varius
Size: up to 1.8 m

The most commonly seen reptile in the Whitsundays is the lace monitor, which is found on numerous islands and on the mainland. It grows to 1.8 metres and can be swift on its feet. It is not uncommon for lace monitors to approach visitors on beaches hoping to get a handout, as they are very partial to barbecued meat. They also raid tents, which should always be kept closed, and be prepared for them to climb trees and to pilfer the contents of any plastic bags hung there 'out of harm's way'. Goannas should not be fed, as it is neither good for them nor without risk to the feeder. Sand goannas are also frequently sighted in the Whitsundays.

Sand goanna
Varanus gouldii
Size: up to 1.6 m

Burton legless lizard
Lialis burtonis
Size: head/body 290 mm
Total length: 620 mm

Legless lizards (sometimes called snake-lizards) are peculiar to Australia. They have a distinctive pointed, angular snout and, sometimes, a dark stripe running the length of the body. Unlike snakes, they have external ear openings. They are harmless. The colour of the body varies from putty to brick red to slate grey.

Butterflies and associates

Butterflies representing all of the major families can be found in the Whitsundays, thanks to the preservation of the natural environment, and these can be a delight to bushwalkers or those taking a leisurely stroll along the walking tracks on the mainland and in island national parks. Probably over 100 of the 400 species found in Australia are present on the islands; one subspecies, possibly unique to the Whitsundays, has been found only on Lindeman, Whitsunday and Hayman islands – the **Whitsunday azure** (*Ogyris zosine zolivia*), a beautiful purple butterfly which has an intriguing relationship with a mistletoe plant and an ant.

Whitsunday azure
Ogyris zosine zolivia
(About 1.1 x normal)

A unique Whitsunday sub-species, the males are purple with a narrow black margin, the females purple with a wide black margin and a yellowish patch on the forewing. This is a fast-flying, medium-sized butterfly that will be seen circling the tops of eucalypts that have mistletoe on them; females may be observed actually laying eggs on mistletoes. Males are found flying around a prominent feature, such as a hilltop.

The butterfly begins life as an egg, which develops into a larva (caterpillar), then a pupa (chrysalis), which metamorphoses into a butterfly. The butterfly stage is relatively short, from perhaps two weeks in small species to six months in larger ones. Mating is the brief, final flourish, and it only occurs once in many species. After mating the female sets off to find a suitable plant on which to lay her eggs. The plant is the source of food for the larva (caterpillar) that develops from the egg. Most caterpillars are very fussy eaters, consuming perhaps only one or two particular plants.

The larval food plant of the Whitsunday azure is a mistletoe. Mistletoes are semiparasitic plants that grow in trees – semiparasitic because, while they take water and some nutrients from the trees, they also manufacture food using their own chlorophyll. Mistletoes have bright red flowers, and bright red berries covered with an extremely sticky, highly nutritious substance that makes them simply irresistible to the **mistletoe bird** (*Dicaeum hirundinaceum*). The mistletoe bird eats the fruit to the exclusion of almost everything else; it passes the seeds not long after eating them (usually within the hour), and the seeds are still very sticky and readily adhere to a branch of the tree, where the mistletoe plant becomes established. The mistletoe bird is solely responsible for the dispersion of the mistletoe plant, so these species are mutually very dependent.

Mistletoe bird
Dicaeum hirundinaceum
Average size: 105 mm

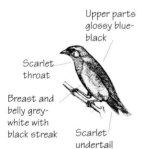

Upper parts glossy blue-black

Scarlet throat

Breast and belly grey-white with black streak

Scarlet undertail

The larvae of the Whitsunday azure eat a particular mistletoe that grows on the poplar gum (*Eucalyptus platyphylla*). The larvae exude a sweet, nutritious liquid from specialised glands that is irresistible to a **sugar ant** (*Camponotus* sp.). These honey-brown ants lovingly tend their source of reward, guarding the larvae, protecting them from predators and parasites and significantly reducing their mortality rate.

Butterflies and associates

The blue tiger is a common butterfly in the Whitsundays; it is black with numerous light blue elongated spots. It is frequently encountered in cool shady gullies. Overwintering aggregations may be observed.

Blue tiger
Danaus hamatus
(About 0.5 x normal size)

During the drier winter months in the Whitsundays, large aggregations of certain species of butterflies may congregate in moist, shady gullies, to while away the cool months in peaceful refuges, waiting for the warm weather to return when everything begins to grow again in earnest, and it is appropriate to fire up the reproductive urges again. The bushwalker who happens upon such a hiding place will be met with a silent explosion of colour and movement, the air filled with a profusion of darting butterflies – an experience not soon forgotten. Such aggregations may be found on the well-forested islands, but particularly on Hook and Whitsunday islands, where there are many such well-protected rainforest gullies.

Dull oakblue butterfly
Arhopala centaurus
(About 0.85 x normal size)

Seen along the shores and at the edge of the rainforest, oakblues are bright blue above with a subdued brown underside. They look like brilliant flashes of blue that 'disappear' when they land. Their larvae are attended by green tree ants (*Oecophylla smaragdina*).

Common Australian crow
Euploea core
(About 0.4 x normal size)

This common species is sometimes called the oleander crow because it frequently lays eggs on that plant and other cultivated ornamentals. It is a medium-sized butterfly, dark brown to black with a series of large white spots. It may be seen in overwintering aggregations.

Nest of the green tree ant
Oecophylla smaragdina

Green tree ants occur on the tropical coast of Queensland as far south as Mackay. Their nests, which are made from leaves bound together with a sticky silk, are hung from tree branches, sometimes about head-high and directly over a walking track. If the nest is disturbed, soldier ants may become aggressive towards the disturber. The ants have a nozzle with which they spray venom into wounds that their jaws have created, causing a painful bite but not an especially dangerous one.

A number of species of butterflies lay their eggs only where green tree ants are present.

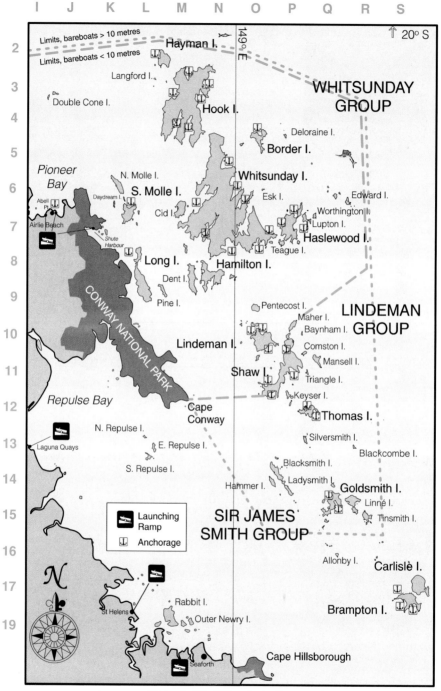

The heart of the Whitsunday boating area

Boating in the Whitsundays

One of the best ways to appreciate the Whitsundays is to explore them in a boat. The unspoilt national park islands have an allure that seems to suggest 'discovery is still possible'. There are scores of anchorages, each within easy reach of the next. These days, a long coastal voyage is no longer necessary to gain entrance to this wonderful marine park; one can simply fly in and step aboard a yacht that has already been provisioned and is ready to sail away. Or, as many people do, it is possible to just hitch the trailer and boat to the back of the car, drive to the Whitsundays and head off from one of several boat-launching ramps along the coast from Dingo Beach (E3) to Port Newry (M18)*.

There is a catch. In days gone by, anyone who found themselves on a boat in this island paradise had already been through a little bit of hell getting there. They had learned something about Barrier Reef waters – the trade winds, the big tides, about the coral reefs lying just beneath the surface, invisible until one is upon them. Today, the experience is most often gained vicariously; skippers who are new to the Whitsundays spend a bit of time before setting sail learning something about the local waters from the charts and particularly from one book specifically about boating in the Whitsundays, *100 Magic Miles of the Great Barrier Reef – The Whitsunday Islands*†, a comprehensive discussion of how to get around the islands safely.

Whitsunday winds
Newcomers to Queensland waters are sometimes unfamiliar with the phenomenon of trade winds – the winds that blow steadily all along the coast for much of the year. Trade winds are caused by the movement of air between latitudes 30° north and 30° south of the equator. They are caused by the sun's heating of the equatorial atmosphere, creating a band of warm, rising air. Cooler, denser air comes in from the north and south to fill the void. Trade winds would blow directly towards the equator but for the rotation of the earth which, because the speed of rotation is faster at the equator, causes them to be deflected to the west, resulting in south-east trades in the southern hemisphere. The name of the winds comes from the fact that, in the days of sail, they could be depended upon by trading ships.

* References such as (E3) refer to letters and numbers around the edges of maps in this section (or on the general map of the Whitsunday area found on pages 24–25).

† Windward Publications Pty Ltd, 464 Woodhill Mountain Road, via Berry, NSW 2535.

The Whitsundays have many more inlets and bays than it is possible for most visitors to explore, even after several trips to the islands. The principal island anchorages are noted on the map opposite; there are also a number of mainland bays north of Airlie Beach that provide peace and good shelter.

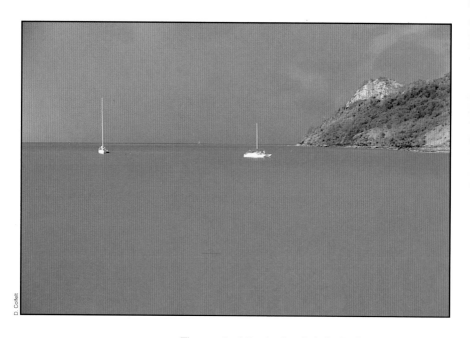

Peaceful anchorages in island national parks are the hallmark of the Whitsundays. Bauer Bay, North Molle Island, is frequently used because of its central location and relative proximity to the mainland. Another attraction is the resort situated at the head of the bay, where entertainment and use of resort facilities are available to visiting yachts. The island has magnificent walking tracks, including one which goes to the lofty Spion Kop, a bare rock promontory (pictured above) from which it is possible to survey 360° of horizon.

The onset of the trade winds in April brings persistent south-easterlies to the Whitsundays. The first winds of the trade winds season are typically blustery, and then they settle down to steady trades that can blow 15–20 knots for days on end, particularly if there is a large, slow-moving high pressure system over New South Wales and Victoria. As the season progresses the winds get lighter, and by late September or early October east and north-east winds occur with increasing frequency.

Whitsunday tides

Another notable feature of Whitsunday waters is the tides, which have a much greater range (3–4 metres) than many sailors have ever experienced. The high tide range is due to a combination of factors – the shape of the continental shelf at this particular point on the Australian coast, the convergence of tide waves from the Pacific, and the characteristics of the local sea bottom. Tides sweep south through the Whitsundays on the flood, causing currents to flow swiftly in narrow passages between the islands and in the Passage itself.

Winds and tides can produce strong currents that may assist or hinder the progress of a yacht, and when the wind and tide are going in opposite directions, the seas can become short and steep in the Whitsunday Passage; yachts plan their movements

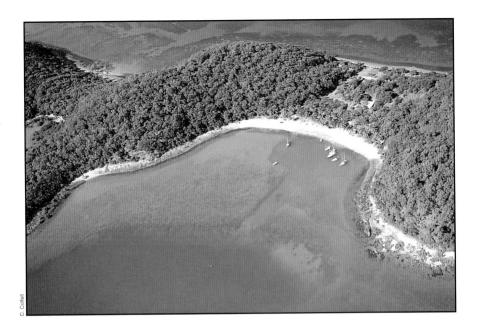

D. Colfelt

accordingly. Tides also affect the amount of beach that is exposed, which may affect one's plans to go ashore.

Boating facilities in the Whitsundays

Launching ramps are found along the Whitsunday coast from Mackay northwards (see maps on pages 84–85), popular spots being Victor Creek just north-west of Seaforth (for access to the Newry Group and southern islands) the Laguna Quays launching ramp (access to the south-central islands), Shute Harbour (access to the central and northern islands), Airlie Beach (3 ramps, for access to the northern and central islands) and at Dingo Beach (access to the northern islands). Marina facilities on the mainland include the 68-berth marina at Laguna Quays and the 200-berth marina at Abell Point. Hamilton Island has a 150-berth marina. A range of marine services is available at Hamilton Island and Abell Point. Slipping facilities in the area include a slipway next to the Abell Point Marina, one at Mandalay Point, one at Shute Harbour and a travelift at Hamilton Island. Shute Harbour is a major embarkation point for the islands and has two jetties, but these are designed primarily for larger commercial vessels, they are frequently busy and not always completely satisfactory to private boat owners. Moorings are avilable at Laguna Quays, Abell Point, Shute Harbour and Hamilton Island.

Palm Bay, Long Island is the site of a small, informal resort and is a popular first-night anchorage for yachts setting out from Shute Harbour. A channel through the fringing reef opens into a small lagoon large enough for about eight yachts tied stern-to to a palm tree on the shore.

Skippering a boat in the Whitsundays

Navigation is quite simple among the islands because there are so many prominent landmarks. The ability to interpret a nautical chart is really all that's required. Anchoring is the most demanding task, and someone in the crew needs to have read the book about how to set an anchor properly. Good anchoring technique is the key to having a peaceful, worry-free night, particularly if fresh trade winds are causing sharp gusts (locally referred to as 'bullets') to rush over island peaks and down into the anchorages. Those bringing their own boat to the Whitsundays, who may be familiar only with estuary cruising, should be sure that their anchor tackle is suitable for coral cruising, with an adequate length of chain and an anchor rope sufficiently thick to be comfortable to pull on. A lot of scope is sometimes necessary in the Whitsundays, and retrieving the anchor can be hard on the hands.

Bareboat yacht charter

Bareboat is a term coined in America where the hiring out of sail-it-yourself yachts was first developed. 'You are the skipper, your friends the crew' the advertisements used to say. Bareboating commenced in the Whitsundays in the late 1970s, and today the area has the largest bareboat fleet in the South Pacific. Bareboats are usually anything but 'bare', normally being quite luxuriously appointed and, due to their being licensed as commercial craft, are constructed to more rigorous standards than are many private yachts. Both power boats and sail boats with auxiliary engines are available, ranging in length from about 7 metres (containing 4 berths) up to 15 metres (10 berths). As a rule of thumb, for maximum comfort, the crew should number two fewer than the maximum number of berths on the yacht.

How to go about it

Bareboat charter bookings can be made either directly with the charter company or through a travel agent. A deposit is required at the time of booking, which is held until the completion of the charter. The balance of the charter fee is usually payable 60 days before the charter begins. Travel insurance is recommended in case it is necessary to cancel.

How much experience is necessary?

Charterers need no formal qualifications. It's proably a good idea to have someone in the crew who has had a little experience handling a boat. The crew is given a briefing and check-out aboard the yacht before setting off, at which time the skipper will need to demonstrate that he or she can handle the vessel. If the charter company has doubts about the skipper's ability, it may request that a professional skipper go

along for a day or two (at the charterer's expense) until the crew is capable of handling the yacht themselves. A charter in the Whitsundays is perhaps not the best time to learn for the first time how to drop an anchor, but if someone in the crew has had a little previous experience, there shouldn't be any problem.

How long to charter?

Charters are measured in nights aboard the vessel. They usually begin at midday, and the first afternoon is largely taken up with briefing and being checked out aboard the yacht. The first night will therefore be spent at, or close to, the port of departure (all yachts must be anchored by 4.00 pm because coral reefs are very difficult to see when the sun is at a low angle). Charters end on the morning of the final day, so the last night out needs to be spent at an anchorage not too far from home base. So, out of a week's charter, this leaves five nights of real freedom of choice of anchorages, making a seven-night charter the practical minimum if one is to have enough time to see something of the area without imitating a road-runner.

A cruising itinerary

The central group of islands are within easy reach of the mainland and island charter bases, and these islands offer many choices of anchorages which have appeal for different reasons; for example, some offer excellent snorkelling, some good fishing, some have good beaches for swimming, some have resorts. Beware of being too ambitious in drawing up an itinerary. Everyone always wants to see as much of the islands as possible, but just as spending only one night in each city on a world trip can prove exhausting, going to a different anchorage every night may defeat the purpose of a truly relaxing holiday. In practice it's nice to stay a few nights at some destinations to get into the relaxed rhythm of life aboard, doing only what's necessary to survive and not thinking about moving on to the next port straight away.

The central islands are the most popular, having the pick of the all-weather anchorages. The southern islands are less frequently visited and may appeal to those seeking greater solitude.

Seven of the islands have resorts, most of which welcome visitors in boats provided they register on arrival and pay a mooring fee. In most cases this fee gives you 'the keys to the resort'. A stopover at a resort can be a pleasant break in a cruise, making a land-fall and having a night out.

The costs of a bareboat charter include the hire of the yacht, food, and perhaps a few extras, such as mooring fees

when visiting an island resort. Charter companies offer a complete provisioning service which takes all the work and worry out of procuring food and planning meals. Several standards of provisioning, from 'basic' to 'gourmet', are available. Alternatively, charterers can do all the shopping and loading the food aboard themselves, which takes time out of the holiday, or they can provide a shopping list in advance and have the company buy to order (for which a service fee is charged). The cost of a bareboat holiday can become relatively inexpensive if the cost of hiring the boat is divided among a number of crew.

Crewed charters

For those who don't want the responsibility of skippering a yacht themselves, crewed charter vessels operate in the Whitsundays. These vessels come with a licensed skipper and assistant, who run the boat and pamper their guests. Sometimes the guests wish to take over the sailing and decision making, in which case the professional skipper and assistant are usually quite willing to simply become part of the crew. For some charterers this situation offers the best of both worlds – being able to skipper the boat themselves while being free of some of the restrictions (and responsibilities) under which bareboat charterers operate, such as the limited charter area (which does not include the Barrier Reef), the need to be anchored by 4.00 pm, and so on.

Another variation on the theme is hiring a bareboat and arranging to have a professional skipper as well, in which case the charterer pays the normal costs of the bareboat plus the additional fee for the skipper and his/her food.

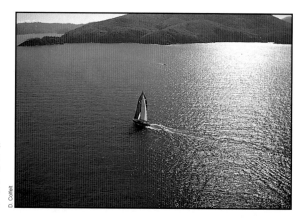

Apollo, one of a number of famous yachts in the annals of Australian ocean racing to have 'gone into retirement' in the Whitsundays, where she takes day-trips around the islands.

D. Colfelt

Camping in the Whitsundays

To camp in the Whitsundays is to indulge in what many believe to be the ultimate camping experience – sleeping under the stars on a 'desert isle'. There are many islands to choose from, and the final choice of site may depend on whether you wish to get away from it all, or to be more gregarious. The choice may also depend on a willingness to 'rough it' (with no facilities) or to have creature comforts such as picnic tables, a shelter, bush toilets, and possibly, in season, water at the site. Transport to the islands is another key factor.

The campsites recommended by the Queensland Department of Environment and Heritage (Q.DEH) have been selected for their natural attributes, and most campers will find one which is suitable (the list is available from local Q.DEH offices – see below). Campers may, however, request a location of their own choice. Camping in commercial camping grounds is also available – for example, at Hook Island, next to the underwater observatory (N3)* – and it is possible to participate in organised camping safaris. Information about commercial camping is available from any of the travel and booking agencies in Airlie Beach or Shute Harbour.

The Whitsunday mainland has several national park campsites, and there are also privately operated caravan and camping parks as well as one or two camping grounds operated by local councils – for example, at Seaforth (N19).

This section deals with camping in national parks on the mainland from Cape Hillsborough (O19), about 45 kilometres up the coast from Mackay, to Conway National Park (J7), near Shute Harbour, and on the islands from Gloucester Island (E2) in the north to Scawfell Island (Z18) in the south.

Camping permits

Camping permits are required in all Queensland national parks. Information about all of the sites and facilities available may be obtained from regional offices of the Q.DEH. Advance bookings are advisable. Booking details required when applying for a permit are:

- Name and address
- Number in the party
- Preferred campsite
- Date of arrival and length of stay (number of nights)
- Size of tent (small, large)

D. Collett

Kangaroos at the Cape Hillsborough national park

* References such as (N3), refer to letters and numbers around the edges of maps in this section (or on the general map of the Whitsunday area found on pages 24–25).

Camping information and permits

Northern, central islands
Q.DEH
Whitsunday Information Centre
Corner Mandalay Road and Shute Harbour Road
(PO Box 332)
Airlie Beach, Qld 4802
Telephone (079) 467 022
Fax (079) 467 023

Southern islands
Q.DEH
Mackay District Office
Lands Office, corner Wood Street and River Street
(PO Box 623)
Mackay, Qld 4740
Telephone (079) 518 788
Fax (079) 572 036

Camping permits are granted for up to two weeks at any one site. During busy times, the maximum allowable two weeks at mainland sites may be reduced. Campers using commercial vessels for transport must show their ticket before a camping permit is issued so that transport details can be recorded and monitored in the event of bad weather delaying pick-up from the islands. To secure a booking the total fee is payable in advance by cash, cheque or credit card. Phone bookings can be made and confirmed with payment by credit card (Bankcard, MasterCard and Visa card only).

Getting to the islands

The principal consideration in selecting a site is how to get there. Campers with their own transport have complete freedom of choice within the safe operational limits of their vessel. Trailable boats can be launched at any of a number of locations – for example, Dingo Beach (E3), Earlando (F4), Shingley Beach (I6), Airlie Beach (I6), Shute Harbour (J7), Port Newry (M18). Campers who don't have their own boat can arrange transport with one of the charter boats that depart daily from Shute Harbour or Abell Point marina. Charter boats will take campers and equipment to destinations that are more or less on the way to where they themselves are headed. This limits the choice of campsites. Another alternative is to hire a water taxi or amphibious aircraft from Shute Harbour or Whitsunday airstrip. The latter are, obviously, more expensive options. Campers who are watching the budget might consider one of several island sites close to the coast, such as Tancred Island in Shute Harbour, or the Newry Group off Seaforth. These are very much easier to get to and can provide a very satisfactory camping experience.

Fringing reefs around most islands in the Whitsundays make most beaches difficult to land on unless the tide is high or near-high. Reef flats are difficult to walk on at the best of times, let alone when carrying camping equipment. Tide times need to be considered and discussed with the skipper.

What to take

Water. Fresh water is available at relatively few campsites and may not always be available (depending on seasonal rainfall), so campers need to take adequate supplies. Five litres per person per day is recommended (3 litres is 'survival rations'). An extra three days' water should be taken in the event of bad weather or an absent-minded boat skipper delaying your return.

Food. It is wise to carry enough for your stay plus three days' extra. Make sure to have a food safe or some means of

protecting your supplies from wildlife that may discover your presence.

First-aid kit. A good first-aid kit is essential for any camping, but it is particularly important when camping on an island, where help may not be immediately available. In addition to the contents normally found in a first-aid kit, it should contain ample supplies of sunscreen, personal insect repellent, a bottle of vinegar, and several compressive bandages (see 'Tips for tropical travellers' beginning on page 183).

Clothing. Even when the days are hot, nights can be chilly, and warm clothing should be part of a camping wardrobe. Wet weather gear, a light-weight, long-sleeved shirt and a broad-brimmed hat should also be included. Adequate footwear is a *must* for bush or reef walking.

Equipment. A fuel stove for cooking is essential, as fuel is generally unavailable on the islands. A free-standing tent that requires few pegs will be an asset. A sleeping mat will make nights much more comfortable. A hand trowel is necessary for burying human waste where toilets are not available.

Campfires

The pleasant tradition of gathering around a campfire is, unfortunately, causing increasing environmental damage, and open fires are, in general, discouraged. They pose a threat to vegetation, particularly in dry conditions, and fire remains are unsightly and depreciate the naturalness of the islands. From a practical standpoint, there is just no available fuel for fires in national parks. All vegetation, dead or alive, is protected; dead wood is a source of food for some animals, others use it as a home, and the total protection benefits these animals as well as allowing visitors to the park to observe nature completely undisturbed by humans. Open fires are completely prohibited at a number of sites (this information will be supplied when applying for a permit). Where they are permitted, open fires are for cooking only and must be below high-water mark. They should not be larger than 0.5 metres in diameter and 0.5 metres high. Be absolutely sure that the fire is out and that the fire ring is completely dispersed before leaving. Campers should always check, before lighting a fire, that a total fire ban isn't in effect.

The campsite

Camp at an existing site where possible, or search for a spot where it isn't necessary to move rocks or branches or otherwise interfere with vegetation. Sandy or hard surfaces are better than boggy or vegetated areas. Camp away from vulnerable frontal dunes on beaches. Never dig trenches

Continued on page 84

Symbols indicating facilities available at campsites

 Toilets

 Private camping (some facilities)

 Bush camping

 Water

 Boat-launching ramp

 Picnic table(s)

 Shelter

 Cooking facilities (gas/electric barbecues)

 Showers

 Graded walking track

 Bush-walking track

No fires

Figure 1
The northern islands

The northern islands are most accessible from Dingo Beach and Earlando. There are also several boat-launching ramps in the vicinity of Airlie Beach, and some commercial vessels, also bound for central islands, depart from Abell Point marina, Airlie Beach.

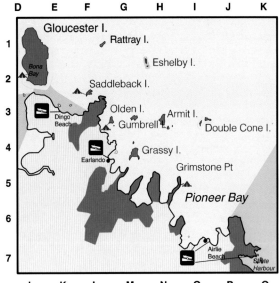

Figure 2
The central islands

Shute Harbour has boat-launching facilities, and a number of commercial day-trip operators depart for central island destinations daily, which may provide a means of transport for campers.

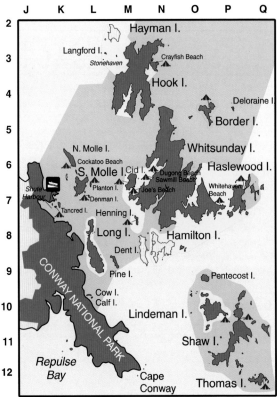

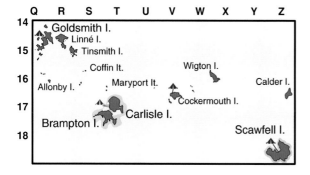

Figure 3
The southern islands
Mackay (R23) and Port Newry
(M19) (see map on pages
24–25) provide the nearest
mainland access for the
southern islands.

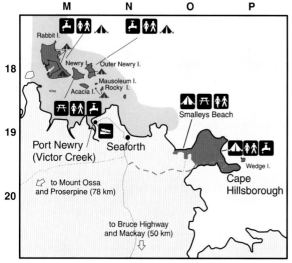

Figure 4
**Cape Hillsborough and the
Newry Group**
The Newry Island Group lies close
to the coast in well-protected
waters, which are safe for small
craft even when the trade winds
are piping fresh further offshore.
Boat-launching facilities are
located at Victor Creek, Port
Newry. Victor Creek is also used
as a jumping-off point for
Goldsmith and Carlisle islands.

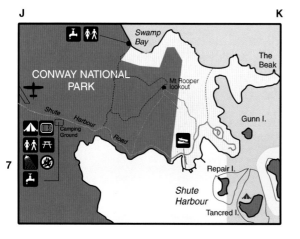

Figure 5
**Conway National Park and
Shute Harbour**
Conway National Park camping
ground can be used as a staging
point for island campers or for a
mainland camping holiday. Shute
Harbour, about 3 kilometres
down the road, is the principal
point of embarkation for the
central Whitsunday islands.

Camping 83

around your tent or cut vegetation for bedding. Aim to leave the campsite as you found it, or cleaner.

Hygiene in the bush

Campers need to observe proper sanitation and hygiene and must avoid polluting water. Use toilets if they are available. When toilets are not available, ensure that all faecal matter and toilet paper are properly buried (15 centimetres deep) well away from tracks, campsites, water courses and drainage channels (100 metres away). Sanitary pads and tampons should not be buried but removed with other rubbish. When bathing or washing cooking equipment or clothes, always wash at least 100 metres from streams. Creeks and streams should be kept free of pollutants, such as soap, detergents, shampoo, sunscreens and food scraps.

Rubbish

'Ship it in, ship it out'. Don't bury or leave any rubbish, including food scraps, which wildlife invariably dig up and scatter through the bush. Take a supply of strong garbage bags, and bring back with you everything you don't consume or use. Pack to minimise rubbish; avoid taking items such as bottles or those with excess packaging.

Walking track tips

To help protect vegetation and limit erosion:

- Keep on the track. Shortcutting promotes erosion, and it may confuse other walkers as to the whereabouts of the track. Marking unofficial routes is not a good idea; blazed trees are prone to fungal attack and may die, and extra markers, even tape, can confuse walkers coming along later.
- Avoid walking on fragile vegetation. Wherever possible, stay on rock and hard ground.
- Walk softly. Choose footwear for the terrain. Soft-soled shoes lessen the impact of each footstep.

Minimal-impact camping

To help protect camping areas and the islands:

- Remember that you are in a national park. The surrounding island, plants and animals should be left undisturbed.
- Firearms must not be taken onto any islands or national parks (this includes spear guns).
- Fuel stoves should be used, with care.
- All rubbish and food scraps must be returned to bins on the mainland; nothing should be buried, as it will, in one way or another, be detrimental to wildlife and will degrade the aesthetics of the campsite.
- Use constructed beach access points to prevent erosion.
- Pets and domestic animals are not permitted in national parks.

Camping on the mainland

Mainland campsites can provide a staging ground in prepara-
tion for an island camping adventure or may be a base for
a holiday in the Whitsunday area. Permits for mainland
national park sites are issued for periods of up to two weeks
but, when demand is high in peak seasons, this period may
be reduced to four days.

Cape Hillsborough National Park

Cape Hillsborough (O19) was named by James Cook in June
1770 and today is the site of an 830-hectare national park
with expansive beaches, hills clad in tropical rainforest and a
network of walking tracks that provide opportunities to view
wildlife and the ocean. Tourist accommodation and a council
camping ground are located on the eastern beach (O19),
where kangaroos and scrub turkeys wander amongst the
tents, and wallabies take it easy on the grass near the beach.
There is a national park camping ground at Smalley's Beach
(O19) with toilets and picnic areas.

Seaforth (N19) has a council caravan park and camping
ground right on its palm-fringed beach, with toilets, showers,
and fireplaces.

Conway National Park

The Conway Range is the spine of a prominent peninsula that
forms a dramatic backdrop to the Cumberland Islands. It is
part of a 23 800-hectare national park characterised by tropi-
cal lowland rainforest, deeply incised valleys and rugged peaks
that offer views of the Whitsunday Passage. A national park
camping ground (J7) on Shute Harbour Road, 7 kilometres
beyond Airlie Beach towards Shute Harbour (3 kilometres
from the harbour itself), has toilets, hot showers, water and
electric barbecues. A system of walking tracks commencing
in the vicinity of the camping ground offers a good opportu-
nity to view vegetation, wildlife and spectacular island scen-
ery. There are private camping grounds on Shute Harbour
Road in the vicinity of Airlie Beach and along the road to
Proserpine.

Island campsites

The maps on pages 82–83 show the principal sites. Details
of individual sites and facilities should be obtained from the
relevant Q.DEH district office (see page 79), as these change
from time to time in the course of managing the parks.

Coral trout (*Plectropomus leoopardus*)

Fishing in the Whitsundays

The Whitsundays offers many anglers a new kind of fishing adventure – the opportunity to fish a coral reef and perhaps to land one of the most highly prized species of the Australian coast – the coral trout. Whitsunday waters are studded with islands and fringing reefs but, in addition, there are many deep bays along the mainland and on the larger islands that yield a variety of estuarine species, too. And schooling mackerel come through the Whitsundays during the winter months (a Spanish mackerel can be caught in the area at almost any time of year). But the Whitsundays are perhaps most renowned for game fishing. It is Australia's prime bill-fishing area, and during the spring and summer months, game fishermen come from around the world in hopes of catching a record sailfish, or perhaps a black marlin or bluefin tuna. Over the years many light-tackle records have fallen in the Whitsundays.

Amateur anglers do not require a fishing licence in Queensland, although it is unlawful to sell fish without a permit.

The coral trout is the most highly regarded of reef fish; the specimen pictured is a deep-water variety weighing about 3 kilograms.

Reef fishing

Coral reef fishing is the preoccupation of local fishermen and can be done almost anywhere among and between the islands. For those inexperienced at fishing around coral, there are a few tricks that may improve one's luck. Fishing in coral requires line of *at least* a 25-kilogram breaking strain, not so much because a huge fish is waiting to pull you out of the dinghy but because coral is murder on fishing gear. Always have plenty of spares on hand. Thin line will, in short order, be chewed to pieces by coral, and fish living around coral tend to take the bait and run for cover under the nearest boulder. A line attached to a fleeing fish can be quickly severed, and it may also cut the fingers, which is why many coral fishermen tape their finger joints. Keep enough tension on the line to register bites and to avoid snagging. The weight of sinker can be adjusted to suit the current.

Fish over the edge of the reef one hour before or after high tide for best results (neap tides are better); early morning and evening are also better than when the sun is high.

Night-time on a rising tide can be excellent. Trolling along the edge of a reef may also produce dividends.

Baits readily available in the Whitsundays are prawns, squid, Western Australian pilchards, small fish known locally as 'herring' and garfish. If you have a throw net, small fresh fish from the shallows make excellent bait. A few suggestions about tackle are given later.

Estuary fishing

The Whitsunday mainland coast is studded with mangrove inlets that can yield good catches, and on some of the larger islands, such as Whitsunday and Hook, there are deep embayments with mangrove areas that also can reward the angler. As the tide runs out of estuaries and creeks, predator fish look for baitfish that hide around sheltering 'snags' or which are being flushed from streams and gutters on the flats and out into the main creek. During the last half of the runout and the first part of the rising tide these areas can be a good place to drop a lure or a live bait. Some of the bigger fish hang around the deeper holes and channels.

Where to fish for reef and estuary species

This is the million dollar question, and regard with suspicion any 'hot tips' that are other than pretty general in nature. It is impossible to pinpoint exact locations both because these are constantly changing but also because one can easily be a matter of metres off the right place – for example, a particular deep hole. Professional fishermen take years to locate productive fishing spots, and even when they think they know where to go, they often find that they have to keep moving to find the fish. Good spots go cold; months later they may become productive again. Some general locations that are popular with amateurs and which usually yield results are:

- Shute Harbour: bommies near Gunn Island; the reef opposite Cane Cockies Cove; the channels between Repair, Tancred and Shute Islands; offshore mudflats on the south side of the

For best results when reef fishing, drop a line beyond the edge of the reef a short distance seawards of rock outcrops or bommies. Fish have more or less permanent homes amongst the bommies but come out over broken coral rubble to feed, which is the place to fish. Further out is unlikely to yield much. The hour just before and after the high tide can be a good time; evenings and early mornings are better than in the middle of the day.

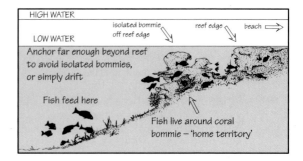

A typical game-fishing boat in the Whitsundays, *Sally-Anne* is a 12.8-metre Steber capable of taking up to six light-tackle fishermen out to the Barrier Reef or among the islands in search of mackerel, tuna, sailfish or marlin. Experienced local skippers know where to go and how to get results.

Courtesy G. and P. Hallam

harbour; the reef fringe along the northern coast of Shute Harbour (alongside the main approach channel).

- Pioneer Rocks and the mainland rocky fringe (a good trolling area for mackerel
- Airlie Beach: the rocks and headlands, or trolling offshore
- Cannonvale: the rocks and headlands, or trolling offshore
- Islands: all the inlets are fish habitats, and reef areas too; generally, the more remote locations will be less well-worked.

Game fishing

The Whitsundays are a renowned game-fishing area, particularly for billfish. Game-fishing charter boats operate from the mainland and from several of the islands.

In the winter months, the Whitsunday's experience big runs of Spanish mackerel – beginning mid to late May and running till late September or early October, although mackerel can be caught any time of year. In summer, the Whitsundays are a prime billfish area – black marlin, swordfish, sailfish – and tuna are caught in large numbers from October through April, although the latter may also be caught year round. Tournaments are held throughout the year for a number of different species, with major meetings in November and December in quest of billfish.

Game fishing takes place around the islands and out at the Barrier Reef (weather permitting). Mackerel can be caught anywhere, but the best locations are the outlying islands – from Deloraine, the Edward Group, Minstrel Rocks, around past Pinnacle Point at the top of Hook Island to Dolphin Point, Hayman Island. 'The Paddock', which is the open water just north-east of Hayman and Hook islands, yields some magnificent game fish.

Tuna can be caught right amongst the islands. Experienced anglers look for birds diving on the water, a sure sign in

Continued on page 92

Fishing 89

Reef fish species to which size and bag limits apply

Fingermark
Lutjanus johnii
35 cm / 10 fish

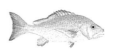

Hussar
Lutjanus adetii
25 cm

Large mouth nannygai
Lutjanus malabaricus
40 cm / 10 fish

Mangrove jack
Lutjanus argentimaculatus
35 cm

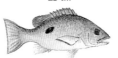

Moses perch
Lutjanus russeli
25 cm

Red emperor
Lutjanus sebae
45 cm / 10 fish

Small mouth nannygai
Lutjanus erythropterus
40 cm / 10 fish

Stripey
Lutjanus carponotatus
25 cm

Estuary cod
Epinephelus tauvina (= coioides)
35–120 cm / 10 fish

Potato cod
Epinephelus tukula
35–120 cm / 1 fish

Queensland groper
Epinephelus lanceolatus
35–120 cm / 1 fish

Pearl perch
Glaucosoma scapulare
30 cm / 10 fish

Grass sweetlip
Lethrinus fletus (= laticaudis)
30 cm

Red throat emperor
Lethrinus miniatus
35 cm / 10 fish

Spangled emperor
Lethrinus nebulosus
40 cm / 10 fish

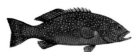

Coral trout
Plectropomus species
38 cm / 10 fish

Black spot tusk fish
Choerodon schoenleinii
30 cm / 10 fish

Purple tusk fish
Choerodon cephalotes
30 cm / 10 fish

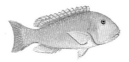

Venus tusk fish
Choerodon venustus
30 cm / 10 fish

Maori wrasse
Chelinus undulatus
75 cm / 1 fish

Silver jew
Nibea soldado
45 cm

Reef and pelagic fish species to which size and bag limits apply

Spotted (black) jew
Protonibea diacanthus
45 cm / 10 fish

Teraglin jew
Atractoscion aequidens
45 cm / 10 fish

Mulloway
Argyrosomus hololepidotus
45 cm / 10 fish

Reef fish subject to size and bag limits

The 26 species of reef fishes shown and 10 pelagic species are among those under particularly heavy pressure from recreational and commercial fishing.

Silver teraglin
Otolithes ruber
30 cm

Snapper
Pagrus auratus
30 cm / 30 fish

For the purpose of assessing a bag limit, two fillets equal one fish. No more than a total of 30 reef fishes may be taken in any combination. Recreational fishers are required to leave the skin on all fillets to provide a means of identification for bag-limit monitoring.

Broad barred (grey) mackerel
Scomberomorus semifasciatus
50 cm / 10 fish

School mackerel
Scomberomorus queenslandicus
50 cm / 30 fish

The figures shown beneath the scientific name of each species indicate (a) the minimum size that may be kept and (b) the bag limit.

Sharkey mackerel
Grammatorcynus bicarinatus
50 cm

Spanish mackerel
Scomberomorus commerson
75 cm / 10 fish

Example
45 cm / 10 fish

45 centimetres is the smallest size of this species that may be kept. 10 fish is the maximum number of this species that may be in one's possession at any one time.

Spotted mackerel
Scomberomorus munroi
50 cm / 30 fish

Wahoo
Acanthocybium solandri
75 cm / 10 fish

Where a range of figures is given, for example, 35–120 centimetres, fishes smaller than, in this case, 35 centimetres or, in this case, larger than 120 centimetres, must be returned to the water.

Black kingfish
Rachycentron canadus
75 cm / 10 fish

Yellowtail kingfish
Seriola lalandi
50 cm

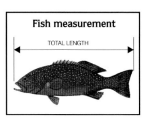

Fish measurement

TOTAL LENGTH

Rosy job fish
Pristipomoides species
30 cm / 10 fish

Dolphin fish
Coryphaena hippurus
45 cm

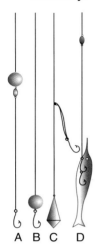

A B C D

(A) for fishing over sand and mud: line, 'running' ball sinker (threaded but not attached), swivel, wire trace and hook. Some movement helps to attract fish. Bean-shaped sinkers are sometimes preferred when line must be kept in place.

(B) for fishing in reef areas: line threaded through a ball sinker and attached to the hook; the sinker runs freely and maximises sensitivity, minimises snagging, and does not deter timid fish that might baulk dead weight of the sinker.

(C) for deepwater drifting: a loop passed through the eye of the hook and back over the shank, with heavy sinker (perhaps as much as 225 grams).

(D) for trolling: simply a gang of hooks at the end of a long wire trace attached to the line with a swivel; hooks are embedded in a garfish and made to look as natural as possible. Or, use a single live fish hooked through the back above the spine. The size and number of hooks, and the bait, depend upon the fish sought. Use shock cord or rubber tube as a shock absorber if line is fixed to a boat.

season that there are tuna. One tactic employed for hooking tuna is to run just upwind of the feeding school and cast across and through the school with a spinning outfit, such as a small chrome spinner with treble hooks hanging off the back. This tactic avoids 'spooking' the fish, which sometimes happens when trolling around tuna. Run upwind, which will facilitate casting, and shut down the motor; in this way it's possible to get within 6–10 metres.

Billfish are found in the shipping channel, between the islands and the Great Barrier Reef, in deep water where there are lots of bait fish in the summer months. Marlin range in size from 10 to 125 kilograms, the average being 30 to 50 kilograms.

The great majority of billfish caught in the Whitsundays are tagged and released.

Estuary, coral and trolling rigs

A rod may have its advantages when fishing from rocks on the mainland, but hand lines are easier to manage on a boat. A large diameter casting reel makes hand-line management much easier.

The illustration represents the most popular rigs with local fishermen. A, B and C may all be used for reef or estuary fishing, for bottom fishing over sand, mud, near bommies or around reefs. A and B are preferred in reef fishing as they are light; the important basic principle in all rigs is to use the minimum amount of wire trace, the smallest number of swivels and the lightest possible sinker. Too much hardware makes it difficult to register bites and increases the risk of the line being snagged on coral or some other obstruction. Running sinkers (through which the line can easily pass) help timid fish to go with the bait without having to drag a weight that might otherwise deter them. Some fishermen prefer bean-shaped sinkers instead of ball sinkers as the bean keeps the line in place more effectively. Rig A is good over sand or mud, as some movement helps to attract fish such as flathead. Rig C is sometimes called a 'snapper rig' and is used in deep channels. The sinker may weigh as much as 225 grams. Rig D, the 'floater', is simply a gang of hooks (the size to be determined by the quarry sought) generally used to catch surface swimming fish such as mackerel.

Garfish is popular bait for mackerel, usually on a piece of wire 30–35 centimetres long with two or three ganged hooks run into the belly of the bait. In front of this some of the professionals use a coloured plastic squid (any bright colour will do), about 12 centimetres long, with a barrel sinker in the front end to keep it underwater when trolling at 5 knots

or so. When trolling with a rig other than a rod, it's a good idea to have some shock absorber in the line, perhaps a bit of bicycle tube or a shock cord tied between the line and where it is secured.

Whitsunday fishing restrictions

Fishing is permitted in most areas of the Whitsundays, but there are some areas that are totally protected and others where some fishing restrictions apply (see pages 24–25 for information about park zones).

Where not to fish

Fishing is prohibited In the green Marine National Park 'B' zones, such as:

- all along the northern side of Hook Island from Alcyonaria Point on the western side of Butterfly Bay to 'The Woodpile' on the eastern side of Manta Ray Bay;

- Border Island, for 100 metres off the reef edge all around the island;

- all along the eastern side of Haslewood Island and all around Lupton Island, for 100 metres off the reef edge.

Fishing is also prohibited within 100 metres of the underwater observatory on Hook Island.

Areas with conditional restrictions

In Marine National Park 'A' zones (yellow), fishing is permitted with the use of only *one* hook on one *hand-held* line or rod (per person); no set lines are permitted. Trolling for pelagic fishes is allowed.

Spear fishing

Spear guns and spears may only be used by persons aged 15 years and over and are not permitted to be used while wearing underwater breathing apparatus other than a snorkel. Power heads are not permitted. Spear fishing is totally prohibited in all Marine National Park 'A' and 'B' zones and within 100 metres of the underwater observatory on Hook Island. Spear fishing is also prohibited within 400 metres of:

- the area between Brampton and Carlisle Islands;

- the south and west sides of Lindeman Island;

- Seaforth Island;

- the western side of Long Island;

- South Molle Island between Ker Point and The Causeway, and in Bauer Bay;

- Daydream Island;

- the east, south-east and south side of Hook Island from 800 metres north of the observatory around to the west side of Nara Inlet; and

- Hayman Island (south and west) from Groper Point to Blue Pearl Bay.

continued on page 94

Marine park fishing restrictions

Totally protected species
- Ceratodus or lungfish
- Helmet, trumpet and clam shells
- Female mud and sand crabs
- Whales, porpoises, dolphins, dugong and other marine mammals
- Turtles
- Egg-bearing female spanner or frog crabs
- Egg-bearing female Moreton Bay bugs and any other egg-bearing female sea bugs
- Egg-bearing slipper lobsters
- Corals
- Sea fans
- Estuary, greasy and potato cods greater than 1200 mm
- Giant groper greater than 1200 mm

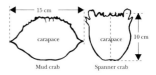

Mud crab Spanner crab

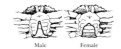

Male Female

Crab identification and measurement

Female crabs are totally protected in Queensland waters and must be released.

Helping released fish to survive

Fish use their air bladder to control their depth (by adjusting the pressure and therefore the volume of gas in the bladder). In some species quick vertical movement, such as can occur when a fish is pulled up from deep water on a fishing line, can result in an excessively inflated bladder. The bladder may distend the abdomen, or it may be forced, with the gut lining, out through the mouth. Undersized fish released with a distended bladder frequently die; other fish or predators attack while they float on the surface. Anglers can help improve the survival rating by deflating the bladder.

To deflate the bladder, do not penetrate the protruding gut lining, which most likely will lead to salt water getting into the body cavity, killing the fish. It is best to insert a fine hollow tube with a sharp point (such as a hypodermic syringe that might be found in the first aid kit, or any clean, fine-pointed object if a hypodermic isn't available) through the side of the fish immediately behind the upper part of the pectoral fin base. Penetration below the fourth or fifth dorsal spine is generally appropriate. This will allow the air to escape through the side of the fish rather than inside. The hissing of escaping air will be audible. Keeping these fish in a bait tank for a short period will show whether enough air has been released for the fish to achieve 'balance' in the water.

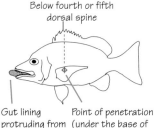

Below fourth or fifth dorsal spine

Gut lining protruding from mouth

Point of penetration (under the base of the pectoral fin)

Seasonal restictions, legal sizes and bag limits

Fishing is an extremely popular recreation in the Great Barrier Reef Marine Park as well as an important commercial activity and, to protect a seriously diminishing resource, some restrictions, including minimum and maximum size limits and bag limits (maximum number taken), have had to be implemented for species that are under heavy pressure from fishing.

The purpose of minimum size limits is to protect fish until they grow to maturity and can have at least one spawning cycle. Maximum size limits have been introduced to protect large groper and cod. Any fish falling outside the size limits must be released. Bag limits help to conserve heavily exploited species and spread the catch more equitably among fishers.

Anglers are not supposed to mutilate any fish so that the fish inspector can't determine what's been caught. If fish are filleted, skin must be left on. Fisheries inspectors make regular checks of vessels, and the penalties are quite heavy for possession of undersized or too many fish.

There is no particular season for fishing in the Whitsundays with the exception of barramundi, which may not be taken from midday 1 November to midday 1 February.

Bag limits for all Queensland have been placed on certain other species, the following which apply in the Whitsundays:

- Barramundi (5 taken or in possession at any one time)
- Mud crabs (10 taken or in possession at any one time)
- Molluscs (50 of any species [excluding oysters] taken or in possession at any one time)

Oysters

Oysters may be taken only for immediate consumption *on the spot* in most of the Whitsundays, except in the totally protected Marine National Park 'B' Zone where they may not be taken at all. Under Queensland fisheries legislation you may not collect oysters in a container to eat later.

Identifying your fish

The best way to identify fish caught in the Whitsundays is to ask a local fisherman. Some assistance may also be found in two very good books on fishes of Queensland and the Barrier Reef region, *Guide to Fishes*, by E.M. Grant, and *Fishes of the Great Barrier Reef and Coral Sea*, by J. Randall, G. Allen and R. Steene.

Fish poisoning

There are a few fishes in Queensland which are known to cause tropical fish poisoning (ciguatera) and which should

not be eaten: Chinaman fish, paddle tail, red bream, barracouta and moray eel. It's a good idea to check locally to see that others have not been put on the list temporarily (fish can become temporarily ciguatoxic in a particular locality). Generally, larger fishes are more likely to be ciguatoxic. Avoid eating any fish larger than 4 kilograms, and don't eat repeated meals from the same large fish. Puffer fishes are inherently poisonous and should never be eaten. (See 'Tips for tropical travellers', beginning on page 183.)

Fish species to avoid eating

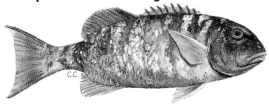

Adult Chinaman fish (*Symphorus nematophorus*)

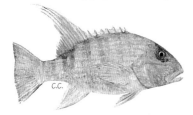

Juvenile Chinaman fish (*Symphorus nematophorus*)

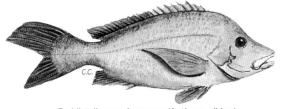

Paddletail, or red snapper (*Lutjanus gibbus*)

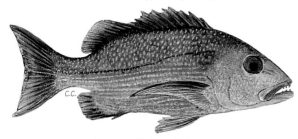

Red bass (*Lutjanus bohar*)

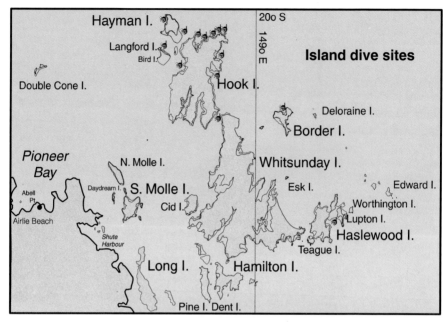

Hayman I.

Langford I.
Bird I.

Double Cone I.

Pioneer
Bay

Abell Pt

Airlie Beach

Shute Harbour

20o S

149o E

Island dive sites

Hook I.

Deloraine I.

Border I.

N. Molle I.

Whitsunday I.

Daydream I.

S. Molle I.

Esk I.

Edward I.

Cid I.

Worthington I.

Lupton I.

Haslewood I.

Teague I.

Long I.

Hamilton I.

Pine I. Dent I.

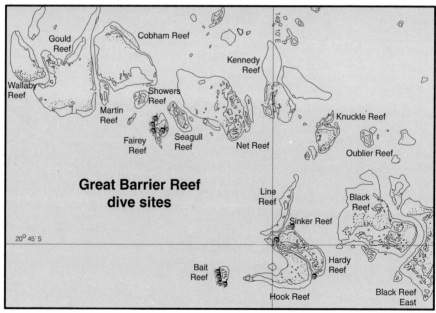

Gould Reef

Cobham Reef

149o 10 E

Kennedy Reef

Wallaby Reef

Showers Reef

Martin Reef

Knuckle Reef

Fairey Reef

Seagull Reef

Net Reef

Oublier Reef

**Great Barrier Reef
dive sites**

Line Reef

Black Reef

Sinker Reef

20o 45' S

Bait Reef

Hardy Reef

Hook Reef

Black Reef East

Popular dive sites among the Whitsunday Islands and at the Great Barrier Reef to the north-east

Diving and snorkelling

TONY FONTES

The many islands of the Cumberland Group with their fringing coral reefs offer a wide range of easily accessible sites for diving and snorkelling. It is possible to find somewhere that is protected in almost any weather, so that snorkelling and diving can be enjoyed virtually 365 days a year, even when Reef excursions elsewhere along the coast are being cancelled because of wind. For this reason the area has become a popular destination for both the novice and experienced diver. It is also a gateway to the Great Barrier Reef, which lies about 34 nautical miles to the north-east of the Whitsunday mainland, about two hours or so by fast dive boat (or slightly longer in a motorised catamaran, which makes a few stops at island resorts on the way to and from the Reef). The fleet of charter boats that depart daily for the islands and the Reef offer a number of ways for snorkelling enthusiasts and divers to explore the underwater world. These include:

- general day trips to the Great Barrier Reef aboard fast catamarans each capable of carrying over a hundred tourists and sightseers. These vessels tie up at a large pontoon permanently moored at the Reef, and guests are free to go snorkelling on their own or on guided tours; dive instructors on board organise scuba diving for both beginners and certified divers;

- day trips to the islands aboard charter sailboats catering for general sightseers, with a bit of swimming, sunbaking, island exploring, snorkelling and, if arrangements are made in advance, diving for certified divers;

- day trips to the islands aboard boats catering exclusively for divers and snorkellers, both experienced and inexperienced – a leisurely day with up to two dives at a fringing reef and plenty of snorkelling time;

- day dive trips to the Great Barrier Reef aboard purpose-oriented dive boats; the program includes two dives – an ideal trip for the diver or keen snorkeller who wants top diving but has limited time;

- dive trips of 1–5 nights duration to the Great Barrier Reef, with virtually unlimited diving, including night diving; these trips offer the best value for keen divers;

- overnight trips to the islands for both diving and snorkelling as well as island exploration.

Certified divers should remember that it's essential to carry your certification card with you or you will not be able to dive (other than as a beginner, with an instructor). It's necessary to carry your log book as well.

T. Fontes

D. Collett

Snorkelling is a good way to appreciate a coral reef and involves little equipment and only very modest expertise.

Snorkelling

Snorkelling is one of the best ways to appreciate a coral reef – in shallow water where the sunlight is bright and the colours of the reef can really be appreciated. Snorkelling requires little equipment, and one can become totally absorbed observing the wide variety of corals or watching reef creatures going about their business in their own environment. A few hours of snorkelling practice before departing on a holiday, particularly for those who are new to it or who haven't done it for several years, will be well rewarded when the time comes, because the brush-up on basic skills will make it easier to relax in the water, which is the key to enjoyment.

Equipment for snorkelling

All that's needed is a face mask, snorkel, and fins. It's important to have a mask that fits well, for a leaking mask is not only annoying but it interferes with relaxing. Anyone who intends doing much snorkelling should consider purchasing their own mask rather than leaving it to chance that they'll find a good fit among those provided by a cruise operator. And, it's wise to purchase a mask at a dive shop rather than a supermarket, for example, because dive shops stock a wider range, and they know how a mask is supposed to fit. Test the mask by holding it against the face with the index finger, making sure that all hair is away from the part that seals around the face, then breathe in gently through the nose. The mask will be sucked against the face and should stay there without being held, even when the head is shaken gently from side to side.

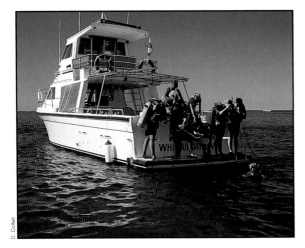

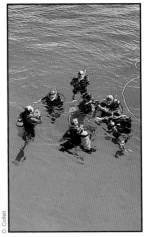

Snorkels come in a variety of models, some with features such as adjustable mouth pieces and purge valves, which make them very comfortable to use, but basically a snorkel is just a simple tube, and the simplest model can be quite adequate. They're not expensive, so when buying a mask, it's a good idea to get the snorkel as well, and that way they will always be together in your bag, properly assembled.

Fins come in three or four size ranges, and it's usually quite easy to find a pair that fits among those provided by the cruise operator.

Scuba divers (above) take their 'final exam' at Bait Reef on board a purpose-oriented dive boat. Successful completion of the 5-day course will liberate them to explore all dimensions of the underwater world.

Water temperature in the Whitsundays

The water in the Whitsundays is relatively warm all year round, but even so, most snorkellers wearing only a swimsuit find that 20–30 minutes is about as long as they can go without beginning to get chilled. A wetsuit with short sleeves and short pants (a 'shorty') may give some added comfort in the cooler months, although the minimum average temperature in mid-winter (21°C) is certainly not too cold for ordinary swimming.

Basic skills

Enjoyable snorkelling depends on one's being able to lie face down in the water completely relaxed, keeping the body flat on the surface and breathing easily. Being relaxed is the key to staying parallel with the bottom, which is the correct position for viewing. If the body is tense, the feet and legs have a tendency to sink, and you find yourself churning the water to stay afloat, perhaps even kicking the bottom if you're in shallow water, which will certainly frighten away any wildlife

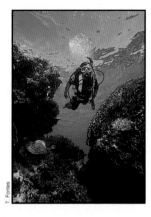

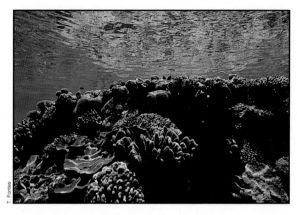

T. Fontes

T. Fontes

Diving in the Whitsunday area is undertaken both at fringing reefs surrounding the islands and at the Great Barrier Reef itself, a journey that takes 2 hours or so in a fast dive boat. Pictured are dive sites at Gary's Lagoon, Bait Reef (above) and at Fairey Reef (above centre). Bait Reef (opposite) offers a variety of five-star dive sites.

that you might hope to see. Newcomers to snorkelling should practise in the shallow end of a swimming pool or near a beach (where it's easy to stand up) until breathing through the snorkel feels natural.

Finning is an almost straight-legged action, with knees slightly bent. Some say it helps to imagine having splints on your legs. It's sometimes easier to get the feel of it on your back.

Watch out for currents and for sunburn

Surface currents can be quite strong in the Whitsundays, particularly at times of spring tides. Keep an eye on the boat to see that you haven't drifted too far away.

Sunburn can be a potential hazard for snorkellers because one feels no heat, and it's possible to get a burn on the back of the legs and upper back while absorbed in the underwater scenery. Always put on plenty of water-resistant sunscreen, or wear a T-shirt; some snorkellers wear a Lycra suit, or shirt and trousers, which gives good protection from the sun and also protection against scrapes and scratches.

When in the water

There are few aggressive creatures to be encountered, although some are curious about snorkellers just as snorkellers are curious about them. It's a good idea when entering 'foreign territory' to behave like a guest in someone else's house. In this state of mind, interaction with the local inhabitants will almost certainly be polite and pleasant. As a general rule it's wise to be a passive observer and not to handle the animals.

Don't splash around on the surface making a lot of noise, impersonating a wounded fish; you may send out the wrong signals. Marine creatures depend on a spectrum of low-

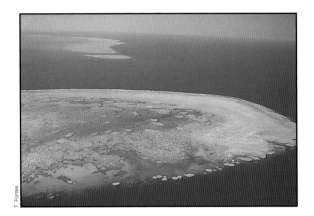

T. Fontes

frequency vibrations for communication, navigation, and for detecting wounded prey.

Scuba diving

There are half a dozen or so training organisations on the mainland offering full certificate courses of 5–7 days duration, including training dives at island and Barrier Reef sites. There is a lot of competition for students among the operators, and don't judge a course on price alone. Check out several options, ask about training centres, find out what's included in the price, and ask where the training dives are conducted and on what kind of vessel. Diving instruction is available at most or all of the island resorts.

Water temperature in the Whitsundays

Wetsuits required for comfortable diving in Whitsunday waters are shown below.

Month	Temp.ºC	Wetsuit required for diving
January	27	Lycra suit or 3 mm 'shorty' or 'steamer'*
April	25	3 mm 'shorty' or 'steamer'
July	21	5 mm 'steamer' or 'long John' and jacket
October	23	3 mm or 5 mm 'steamer'

Diving at the Great Barrier Reef

The Great Barrier Reef is renowned for its spectacular diving, with unparalleled coral diversity and reef life. Some of the reefs accessible from the Whitsundays offer diving on a par with the best along the length of the Reef. Visibility ranges from 6 to 30 metres depending upon the winds, tides and

Diving to preserve the reefs

Dive sites throughout the islands and Barrier Reef are visited frequently, and good technique on the part of divers is important to prevent inadvertent damage to coral. The cumulative effects of many small incidents can lead to overall degradation of reefs and the quality of the diving or snorkelling experience. The most common causes of coral damage are: snagging by divers' spare regulators and instrument consoles; damage caused when divers pull themselves along by grasping coral; crash landings due to being improperly weighted and poor buoyancy control; damage cause by fins; collisions with coral by underwater photographers intent on what's in front of the viewfinder rather than what's going on behind it. Divers and snorkellers can help preserve dive sites by:

- keeping spare regulators and instruments close to the body by making sure that these are tucked into the buoyancy compensator (BC);
- maintaining neutral buoyancy by using the correct amount of weight and by inflating the BC on the way down;
- not using coral for support;
- watching the fins, avoiding downwards kicks when near the bottom, which may break coral or stir up sediments that can choke delicate organisms;
- not feeding fish things, such as pasta, that aren't part of their naturally-occurring diet; and
- being mindful, when taking pictures, of what's going on at your end of the camera.

* A 'steamer' has long sleeves and long pants; a 'long John' is similar to a pair of overalls, that is, it has a bib, shoulder straps and long pants.

T. Fontes

(a)

J. Cruise

(b)

Coral reefs display an amazing variety of colour and form which is readily revealed to the diver and snorkeller. Sea whips (a) belong to a sub-class of reef-building corals, in an order called Gorgonocea; they are animals, with a skeleton composed of a horny material called 'gorgonin'; they anchor themselves to the substrate, waving in the currents, capturing zooplankton for food.

The colourful 'growths' pictured in (b) are sea slugs (*Ceratosoma tenue*), shell-less molluscs called nudibranchs ('naked gills') which have plumelike breathing apparatus on their backs. They feed on bottom-dwelling organisms, such as anemones and gorgonians.

The 'flowering coral' (c) is actually a coral head with many colourful Christmas-tree worms (*Spirobranchia* sp.) that live in calcium tubes embedded in the surface. The worms withdraw quickly into their tubes when alarmed.

The diver in (d) is surrounded by scissor-tailed sergeant fish (*Abudefduf sexfasciatus*), one of many small and colourful damselfishes of the reef.

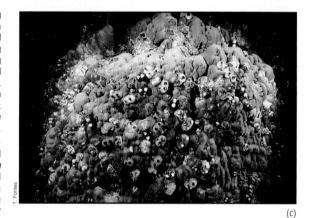

T. Fontes

(c)

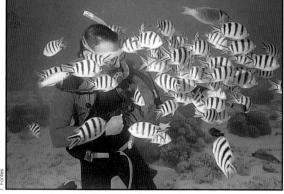

T. Fontes

(d)

location. Among sites regularly visited by local operators, Bait and Fairy reefs have the best water clarity. Surface conditions depend on wind and tide; at low tide, an individual reef can provide protection from choppy seas. Currents are a fact of life offshore, and it is often best to dive during periods of slack tide, or to dive in protected areas. A drift dive is sometimes the answer when currents are strong.

Diving around the islands

The fringing reefs of the Whitsundays are noted for their high diversity of corals and their teeming fish and other marine life. The water is not as clear as it is out at the Barrier Reef itself due to the presence of fine sediments from adjacent mainland rivers and runoff from the islands themselves. Visibility in the water ranges from 2 to 15 metres depending upon the weather, the tides and the location, and it tends to improve as one gets further from the mainland. It is generally clearest at sites along the northern side of Hook and Hayman islands. There are nevertheless some definite advantages to diving among the islands:

- the islands are easily accessible and offer calm waters in nearly all weather conditions; most dive sites have little current (except where near a headland or within a narrow passage); and

- there is prolific sea life at nearly every site – nudibranchs, feather stars, Christmas-tree worms, sea cucumbers, and almost every small tropical fish in the book.

Diving in the Coral Sea

Diving in the coral sea is renowned for excellent visibilty in the water and for large pelagic fishes and other marine life. Extended dive charters to the Coral Sea (5 days and longer) are available from the Whitsundays.

Diving safety

Dives at island sites are usually fairly shallow, and decompression is not an issue. At the Barrier Reef there is greater temptation and opportunity to go deeper. The nearest recompression facility is at Townsville. The outer reefs are several hours from the mainland by boat, and Townsville is a 3½ hours drive – that's at least 7 hours before recompression can begin. Therefore it's best to say that, for practical purposes, recompression is not available in the Whitsundays, and prevention should be the guideline.

Dive sites

Pages 105–11 have details of the most popular diving and snorkelling sites among the islands and at the Barrier Reef. Sites are rated two to five stars; sites with two stars in solid black and a third in grey vary depending on water clarity.

Dive sites with a mixture of black and grey symbols (see following pages) rate differently depending upon diving conditions.

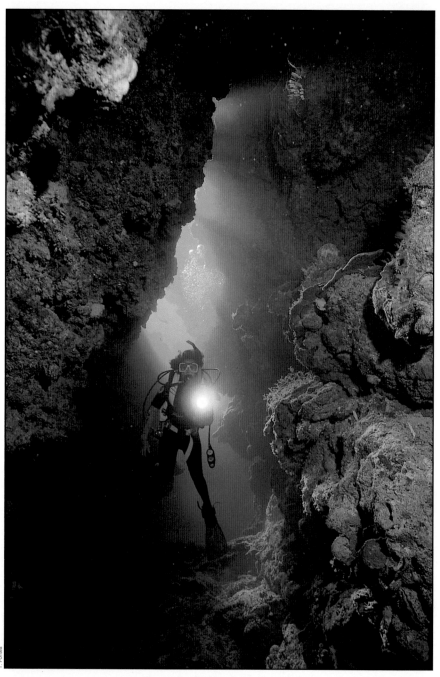

Diving at the Stepping Stones, Bait Reef

Bird Island

Visibility: 2–12 metres
Diving depth: 2–15 metres
Bottom: Rock in the shallows down to 6–8 metres, then dropping off to coral rubble and silty sand.

This site very open to currents; best to plan a drift dive or stay close to the island. Interesting rock formations down to 8 metres; shallow caves, ledges and gullies. Not a lot of coral, but the fish life can be quite good with large cod, sweetlip and trevally.

Snorkelling: Only mediocre.

Black Island (West Reef)

Visibility: 2–10 metres
Diving depth: 3–12 metres
Bottom: Small, scattered coral heads on a silty sand bottom gently sloping from the beach to 15 metres.

An easy shore dive (as the majority of interesting corals are very near the shore) from the northwestern corner of Black Island. Fish life rather small, but colourful. Current can be strong offshore, particularly near the northern end of the beach.

Snorkelling: Yes, but a bit deep at high tide.

Border Island (Cataran Bay)

Visibility: 2–12 metres
Diving depth: 2–12 metres
Bottom: Good hard coral cover in shallow water to 6 metres with patches of sand. Below 6 metres predominantly small coral heads, coral rubble and silty sand.

Best diving on either side of entrance into bay. Coral reefs are relatively shallow, dominated by large beautiful plate coral. From the top of reef a small wall drops down to 6 metres. Scattered coral bommies continue down to 12 metres. Plenty of gullies and ledges to explore. Fish life average, though some larger sweetlip and cod can be found under the ledges. Inside the bay, current is minimal; however, beware strong currents at the entrance, particularly off the northwest tip.

Snorkelling: Coral very shallow, making for easy snorkelling.

Haslewood Island (Waite Bay)

Visibility: 3–15 metres
Diving depth: 3–18 metres
Bottom: Very good coral cover with scattered small bommies and sand patches in shallow water gradually sloping from 3 metres to 6 metres. Good wall down to 12–18 metres then coral rubble and silty sand.

Very diverse dive site. A maze of interesting coral bommies in shallow water from 6 metres. Good quality coral. A descent wall dive from 6 metres to as deep as 18 metres on reef edge. Again, good coral cover, plenty of gullies and ledges to explore. Good fish life of all sizes. Watch for manta rays in the winter months, May to September. Current is not normally a problem except during spring tides. Bay is open to south-easterlies. Can only be dived during light winds or northerlies.

Snorkelling: Best in shallows near beach, though is also very good for the intrepid snorkeller who prefers something a bit deeper on the reef edge.

Hayman Island (Blue Pearl Bay)

Visibility: 3–15 metres
Diving depth: 3–18 metres
Bottom: Best coral cover in shallow water off southern beach. Scattered bommies with silty sand bottom at 5–18 metres, dropping off to coral rubble and silty sand below 18 metres.

Best dive off southern beach, near Castle Rock. Shallow coral ledge (2–3 metres) dropping off as descent wall to 10–15 metres. Wall is cut with narrow canyons and caves – makes for some great exploration. Strong currents near Castle Rock have produced some beautiful gorgonian fans at 8–15 metres as well as numerous whip corals. The shallow water is dominated by the ubiquitous staghorn coral. Plenty of *Millepora* (stinging coral) around – so be careful. Current quite strong at Castle Rock, best to avoid at all times. Good protection from all winds except north-westerlies.

Snorkelling: Very good off southern beach, near Castle Rock.

Hayman Island (Dolphin Point)

Visibility: 3–15 metres
Diving depth: 5–18 metres
Bottom: Rugged terrain of coral outcrops and huge boulders set on coral rubble and sand.

An unusual dive amongst house-sized rock slabs making for great exploration. Large coral bommies at 5–15 metres add to the diversity of the dive. Excellent large fish life for island diving, including trevally, mackerel, barracuda and the odd shark. This is a relatively deep dive with potential currents near the point. Good anchorage in all but northerly winds.
Snorkelling: Not really. Too deep.

Hayman Island (East Reef)

Visibility: 5–15 metres
Diving depth: 2–12 metres
Bottom: Very good coral cover in shallow water (6–8 metres) cut with numerous small canyons. Small bommies and sand–coral rubble from 8 to 15 metres.

A very pretty shallow dive and snorkel site. The shallow coral cover is dominated by large plates, creating numerous small canyons and ledges which make for interesting exploration. Plenty of small, friendly reef fish. Access to this site is difficult due to its exposure to wind from every direction and to currents. A site for very calm days at slack tide.
Snorkelling: Excellent shallow coral.

Hook Island (Alcyonaria Point)

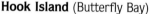

Visibility: 3–15 metres
Diving depth: 3–18 metres
Bottom: Good coral cover with patches of coral rubble and silty sand.

Excellent coral and fish life, particularly along the shallow ledge that runs along the point to Flat Rock. Plate corals dominate the shallow water. Ledge drops vertically with wall penetrated by numerous gullies and small caves. Many colourful soft corals at 10 metres, hence the site name. Large wrasse, cod and sweetlip found at depth. Current can be a problem, particularly at mid-tide. Anchorage is difficult due to drop-off. Exposed to northerlies and strong south-easterlies.
Snorkelling: Excellent shallow corals but prone to strong current.

Hook Island (Butterfly Bay)

Visibility: 2–10 metres
Diving depth: 5–12 metres
Bottom: Coral cover with large patches of coral rubble and silty sand.

This popular bareboat anchorage offers coral outcrops with shallow walls. Many small, colourful fish. Best of the bommies is found in the centre of the bay, though difficult to locate at high tide. Tidal currents can be a problem as one moves away from the bay edge towards the centre.
Snorkelling: Only along the bay edge or just off the beach.

Hook Island (Luncheon Bay)

Visibility: 3–15 metres
Diving depth: 3–15 metres
Bottom: Good shallow coral cover to 8–10 metres, coral rubble and silty sand at depth. Large bommie on eastern point.

Interesting terrain along foreshore down to 10 metres, best along eastern side of bay with coral gullies and ledges. Best part of dive is the bommie on the eastern point. Large fish life including wrasse, sweetlip and red emperor. Tidal current on point can be quite strong, particularly at mid-tide. Open to northerly winds.
Snorkelling: Good coral cover in shallow water on east side of the bay.

Hook Island (Mackerel Bay)

Visibility: 2–10 metres
Diving depth: 2–12 metres
Bottom: Good coral cover in shallow water, dropping off to scattered bommies at 7–12 metres.

A dive which is better at some times than at others depending upon visibility. This is a popular dive site during northerlies when most of the more popular sites are untenable. A relatively shallow dive through a maze of coral bommies, which form shallow canyons, ledges and swim-throughs. The fish life is medium in size and quite good. Exposed to southerly winds.
Snorkelling: Visibility adversely affected by the tide. Best during neap tides.

Hook Island (Manta Ray Bay)

Visibility: 3–15 metres
Diving depth: 3–15 metres
Bottom: Scattered coral bommies with sandy bottom. Below 15 metres mainly silty sand and coral rubble.

Hundreds of small damselfishes make this a top island dive. For years divers have hand-fed the fish of Manta Ray Bay which include some not-so-small Maori wrasse. The terrain is diverse with scattered bommies starting at 10–12 metres and reaching up to within 2 metres of the surface. Acropora corals dominate, with large plates on the top of the bommies and fields of staghorns in the shallow waters near the beach. A small but spectacular coral canyon (10 metres) can be found about 50 metres off the western end of the beach. Manta rays are common in the winter months, May to September. Excellent protection from all winds except the northerlies.
Snorkelling: Very good throughout the bay.

Hook Island (Maureen's Cove)

Visibility: 3–15 metres
Diving depth: 3–15 metres
Bottom: Large coral bommies and sandy bottom at back of cove. Good shallow coral cover with coral rubble and silty sand on eastern side of cove.

There are two dive sites here. At the back of the cove off the western side of the beach, a series of bommies starting at 12–15 metres and rising to within 3 metres of the surface, parallel to the shoreline. Gullies and shallow caves make for an interesting dive. Good medium-sized fish life. Along the eastern edge of Maureen's Cove is another good dive site locally known as the Boulders. Plate corals and other acropora dominate the shallow ledge which drops off as a small wall to 10–12 metres. Best corals, including large gorgonian fans found near the point, but beware of strong currents. Open to northerly winds.
Snorkelling: Best on the east side of the cove (otherwise, becomes too deep).

Hook Island (The Pinnacles)

Visibility: 3–15 metres
Diving depth: 3–18 metres
Bottom: Near solid coral cover in shallow water, breaking up into scattered but dense bommies from 5 to18 metres. Below 18 metres only coral rubble and sand with the odd small coral head.

Arguably the best dive site in the Whitsunday islands – certainly the best hard corals which compare favourably to the Great Barrier Reef. The best dive would be off the western beach, adjacent to the Woodpile and swim east at a depth of 7–15 metres. Large coral bommies dominate the terrain, reaching nearly to the surface. As usual, acropora corals are everywhere but huge porites corals in the shape of huge boulders and massive towers can also be seen. The fish life is medium in size and average in quality. Manta rays are very common in the cooler months, May to September. In the shallow water, particularly off the western beach, the coral cover is nearly solid, mostly staghorn, with only a few sandy patches. The quality of the corals diminishes the further east one goes (towards the rock pinnacles). This site is open to northerly winds and swell from strong south-easterlies.
Snorkelling: Some of the best in the Whitsundays just off the western beach.

Hook Island (Saba Bay)

Visibility: 2–12 metres
Diving depth: 2–15 metres
Bottom: Good coral cover in shallow water, dropping of to scattered bommies at 7–12 metres

As with Mackerel Bay, this is another popular dive site during northerly winds which can be better at some times than others depending upon visibility. The northern end of the bay is studded with numerous small bommies in relatively shallow water, dropping down to 10–15 metres with scattered bommies among coral rubble and sand. Plenty of shallow canyons, ledges and swim-throughs. The fish are small- to medium-sized and in good numbers. Visibility is adversely affected by tide. Best dives during neap tides. Exposed to southerly winds.
Snorkelling: Interesting bommies on both sides of bay.

Hook Island (Stonehaven Anchorage)

Visibility: 2–10 metres
Diving depth: 2–12 metres
Bottom: Scattered small coral heads with a silty sand bottom.
This site offers interesting shallow diving with lots of small marine life including damselfishes, Christmas-tree worms and nudibranches. The coral heads are small but diverse. The visibility is very much controlled by the tides, but is best during the neaps.
Snorkelling: Only at high tide, as can be quite shallow.

Hook Island (The Woodpile)

Visibility: 4–15 metres
Diving depth: 5–30 metres
Bottom: Rock wall drop-off with scattered deep coral and sandy bottom.
The unusual rock formation known as the Woodpile has created the best wall dive in the Whitsunday islands. The wall drops down to nearly 30 metres on the point. Best to start the dive about halfway between the beach and the point. Here the wall is covered in soft corals down to 5–7 metres. Below 7 metres, the wall is somewhat devoid of corals but provides some excellent exploring, with large overhanging ledges and shallow caves. Some fairly large black coral trees can be found between 10 and 15 metres. Back away from the wall is a maze of coral bommies, including some large porite corals, Approaching the point the landscape becomes rather barren due to strong currents – an area to be avoided. This site is exposed to northerlies, and swell from strong south-easterlies can make anchoring quite uncomfortable.
Snorkelling: No.

Langford Island (Langford Reef North)

Visibility: 2–10 metres
Diving depth: 3–15 metres
Bottom: Scattered small coral bommies on sandy bottom, gradually sloping from shore to 15 metres. Below 15 metres mostly coral rubble and silty sand.
A very popular day-trip destination for sailors, snorkellers and divers. Best diving is found on north-western end of beach, where curent is strongest at mid-tide. Scattered bommies offer an interesting maze to explore. Some shallow walls at the eastern end of the island. The majority of fish life is small but abundant. Expect to encounter tidal currents at all times except slack water. Reasonable protection from all but the strongest wind condition.
Snorkelling: Just offshore along the beach; best towards the island.

Whitsunday Island (The Gardens)

Visibility: 4–15 metres
Diving depth: 5–15 metres
Bottom: Reasonable coral cover on a gently descending slope with silty sand patches.
Easy, shallow dive just off Hook Island, very near the Underwater Observatory. Coral cover dominated by large plate corals. Plenty of small friendly reef fish looking for a handout. Occasionally, large pelagic fishes will cruise through. Excellent protection in all wind conditions. Current can be a problem during spring tides.
Snorkelling: Watch current during big tides.

Bait Reef (Gary's Lagoon)

Visibility: 10–20 metres
Diving depth: 4–18 metres
Bottom: Walls forming inlets are solid coral, bottom is sand with scattered, low coral bommies.
An easy site offering two very different dives. The outside edge and entrance into the inlet is a relatively deep dive, 10–18 metres among the low coral bommies and along the wall that forms the edge of Bait Reef. The coral is excellent including soft corals and gorgonian fans. Fish life can be reasonably large with cod, mackerel, barracuda and trout. Once outside the inlet, current can be a problem. Diving within the inlet is easy and relaxing with minimal to no current and 4–12 metres of water. The walls are cut with canyons and deep ledges. Numerous giant anemones at the back of the inlet. Look for wobbegong sharks under the ledges. Good protection in all winds but north-westerlies.
Snorkelling: Very good shallow coral along the edge of the inlet. A 100-metre swim to the east at high tide is a beautiful shallow, unnamed lagoon with a couple of resident reef sharks. Worth the effort.

Bait Reef (Manta Ray Drop-off)

Visibility: 12–30 metres
Diving depth: 3–36 metres
Bottom: Total coral cover in shallow water to 5 metres, wall dropping to 30 metres cut with crevices. From 30 metres down, bottom is made up of coral rubble, sand and scattered coral heads.

Great Barrier Reef diving at its best. A spectacular wall dive from 5 to 30 metres vertical. At the top of the wall is a gorgeous coral garden with a diverse array of hard corals. The wall itself is covered in small colourful soft corals, gorgonian fans, whips and feather stars. The most interesting aspect of the dive is exploring the deep fissures that cut deep into the wall, including a vertical tunnel or chimney. At the base of the wall the bottom continues down and is covered with numerous small coral heads. Between 30 and 35 metres are tall, corkscrew sea whips that reach upwards 3–4 metres towards the surface. The fish life is never-ending, with an array of big and small forms. Schools of fusiliers cruise the drop-off, large wrasse and bumpheaded parrotfish are often seen along the wall, trevally, mackerel, barracuda and sharks come up from the deep and, of course, manta rays. This site is exposed to southerly winds and is very prone to strong currents. Best to dive during slack water, neap tides.
Snorkelling: Excellent coral garden in shallow water but very prone to current.

Bait Reef (Stepping Stones)

Visibility: 10–20 metres
Diving depth: 3–30 metres
Bottom: Very large coral bommies on sand. Behind the Stepping Stones sand often covered by huge thickets of staghorn coral.

The Stepping Stones are a unique feature of Bait Reef. They are made up of 18 or more flat-topped coral pinnacles lined up in a row along the south-west side of the reef. Each pinnacle rises from a depth of 15–25 metres and stops within 1 metre of the surface. The pinnacles are circular in shape and have absolutely vertical sides. Each of the stepping stones is completely covered with coral of all varieties – huge plates on top, soft corals and gorgonian fans on the sides. The stones vary in size from small (15 metres in diameter) to large (50 metres in diameter). Clouds of small colourful tropical fishes swarm around the tops of the stones, while large wrasse, sweetlip, cod, trevally, trout and others cruise the numerous canyons, ledges and caves at depth. Large rays are common, especially manta rays from May to September. Watch the tidal movement as currents are fairly consistent. There are numerous dive sites within the Stepping Stones complex. Some of the highlights are:

- The Maze: located at the southern end of the Stepping Stones, this dive site is literally a maze of canyons, caves and crevices and relatively shallow (5–15 metres). Large fish are often found in the caves and under ledges. Angelfish are also common. Minimum current within the maze;
- Hawaii: this large solitary Stepping Stone is located near the northern end of the chain. It drops to nearly 20 metres on the seaward side. Plenty of big fish life but also plenty of current at mid-tide;
- Cluster of Four: as the name implies, four medium-sized stones in close proximity have created some excellent terrain for exploring – deep canyons and narrow crevices full of whip corals and large fish life. Some current on outside.
- The Lost Stone: at the northern end of the chain, the stones seem to disappear but are actually just deeper, rising to within 5 metres of the surface. Very good fish life, medium- to large-sized. Fairly deep dive, 8–30 metres. Current at mid-tide.

Snorkelling: Excellent shallow coral on top of the Stepping Stones.

Bait Reef (Southern Face)

Visibility: 12–30 metres
Diving depth: 5–30 metres
Bottom: Shallow water dominated by flat terrain completely covered by hard corals with the odd sand patch. Drops away quickly from 5 metres down to 20–30 metres. The slope is cut with numerous gullies with coral rubble and sand bottoms.

This dive is very similar to Gorgonia Hill without as many fans at depth. The numerous deep gullies make for very interesting diving, often filled with a variety of fish life including angelfish, sweetlip, cod and soldier fish. Large turtles, manta rays and some pelagic fishes such as mackerel and barracuda are often seen cruising along the drop-off. Open to southerly winds and current. Best to dive at slack water.
Snorkelling: Excellent.

Fairey Reef (Henry's Bommie)

Visibility: 10–20 metres
Diving depth: 5–15 metres
Bottom: Relatively flat, sandy bottom studded with small coral outcrops. Largest bommie cut with ledges and a large cave.

An interesting dive in the lagoon at Fairey Reef, Henry's Bommie is considered to be a premier attraction. The bommie reaches from 12 metres to near the surface. A narrow gap opens into a cave which is worth exploring but beware the small opening. Inside you will find a huge clam, 1 metre across. There is also a resident turtle that is often spotted at night. Circumnavigation of Henry's Bommie is the usual dive plan. Good coral cover and clouds of small tropical fish.
Snorkelling: Excellent with minimal current.

Fairey Reef (Little Fairey Inlet)

Visibility: 10–20 metres
Diving depth: 5–18 metres
Bottom: Shallow wall at back of inlet dropping to 10 metres, sandy bottom sloping down to 16 metres, studded with small coral outcrops.

Classic dive starting at wall along entrance to inlet, depth 16 metres. Excellent coral cover which tends to degenerate below about 18 metres. Possible to miss inlet if deeper than 16 metres. Swimming along wall and into inlet brings you in contact with very good fish life including brightly coloured angelfish, cod, trout and sweetlip. Plenty of nooks and crannies to explore when going into the inlet, and shallower water (10 metres). Small current should be expected outside the inlet but good protection once inside.
Snorkelling: Excellent along the wall of the inlet. Some current at opening of inlet.

Fairey Reef (The Shoals)

Visibility: 10–20 metres
Diving depth: 5–25 metres
Bottom: Relatively flat, sandy bottom at 6–8 metres backed by a shallow coral wall cut with shallow canyons opening into small lagoons. Eventually drops to 25 metres with small coral bommies on sandy bottom, some coral rubble.

A very 'easy diving' site with negligible current at almost all tidal conditions. Swim-throughs into small lagoons make for good exploration. Heaps of giant clams, sea cucumbers and all the small tropical fish. Blue spotted rays, Maori wrasse and the odd reef shark are also common. Average depth is only 8 metres but does drop away to 24 metres. Current can be a problem at depth.
Snorkelling: Quite good, with little current.

Fairey Reef (Tina's Arm)

Visibility: 15–30 metres
Diving depth: 5–30 metres
Bottom: Small bommies extending from coral wall. Bommies and wall bottom out at 20–30 metres, then relatively flat, sandy bottom with coral rubble.

This is one of the prettiest sites on Fairey Reef. Very good coral cover including large porites coral and gorgonian fan, the largest found at 25 metres. Plenty of fish life of all sizes and colours, regular encounters with reef sharks, barracuda and turtles. As with most of the better dive sites, currents can be a problem, best to dive at slack water. However there are plenty of swim-throughs to explore if current poses a problem.
Snorkelling: Excellent, but prone to currents.

Hardy Reef (Fantasea Reef World pontoon)

Visibility: 8–18 metres
Diving depth: 5–18 metres
Bottom: Wall with good coral cover down to 10 metres, cut with numerous shallow curves, canyons and ledges. Below 10 metres, there are steep slopes of coral rubble and sand, with low coral outcrops.

An easy dive, good for exploring the undersides of numerous ledges and caves covered with small colourful gorgonian fans and soft corals, down to 10 metres. Best hard coral cover found in the shallow water of the reef face down to 5 metres. However, the fish life is where it's at. For years the pontoon has been feeding the locals who are now big and quite friendly. Largest among the residents is a groper coming in at 2 metres in length and nearly 200 kilograms! Large Maori wrasse, trevally, trout and cod are always there to greet the diver. Plenty of small

colourful reef fish as well. Good protection in most wind conditions except northerlies. Consistent currents particularly away from the wall. Possibly opt for a drift. Extremely deep water (60 metres) in the channel away from the wall.
Snorkelling: Excellent fish life; some current.

Hardy Reef (The Canyons)

Visibility: 10–20 metres
Diving depth: 3–18 metres
Bottom: Wall cut with caves, tunnels and canyons down to 15 metres, then steep slope of coral rubble and sand.

This dive offers great opportunity to explore an endless maze of tunnels, canyons and shallow caves which start as deep as 15 metres and take the diver right up to the surface. Gorgonian fans often shroud the tunnel entrances and crayfish are common in dark recesses. Large and small reef fish in abundance. One cave is always jammed with 100 or more morwong. Good protection from all but strong northerly winds. Outside of the canyons, current can be quite strong. Very deep water off wall (60 metres) in the channel.
Snorkelling: Current often strong over the reef flat.

Hardy Reef (Shark Alley)

Visibility: 6–15 metres (varies tremendously with tides)
Diving depth: 4–20 metres
Bottom: Wall drops quite steeply; below 20 metres mostly coral rubble.

Plenty of action here, particularly at the bottom of the tide when the waterfalls are running. Sharks are known to cruise this area looking for a feed. White tips and black tips with the odd whaler, hammerhead and even tiger shark. Visibility is often low due to strong currents and outflow from Hardy Lagoon. Generally protected from strong winds of all directions.
Snorkelling: Not recommended.

Hardy Reef (Hardy Reef South)

Visibility: 12–30 metres
Diving depth: 5–30 metres
Bottom: Shallow water dominated by flat terrain completely covered by hard corals and cut by numerous shallow gullies. Some shallow pools with sandy bottom.

The southern face of Hardy Reef, when accessible, offers really spectacular diving, both shallow and deep. The steep slope drops from 3 to 30 metres very quickly and is covered in a variety of hard and soft corals. The numerous deep gullies are often full of fish life, including angelfish, sweetlip, cod and wrasse. Pelagic fishes can be seen off the reef face, including mackerel, trevally and barracuda. Open to southerly winds and current.

Line Reef

Visibility: 8–18 metres
Diving depth: 3–25 metres
Bottom: Basically a coral wall with small gullies and deep ledges. Wall drops to 10–15 metres then steep slope of coral rubble and sand.

A good drift dive along a wall full of nooks and crannies. Small, brightly-coloured soft corals, fans and feather stars are common under the ledges. Fish life is medium in size with cod, sweetlip, wrasse, trout and angelfish. Good protection from wind but no protection from current.
Snorkelling: Prone to current; best to drift with current.

Sinker Reef

Visibility: 8–18 metres
Diving depth: 5–30 metres
Bottom: Top of reef covered with staghorn coral (although some fairly extensive anchor damage). Steep walls dominate the sides, with lots of ledges and short caves to explore.

This is a relatively small reef located in the middle of the channel between two very large reefs, Line and Hardy. Watch the current. The dive is similar in character to Line Reef; a good wall dive with nooks and crannies full of small, brightly coloured soft corals, fans and feather stars. Fish life includes cod, sweetlip, wrasse, trout and angelfish.
Snorkelling: Not recommended due to current.

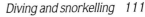

Snorkellers at Fantasea Reef World, Hardy Reef

Visiting a coral reef

At some time during a trip to the Whitsundays most visitors will have a chance to experience a coral reef, either on a catamaran excursion to the outer reefs, or on a day trip to the islands, or during the course of a resort holiday or while on a bareboat charter. This section provides a few basic notes that may help the novice reef visitor get more enjoyment from the experience.

A trip to the outer reefs

It is possible to visit the reefs lying offshore of the Whitsundays in several ways, the most popular method being a day trip aboard a catamaran. Other ways of getting there include the local air taxi service, which operates both helicopter and amphibious aircraft to the lagoon at Hardy Reef, or with dive boats that go out to various reefs when weather is suitable.

Catamarans revolutionised travel to the Reef, making the day visit a possibility for the ordinary traveller. Before the advent of the cats, the journey used to take six hours, often a rolly, uncomfortable experience. The cats reduced the travel time to a little over two hours and made it a very much more comfortable trip. Modern cats are large double-decker affairs, with enclosed lounges and a sundeck, capable of carrying several hundred passengers. They depart most days of the week at 8.30 am, either from Shute Harbour or Abell Point marina, unless it's too windy and the seas are rough (when it's blowing more than 25 knots). On days with fresh winds, those who are prone to seasickness are advised to take the free travel sickness pills handed out by the crew before the journey starts. The cats stop at one or two islands to pick up passsengers and, in all, it takes about 2½ hours from the time one leaves the mainland to get to the destination, a large, covered pontoon moored right next to a coral reef. Guests have about three hours to enjoy the many activities that are available on and around the pontoon.

On the way out, video movies about the Great Barrier Reef are shown in the lounges, the bar is open, and everyone aboard is told about what happens on arrival – introductory scuba dives, diving for certified divers, snorkelling, guided snorkel tours conducted by a marine biologist, coral viewing in specially designed craft, aerial sightseeing trips, and so on. A smorgasbord lunch is available for several hours, and passsengers are free to move about as they please. Other facilities

D. Colfelt

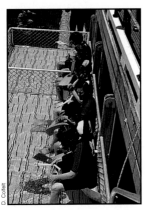

D. Colfelt

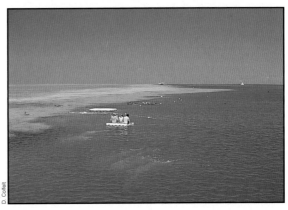

D. Colfelt

Visitors to the outer reefs are transported by fast catamarans that tie up at a pontoon permanently moored alongside a platform reef on the continental shelf. Passengers have about three hours to participate in diving, snorkelling, aerial sightseeing, swimming or just enjoying the sun and sea.

at the pontoon include an underwater viewing chamber, sun deck, tables and benches, toilets and showers, and a small souvenir shop. All that passengers need to take with them is plenty of sunscreen cream, a broad-brimmed hat, bathing suit, towel, and a sweater or wind cheater. The basic equipment needed for snorkelling is provided without charge, and wetsuits, underwater cameras, guided snorkel tours, scuba diving and helicopter flights are available as extras.

Masks, snorkels and fins are found in large bins at one

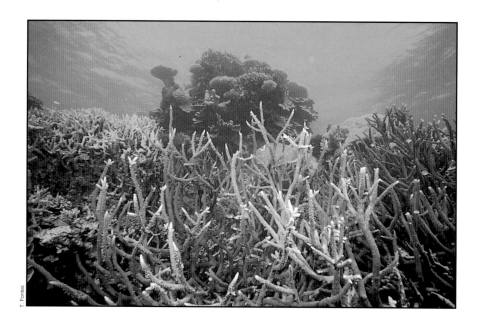

end of the pontoon, and once geared up, snorkellers simply launch themselves from a special platform on the pontoon not far from the edge of the reef. Divers have their own area, with special benches for air tanks and buoyancy vests, and their own diving platform under the pontoon from which they step into the water and make their way down the rope to begin their dive. Along the edge of the reef are other rope trails and small pontoons for swimmers.

A few notes about reefs

Those who have never experienced a coral reef are sometimes a little disappointed because they are expecting an explosion of colour such as one might see at Tivoli Gardens in the full flush of spring. This colourful impression of coral reefs comes from books about the Great Barrier Reef, which invariably show photographs of spectacularly colourful coral polyps – photographs that are real enough but many of which have been taken at night, with the aid of flash. The ordinary day visitor sees the reef in more subtle, muted colours – yellows, oranges, greens, purples and browns – all with a gentle overlay of blue. The main reason is that most corals have their polyps retracted in the daytime to escape predators, and they extend them at night when their favourite food, zooplankton, rises from the reef sands.

The perception of colour on a reef also has to do with the

The colours of the underwater reef in daytime are soft and muted (above centre). The showiest part of corals – their polyps – are usually retracted in daylight and are therefore not always apparent to the reef visitor. At night polyps are in full bloom, safe from marauding fishes, tentacles ready to sting passing plankton and then direct it to the coral's mouth. Pictured above is *Tubastrea*, often found in dimly lit caves.

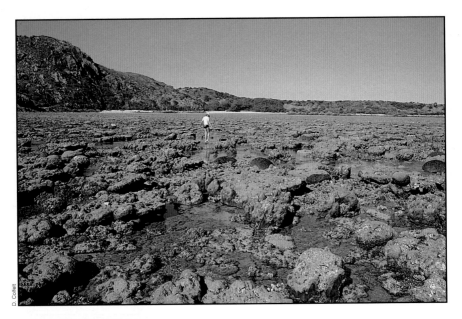

Fringing reefs often have wide expanses of mud and sand flats and a broad stretch of algae-covered coral rubble. This dead-looking intertidal zone is bristling with live shells and crabs; coral growth increases towards the outer margins of the reef. Reefwalking gear must include footwear with stout soles.

depth and clarity of the water. Water is a selective filter of light, removing the reds and purples first, and as depth increases, leaving only the middle of the visible spectrum – blue-green. At 20 metres depth, almost all red light has been filtered out (and a lot of it has been removed before that depth). This phenomenon does not affect the snorkeller as much as the diver, as at shallow snorkelling depths not much colour filterng has occurred.

Once one has attuned the eye to the shades of the reef by day, its possible to appreciate all of its subtle tones, and to become completely lost in its myriad shapes and forms – feather stars and fern-like hydroids swaying in the currents, undulatiing soft corals, billowing anemones with brightly coloured fish nestled amongst their poisonous tentacles, the play of light shimmering on the top of the reef, the profusion of reef fishes.

Reefwalking

While snorkelling and diving are the ideal way to see a coral reef, reefwalking provides a different perspective, an opportunity to become totally absorbed in the marine life that lives on top of a reef in the intertidal zone, the area that becomes exposed when the tide goes down. This is a whole new world, not as 'pretty' as the growing edges of the reef – in fact, it

looks more like a moonscape, with sand and vast expanses of algae-covered brown rubble, but the reef top is alive with shells, crabs, fishes, starfish, sea urchins, sea hares, sea cucumbers, and corals that can survive being exposed to the air between tides. Reefwalking is most readily available on the fringing reefs of the islands, although it can also be done at Hardy Reef, on a trip operated by the local reef airline.

Below are a few hints for reefwalkers:

● Good solid footwear is essential. Any pair of old sand shoes or running shoes with a good thick sole are ideal. Thongs or bare feet are not suitable. A pair of socks can give added protection to the ankles.

● A walking stick is useful for balancing, as it is frequently necessary to step awkwardly over clumps of coral to obtain solid footing.

● Walk slowly and be careful where you step. Try to walk on sandy areas or places that appear 'cemented over' to avoid damaging live coral (and yourself).

● Watch the tide. When the rising tide comes in over the reef crest, which is the highest part out towards the edge, the water covers the reef quite rapidly, and one can get caught unawares. It is just not possible to run on a reef, and walking over a reef in thigh-deep water is difficult.

● Wear a broad-brimmed hat, put plenty of sunscreen on the back of your neck and shoulders (and on the tops of your feet if not wearing socks); a long-sleeved lightweight shirt will provide additional protection if needed. Gloves are a good idea if you intend picking anything up.

● If you pick up a coral boulder to see what is underneath, be sure to put it back exactly as it was; this is the home of a number of creatures, and they may not survive the intrusion if the boulder isn't put back where it was.

● In most areas shells are protected and may not be collected (even dead ones) without a permit. The reason is primarily to leave something for others to see when they come reefwalking, but dead shells are also used by reef animals, such as hermit crabs, and they eventually make a useful contribution to the reef substrate.

● Coral collecting, either dead or live coral, is prohibited. In any event, almost all corals lose their colour soon after being removed from the water, and dead coral smells absolutely dreadful for months. Those who want a coral souvenir will do very much better at a souvenir shop.

Life in the intertidal zone

Reefwalkers in the Whitsundays will find that the most conspicuous animals on a reef flat, apart from corals (or their remains), are molluscs (shells), crustaceans (primarily the crabs), and the echinoderms (sea stars, sea urchins and sea cucumbers). These are among the most heavily populated of

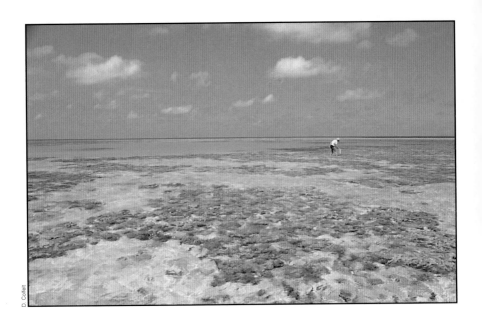

Reefwalker at Hardy Reef, 74 kilometres north-east of the Whitsunday mainland.

the biological phyla, and illustrated on pages 120–122 are a few of the species most likely to be encountered.

Molluscs

Molluscs are among the most successful of all animals, having been around for some 600 million years. They probably evolved from shell-less flatworm-like ancestors. Australia, with its great diversity of climate and habitat, has the richest fauna of marine molluscs of any nation in the world – of the order of 10 000 species. They are particularly abundant on reefs, in the intertidal zone, and the beautifully patterned, spiral shells of the gastropoda have always held a particular fascination for humans. Gastropods are, typically, either algae grazers or meat eaters, some of the latter (the cones) having a highly developed venomous harpoon with which they are capable of killing a human! The gastropods can be found, sometimes in clusters, on the sand and rubble flats, sometimes well disguised, but if you stand still and look hard, one will reveal itself before long.

Perhaps the most sensational of all the molluscs are the giant bivalve clams (*Tridacna* sp.), with their colourful, fleshy lips (mantles), and their habit of sometimes squirting a jet of water at an approaching reefwalker. Clams are filter-feeders and, like corals, also derive nutrition from symbiotic algae that live within their tissues. The giant clam (*Tridacna crocea*) can be seen imprisoned in a coral boulder into which it

burrows, giving the boulder a curious appearance – a rock with 'mouths' all over the outside.

An apparently shell-less mollusc, the sea hare (*Aplysia sowerbyi*) is a large slug-like creature that may be found on the flats where it feeds on algae; if disturbed, sea hares can emit copious quantities of a reddish-purple fluid.

Echinoderms

Echinoderms (literally 'spiny skins') are most evident to reefwalkers in the form of sea stars, sea urchins and sea cucumbers. The blue starfish (*Linckia laevigata*) is, unlike most starfish, conspicuous on the reef by day, probably because its luminous blue colour advises predators that it is poisonous to eat, so it doesn't need to wait for darkness to come out to feed. Holothurians (also called sea cucumbers, bêche-de-mer, and trepang) are scattered all over the sand flats. Last century, trepang was Australia's most important export industry. Beloved of the Chinese, who believed them to be an aphrodisiac, the bêche-de-mer, as early Portuguese fishermen christened them, or trepang as the Macassan fishermen referred to them, were harvested all along the tropical Queensland coast. If disturbed, sea cucumbers can emit extremely sticky white threads, which hopelessly entangle would-be predators and cling tenaciously to anything they touch.

The reefwalker should watch out for spiny black sea urchins (*Diadema setosum*) which are found wedged among corals in pools or clustered around dead coral boulders in shallow moats or on the reef flat. They have very fine, long, sharp, black spines that, if stepped on, are painful and very difficult to remove.

On continental island fringing reef flats, pools and coral rubble provide homes for thousands of animals. A hermit crab (immediately below) has borrowed a dead trochus shell, which it carries around on its back for protection; immediately to its left is a giant clam, with blue mantle, partially buried in the rubble. The mantles of giant clams (bottom) come in many patterns, and sometimes brilliant colours. Light-sensitive organs alert the clam to the presence of a shadow falling on it (and to possible danger), and it draws the two halves of its shell together tightly.

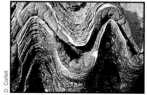

Some animals typically encountered

Cowrie shell
Cypraea caurica

Cowries are among the most attractive shells, coming in great variety, all with a very high glaze. Cowries are primarily herbivorous. When moving about, the animal's mantle completely envelopes the shell, which accounts for the high polish; these shells have been used as money on some Pacific islands. Cowries hide under boulders by day.

Catseye turban
Turbo petholatus

Turbans are turban-shaped and can seal their aperture with a hard plug called an operculum. The operculum of this species looks like a cat's eye and is sometimes used for jewellery. Turbans are herbivores.

Geography cone
Conus geographus

Testile cone
Conus textilis

Marble cone
Conus mamoreus

Cone shells are carnivorous molluscs with strikingly beautiful shells that are, unfortunately, usually disguised by a slimy green substance (periostracum). The species illustrated are all poisonous, armed with venomous darts capable of inflicting a fatal wound in humans. Don't pick these up.

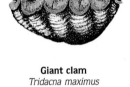

Giant clam
Tridacna maximus

Burrowing clam
Tridacna crocea

Giant clams (above) are plentiful on reef flats where they filter the water for plankton. Their fleshy, lip-like mantles are often brightly coloured and patterned. These clams close rapidly when a shadow falls on them. Some species actually burrow into the coral substrate.

Baler (bailer), or melon, shells (left) are large carnivorous molluscs of the volute family. They are found on sand flats and prey largely on other molluscs by enveloping them with a huge foot. The large volume of the shell and wide aperture makes it useful as a bailer.

Baler shell
Neki anogira

Giant triton
Charonia tritonis

Triton shells (family Cymatiidae) are found among corals and coral rubble. They are carnivorous, preying on a number of species ranging from sea squirts to sea cucumbers. Giant tritons (*Charonia tritonis*) grow up to 50 cm in length and are a totally protected species, being one of the few natural enemies of the infamous crown-of-thorns starfish. .

by reefwalkers in the Whitsundays

Trochus, or top, shells, area heavy conical shells with an inner layer of mother-of-pearl; they were, before the advent of plastics, the backbone of the button industry. Trochids are herbivorous.

Trochus Shell
Trochus niloticus

Spider shell
Lambis lambis

Spider shells (family Strombidae) are abundant, spectacular shells with a highly polished, florid pink outer lip that has long projections. Their head, with eyes on stalks, protrudes from a notch near the outer end of the lip; they have a long green foot with which they move about (and can even turn themselves completely over if necessary). Spiders are found on sand patches around coral rubble. They are primarily herbivorous.

Needle-spined sea urchin
Diadema setosum

The needle-spined sea urchin (family Diadematidae) is covered with long, (up to 20 cm) slender spines which it waves about and which can break off easily if brushed against, causing a painful wound. These starfish aggregate in pools. They are algae grazers.

Blue starfish
Linckia laevigata

The blue starfish, unlike most starfish, is conspicuous by day, probably because its bright blue colour advises would-be predators that it is poisonous.

Sea cucumbers

Sea cucumbers (family Holothuridae) are sedentary scavengers and are abundant on reefs throughout Queensland. When spawning they assume a posture that resembles a rampant penis in the process of ejaculating, which may be why they were reputed to have aphrodisiac properties and why, last century, the Chinese were prepared to pay so handsomely for them. The 'prickly red fish' was the most prized by trepang fishermen.

Holothuria atra (lolly fish)

Holothuria spilota

Bahadschia argus (leopard fish)

Stichopus chloronotus

Thelenota ananas (prickly red fish)

Stichopus variegatus (curry fish)

Brittle star
Ophiaracachnella gorgonia

Brittle Star
Ophiomastix sp.

Green crab
Thalamita sp.

 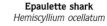

The swiftly moving green portunid (swimming) crab is fiercely aggressive and stands up ready to do battle with all comers, no matter how large.

Brittle stars are capable of very rapid locomotion. Their name comes from their ability to readily shed and arm if attacked.

Hermit crab
Dardanus megistos

Epaulette shark
Hemiscyllium ocellatum

Ghost crab
Ocypode ceratophthalma

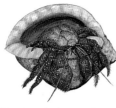 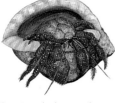 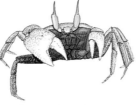

Hermit crabs borrow the shells of dead gastropod molluscs, discarding them for larger ones as they grow bigger. This species is bright red with hairy foreparts. It is frequently seen scurrying amongst coral rubble.

Ghost crabs live high on sand shores where they feed by scavenging.

Epaulette sharks are relatively harmless and can often be seen in shallow pools on reef tops fossicking for food – right at a reefwalker's feet. They are not aggressive.

Blue-spotted stingray
Taeniura lymna

Blue-spotted stingrays are very common throughout the Great Barrier Reef region. They lie along sandy shores and on reef sand flats partially covered, waiting for a mollusc or crustacean to come along, which they grind up with flattened pavement-like teeth. They are timid and always try to avoid reefwalkers, but it's a good idea in sandy areas to shuffle the feet to warn them away and thus to avoid stepping on them, as they have a barb in the tail that is coated with poisonous mucus and can inflict a painful wound.

Crustaceans

Crabs are the most conspicuous of the crustaceans on the reef flat, and reefwalkers can expect to see portunids (swimming crabs), such as the green crab (*Thalimata* sp.), a fiercely aggressive fellow who stands up ready to do battle with anyone or anything that approaches, no matter how large. Rock crabs, with sharp-pointed legs, can be seen moving around beach rock with lightning rapidity. Hermit crabs are comical characters that have no shell of their own but who 'borrow' the shells of dead gastropods, and one can occasionally see a snail shell moving along with amazing rapidity, a red foot sticking out, which is the hermit *Dardanus megistos*.

Fishes

Reefwalkers will see fish darting all over the reef as the tide recedes, and two species that can cause alarm to newcomers are the harmless stingrays and epaulette sharks. Stingrays are relatives of sharks, having taken to life on the bottom where, with flattened pavement-like teeth, they catch and grind up molluscs and crabs. They lie quietly, often partially covering themselves with sand, and can be very hard for reefwalkers to see. Stingrays are timid and will always scurry away if they can (that is, if they're not pinned to the bottom by a human foot!). Be alert for them, and in sandy areas, it's a good idea to shuffle one's feet to scare them away and so avoid stepping on them. They have a venomous barb in the tail and can inflict a painful wound.

Epaulette sharks are frequently encountered by reef fossickers. Those with a little knowledge of this shark's benign nature have been known to pick them up by the tail for a joke, a practice that has occasionally resulted in a painful bite. They are sizeable (about 1 metre) and should be treated with respect.

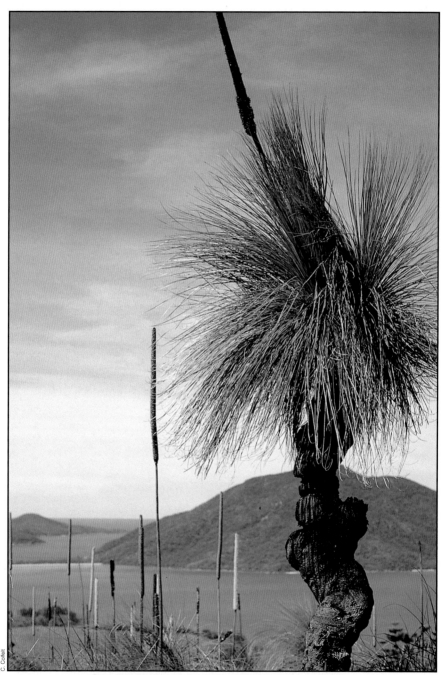

C. Colfelt

Grass tree (*Xanthorrhoea* sp.), Mount Oldfield, Lindeman Island

The Ngaro

The Aboriginal people of the Whitsunday islands

RAY BLACKWOOD

Archaeological research has indicated human occupation of the Whitsunday islands for at least 8000 years, and indeed from Cook onward, every journal of Royal Navy ships makes mention of the presence of the Aborigines. The most frequent reference is to the smoke generated by their practice of burning off grasslands in pursuit of game, either to flush it out or to kill it for later gathering. Barely any island of reasonable size (or the adjacent mainland) escaped this burning practice. It is worth noting that in those days many of the islands carried much more grass and less forest than they do today. It is possible that the burning encouraged grass at the expense of forest, because with the disappearance of the Aborigines, the forests are taking over. On practically every island visited by white men in the days before white settlement at Bowen, evidence of the Aboriginal presence was there – footprints, fireplaces, fish bones, shellfish, and the remains of shelters and canoes.

Aboriginal art motifs on the walls of a cave at Hook Island

However it is significant that actual sightings and encounters with the Aborigines among the islands were relatively few and, when they did occur, it was with small numbers, ranging from two or three in a canoe to larger numbers on some of the islands. The largest recorded number at any one time was on the occasion in 1861 when two men from the *Ellida* were killed on Lindeman Island (see page 132) where there was at the time a camp of 'about 40' Aborigines. In 1868, during HMS *Virago*'s surveys around Shaw, Lindeman and Hamilton islands the comment was made that Lindeman was the only island in that area on which they saw Aborigines.

This paucity of actual contact with the Aborigines among the islands before white settlement, coupled with the nevertheless frequent evidence of visits to the islands, led a number of naval observers to suggest that perhaps the Aborigines only visited the islands from the mainland in certain seasons. The impression is gained that what population there was on the islands at any one time was scattered very thinly, and certainly there was no evidence of massed gatherings nor was there any mention of permanent camps.

Evidence suggests an Aboriginal population passing between islands and mainland as seasons and food demands

dictated, and it is hard to attribute a permanent population to the islands. Equally it is hard to speculate about the numbers in the islands at any one time, but the few seen by the early vessels passing through would suggest something in the low hundreds for the entire group, with probably the main body of any particular tribal group mainland-based.

In later years, after the lighthouse was erected on Dent Island in 1879, that island became a base for many Aborigines, with 'forty or fifty' men, women and children reported there during a visit from HMS *Alert* in May 1881.

The culture

Early reports of the Aborigines invariably describe them as a fine race of people, well built and well fed, the young men in particular carrying themselves confidently and proudly. The Whitsundays must have been a reasonably benign habitat, with fish and other marine creatures abounding, and wildfowl and game in plenty around waterways such as the Proserpine River flood plain.

There is probably no reason to suggest that the Aborigines of the Whitsunday islands had a culture different from those of the adjacent mainland. Anthropologists say the Ngaro (alternative names: Ngalangi, Googaburra) tribe inhabited Whitsunday Island, ranging over the Cumberland Islands, Cape Conway and the mountains east of Proserpine, which indicates a tribe not residing exclusively on the islands but passing to and fro between islands and mainland.

It seems unlikely any one tribe could be regarded as having 'exclusive' access to the islands along their entire length,

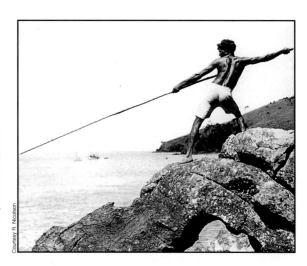

A Whitsunday Aborigine on Lindeman Island in the 1930s (since white settlement on that island). The natives of the Whitsundays pursued a subsistence economy largely based on the marine environment. They were highly skilled in the use of their spears – 'Could hit a sixpence on the tail of a kite', one white settler observed.

Courtesy R. Nicolson

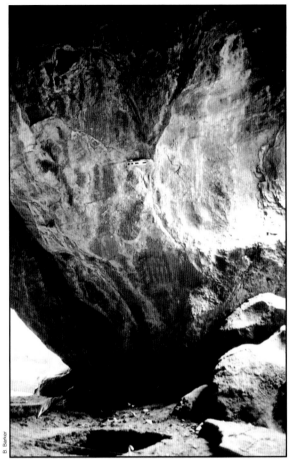

B. Barker

Rock shelter at Nara Inlet, Hook Island. The Ngaro moved from island to island in canoes, making a seasonal round that included the hunting of Torres Strait pigeons, fish, shells and gathering large quantites of plant food. A number of rock shelters have been found among the islands, and archaeological excavation has demonstrated that these sites were first visited more than 8500 years ago. In the last 2000 years the sites have had increasing use. Among artifacts identified are pieces of ground turtle shell, which may have been fish hook blanks, shell scrapers, a wooden bi-point (for a spear), netting, flakes of stone (from a quarry on South Molle Island), and various species of fish, shellfish and plants.

D. Coffelt

Rock art at the Nara Inlet site features net patterns and grid motifs, bearing a closer relationship to central Queensland cave art than to that found along the Queensland coast to the north.

and it is far more likely the islands to the north and south were visited also by Aborigines from their adjacent mainland. Indeed it is evident from the account of the Aboriginal attack on the *Louisa Maria* in August 1878 (see pages 134–35) that Aborigines from Bowen were common visitors to Whitsunday Island. Notable among comments by Royal Navy personnel who passed this way in early years was the repeated hypothesis that the islands were visited by natives from the mainland rather than having a permanent population.

One factor that may have influenced the extent of Aboriginal intercourse between mainland and islands is the lack of convenient island 'stepping stones' to the more southerly islands, where a traveller is confronted with an unsheltered

voyage for a minimum of about 13 nautical miles between mainland and island. Distances between the more northerly islands are much shorter, and 'island hopping' involves passages of no more than several miles at a time. This may indicate a larger population at any time among the northern islands.

As was common among Aboriginal tribes, any shelters built during a short stay were of the most rudimentary kind. They were little more than a few branches or pieces of bark erected as a windbreak, such as the one observed on Long Island in 1881 by a naval officer fresh from a visit to North America:

> Even more primitive than the wigwam in its construction, for the latter gave protection on all sides and was covered with seal and other skins, whereas with the Australian native it is a mere section of hut to give shelter against the prevailing wind.

Watercraft

James Cook remarked in 1770 that he saw several people on a beach with an outrigger canoe, bigger and different in style from any he had previously seen on the coast.

In March 1843, during a survey of the area by HMS *Fly*, one of the crew, Edwin Augustus Porcher, painted a watercolour of Cape Hillsborough with a dugout outrigger canoe containing three natives in the foreground. This painting is quoted frequently, along with Cook's mention, in support of the argument that the Whitsunday Aborigines used outrigger canoes. However, extensive study of early naval logs, narratives, and the like (other than Cook's) reveals no mention at all of outrigger canoes but, instead, frequent mention of bark canoes without outrigger or sails and propelled by paddles. The overwhelming evidence is that simple bark canoes were the norm, and the two examples of outrigger canoes mentioned above indicate exceptions requiring explanation, rather than evidence outriggers were in common use.

Descriptions of the time show that the bark canoes were made either from a single sheet of bark or, for larger craft, from three sheets, one for the bottom and one for each side. The Australian Museum has one such from the Whitsundays, though the three parts are separate. It is about 2.7 metres (about 8½ feet) long, which accords well with writings of the time that talk of lengths from about 8 to 10 feet – this no doubt being dictated by the length of available bark sheets. The larger canoes could carry up to five persons.

In 1860, G.E. Dalrymple described four canoes he encountered on a beach on Brampton Island. They were made from three sheets of eucalyptus bark, about 2.4 metres long (8 feet) by 1.1 metres wide (3½ feet) and 0.5 metre deep (20 inches).

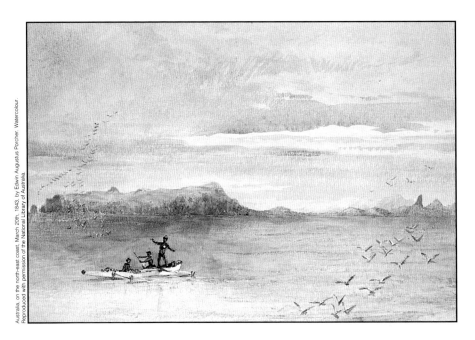

The above watercolour of Cape Hillsborough was painted in 1843 by Edwin Augustus Porcher, one of the crew of HMS *Fly*. The outrigger canoe shown in the foreground was not typical of the Whitsunday area, where a three-piece sewn bark canoe, as pictured left, was commonly in use. Cook reported seeing an outrigger in the Whitsundays in 1770, but it probably came from further north, where this type of canoe was used. Porcher's outrigger was most likely an artistic device, as he often placed objects in the foreground of his paintings simply to balance the composition, and the original sketches in his personal journal, upon which this painting is based, show no outriggers.

The Aboriginal people 129

B. Barker

The ends were pointed and turned up, the whole very neatly and strongly sewn together with a long tough cane-like creeper. Two cross sticks held the gunwales apart. In each canoe was a very neatly made paddle, ornamented with crosses of red paint, or 'raddle', on the blade. They also contained several large shells to carry water or for bailing out.

The expertise with which the Aborigines handled their frail craft and the speed they could attain were a matter of comment in early writings: in waters that can be treacherous to small craft, the extent of their travel among the islands is remarkable, though it could be surmised there would have been losses from time to time. The closeness of the islands to each other and the mainland indicates travel by island hopping would have been the norm.

Hunting and fishing implements

Dalrymple also described a fishing spear in the canoe. To a long coil of fishing line, probably derived from pandanus leaf, was affixed a spearhead of about 125 millimetres, neatly barbed and pointed with a sharp fish bone. This head was fitted into a socket in the end of a long spear. The spear was thrown from the canoe, at dugong for example, the head embedding in the flesh while the shaft floated clear to be picked up. Meanwhile the prey was played and hauled in with the line.

It is evident also the Aborigines employed line fishing, as fish-hooks carved from turtle shell were frequently commented on by writers of the time.

On South Molle Island there is a 'quarry' from which the Aborigines obtained flint for making axe heads and cutting implements. In geological terms the rock concerned is a 'banded chert', a hard, extremely compact, semi-vitreous, microcrystalline, sedimentary rock consisting of interlocking crystals of quartz which fractures easily into sharp-edged pieces and which could be further honed against another stone.

The boomerang was common to the area and was the main weapon used when two men from the *Ellida* were killed on Lindeman Island in 1861, though it seems on that occasion the weapon was used as a club rather than thrown in traditional fashion. Spears other than fish spears were common, as may be expected, but the woomera was not used by the Whitsunday Aborigines. Stones were a common weapon where conflict did arise.

South Molle Island was called 'Whyrriba' by the natives, a name that meant 'stone axe'. A quarry where the Aborigines obtained stones for making cutting implements is located on a steep ridge about 1.5 kilometres east of the resort on that island. The rock is a 'chert', described in the adjacent text, ideal for making ground-edge axes. The quarry site is intersected by a walking track that goes to The Horn and Spion Kop, on the north-east corner of South Molle, where there are excellent views of the surrounding islands and the Whitsunday Passage. Visitors are reminded that Aboriginal sites and artifacts are protected by law and must not be disturbed.

Conflict

Contact between Royal Navy ships and the Aborigines seemed mostly to be peaceful, though on several occasions the Aborigines 'showed some fight' or 'opposed a landing'. But

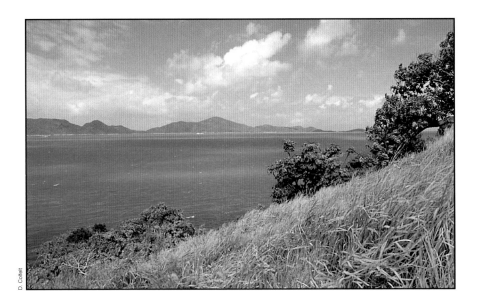

D. Collett

these were not serious confrontations, more ritual posturings as may occur between tribe and tribe, and were resolved by the giving of gifts of tobacco and the like. Naval crews were disciplined and well armed and bound by a policy of peaceful association with the natives, and in Whitsunday waters there is little record of conflict with them.

In later days, once white settlement had commenced at Bowen and Mackay and along the coast between, there was serious and sometimes fatal conflict between white settlers and the mainland Aborigines. This led to the police commissioner for Queensland reporting, in 1868, that 'The coast country all along from Townsville to Mackay is inhabited by blacks of the most hostile character'. The report related mostly to problems at grazing properties along the coast.

This reputation, with some justification, attached itself also to the waters along the coast, but in later years stories of fatal attacks on vessels in the Whitsundays became exaggerated. Certainly events were to show there was a need for crews to be watchful and to avoid being lulled into overconfidence by the friendliness often displayed at first by natives visiting vessels. But the picture was not as fearsome as sometimes it is painted.

From the time Captain Henry Daniel Sinclair in the *Santa Barbara* discovered Port Denison in October 1859 till the last attack on white men among the islands (the *Louisa Maria*

The idyllic scenery of Kennedy Sound, between Lindeman and Shaw islands, where a vessel called the *Ellida* anchored in 1861. Two of her complement were among the few fatalities to occur in the Whitsunday islands as a result of the coming of the Europeans and their interaction with the Ngaro people.

The *Ellida* was a 12-tonne ketch belonging to the Archer family, who pioneered the Rockhampton district. She was the first craft to carry a cargo up the Fitzroy River (where she is depicted above). On 1 September 1855, skippered by Colin Archer, she arrived at what was later to become Rockhampton with supplies for the Archer family property.

In 1861, on a mail run from Port Denison to Rockhampton, the *Ellida* was involved in an incident at Lindeman Island which resulted in the death of two of her crew at the hands of Aborigines who were camped there.

in August 1878 – see pages 134–5), there are substantiated accounts of the death of only three white men – two from the *Ellida* in 1861 at Lindeman Island and one from the *Louisa Maria* near Cid Harbour in 1878. In both these cases the white victims had allowed themselves to be 'seduced' by outwardly friendly Aborigines and suffered the consequences.

While other vague stories exist of fatal attacks, there is no evidence to support them, and the only other substantiated, though nonfatal, attack was one on Sinclair himself at Thomas Island in October 1859, where he had allowed himself to be led away from his companions.

In all, the conflict between white and black among the Whitsunday islands is not as fierce as sometimes is stated. During those early years, white men – for example, timber cutters and the crews of small ships servicing them – moved fairly freely among the islands without being harmed, though they no doubt would have been cautious in their movements.

In 1861 a detachment of Native Mounted Police was stationed at Fitzalan Point (Whitsunday Island) to protect timber-getters camped there. Contemporary reports, however, indicate there was no serious trouble with the blacks on that occasion, and the Native Mounted Police were there more in a precautionary role than a punitive one.

The real reasons for the attacks that did occur will never be known, though in the case of the *Louisa Maria* there was an inference that the victim may have taken liberties with the

Courtesy R. Nicolson

Aboriginal women at the scene. The attack on the men from the *Ellida* at Lindeman Island was, on the evidence of the time, to obtain their gear and clothing.

For Whitsunday waters the end of serious hostilities, by the blacks at least, came after the *Louisa Maria* incident when a detachment of Native Mounted Police was despatched to revenge the killing. It is unfortunate the official report of that raid has been lost to posterity but, given the reputation the Native Mounted Police had acquired, there seems no doubt they handed out 'justice' liberally on that occasion. The number of Aborigines killed will never be known.

A Lindeman Island Aborigine, c. 1930s, employs a traditional spear in the pursuit of a sea turtle. The Ngaro people used such spears for hunting turtles, dugong, and other marine prey. The spears had a detachable head that parted company with the shaft when the target was struck. A lanyard secured to the head was used to pull the quarry in.

Cannibalism

This macabre subject is included here because some stories persist in the suggestion that cannibalism was practised more or less as a matter of course by the Aborigines of the Whitsundays; indeed, one popular anecdote about the *Louisa Maria* has it that the cook was killed and eaten. A study of the official reports of the incident show that, while the cook was indeed killed, there is absolutely no suggestion of cannibalism.

Authoritative studies show that cannibalism did occur sometimes among some Aboriginal tribes, but the instances of blacks killing humans solely to eat were very rare. However, if a person, black or white, of reasonable health died suddenly, the body or part of it may have been eaten if alternative food supplies were scarce. For reasons unknown, it was

Continued on page 134

The story of the *Louisa Maria*

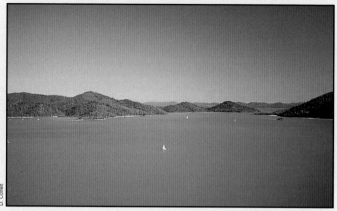

Looking south into Cid Harbour, Cid Island right, Sawmill Beach extreme left

The *Louisa Maria* was a 39-ton schooner owned by Samuel Johnson, a timber merchant of Bundaberg. On 2 August 1878 she left Cleveland Bay in ballast bound for Bundaberg with a crew consisting of master Alexander McIvor, deckhand John Johnson, a cook, John Morrison, and Andrew Walker, a shipwright working his passage to Bundaberg.

The *Louisa Maria* encountered strong headwinds at Gloucester Island and, because the vessel's bottom was so foul, she had difficulty making headway. McIvor decided to beach the schooner for cleaning at Whitsunday Island in or near Cid Harbour.

On the beach the morning of 8 August were some Aboriginal men, women and children, some of whom spoke English. They had come from Cid Island (which forms the western side of Cid Harbour). The Aborigines were friendly and assisted with the careening; they exchanged fish for food from the ship. The deckhand,

Johnson, told how he played and swam with them and gave them tobacco. Morrison on several occasions accompanied some of the gins (Aboriginal women) along the beach in search of firewood.

On 10 August more Aborigines arrived from Molle Island. They must have brought bad news with them, because the natives were very quiet at first, and then the old gins roared and rolled on the beach, and from one of the new arrivals McIvor learned that they were from Bowen and that 'there were two or three blackfellows dead in Bowen' (it is not clear what this news meant but possibly the natives held white men in general responsible).

McIvor by this time was concerned at the number of Aborigines on the beach and determined to relaunch the boat that evening. Meanwhile he took Johnson and Walker and one of the natives in the ship's boat to another bay to get water, leaving the cook

alone to tend the ship, which was not yet fully afloat. It was too late by the time they got there to carry water over the rocks (the tide was rising), and McIvor decided to fill the cask next morning. They returned to the *Louisa Maria* and at high tide got her to float free, anchoring her about half a mile from the shore. Morrison complained to McIvor about being left alone on the vessel and said that while the rest of them had gone for water an Aboriginal man and two gins had come out in a canoe and the man had been looking for the boat's tomahawk and axe and had wanted flour and anything else he could get his hands on. McIvor was to say later in his statement that, when he returned, the native canoe was alongside and two gins were on board but there was no sign of an Aboriginal man. This raises the possibility of whether some action of Morrison's towards the two women had any bearing on what was to follow.

At 7.00 am next morning some Aboriginal men and women came aboard and were given breakfast by McIvor. One of the men then accompanied Johnson and Walker in the ship's boat to get the water from the bay previously visited. Then all the Aborigines from the shore came and boarded the schooner, McIvor offering no objection however concerned he may have felt. All seemed friendly enough.

One of the men picked up the axe but McIvor took it from him and threw it down the forecastle and then proceeded to get lifting tackle ready to hoist aboard the water cask from the boat, which he could see returning. He went to the gangway on the starboard side and was suddenly caught from behind by an Aboriginal man who threw him bodily over the side. On surfacing he called to Morrison to throw a rope but Morrison was not to be seen.

The Aborigines then threw at McIvor in the water every missile they could get their hands on – the boatsprit, leadline, a hand spike and all the firewood. McIvor drifted out of range, whereupon one of the Aborigines boarded a canoe and came after him with a fish spear and tomahawk. On approaching, the native yelled 'You bloody wretch baal [no] you give him tobacco' and he speared McIvor in the face but did not use the tomahawk.

The watering party in the ship's boat heard the commotion and saw someone in the water. As they approached the ship and the canoes beside her, the Aborigine who had accompanied them climbed out of the boat and into one of the canoes and then boarded the

Lousia Maria. Realising that the person in the water 150 yards astern was McIvor, Johnson and Walker went to retrieve him, finding him in a state near exhaustion.

The blacks on board the ship were passing provisions and gear down into their canoes. The three white men stood off for several hours in hope that the Aborigines would leave the vessel, watching them pass the ship's sails down into the canoes. It soon became apparent that the ship was on fire, and as they watched, the flames took a strong hold. That was the end of the *Louisa Maria*.

During this time the Aborigines made no attempt to molest the three men and it seems their argument was primarily with Morrison.

The three men were picked up by the cutter *Riser* near Dent Island at about 5.00 pm. They returned to the wreck about 4.00 am next morning; all that was visible of the ship was her topmasts above the water. The Master of the *Riser*, Johnson and two other men went ashore. The blacks hid behind rocks, poked fun at them and threw rocks. *Riser* then proceeded on to Bowen with the crew of the *Louisa Maria*.

The crew was questioned carefully by the Bowen Harbourmaster, G.F. Sandrock, particularly as to whether Morrison had interfered with the Aboriginal women, but all three said that to their knowledge this had not been the case. McIvor could only venture that the incident occurred because the cook had unwisely opened the food safe while the Aborigines were on board, and because he (McIvor)

had not given them tobacco. This latter may account for the attack on McIvor but the reason for the killing of Morrison remains a mystery.

In early September a party of the Native Mounted Police, accompanied by McIvor, went to the scene of the attack. There a gin told them that Morrison had been tomahawked and thrown overboard. Articles of his clothing were found.

The visit to Whitsunday Island by the Native Mounted Police visit was reported in the *Port Denison Times*, where it was ventured that appropriate justice had been handed out (which undoubtedly meant that the offending Aborigines had been shot). A poignant confirmation of this came in May 1881. At that time a boat party from HMS *Alert* paid a visit to the lighthouse keeper at Dent Island, where they found a large gathering of Aborigines on the hill above the light, all showing obvious consternation. The lightkeeper said that, on seeing the boat party approaching, the Aborigines had gathered at the light seeking protection from what they feared was going to be another reprisal raid. The keeper explained that they had a lasting memory of such an occasion a few years earlier when, as punishment for what was no doubt the *Louisa Maria* incident, a party of Native Mounted Police had been let loose among them with their rifles, creating frightful havoc.

Some versions of the *Louisa Maria* story say that Morrison (who somehow becomes a Chinese cook!) was eaten by the Aborigines; there is no evidence whatever to support this.

sometimes a practice for relatives to eat parts of the body of a deceased person.

As far as the Whitsundays are concerned, the question of cannibalism is an open one, but there is no substantive evidence of this in writings of the time.

The demise of the Aboriginal culture

Over the years following white settlement, and with foreign fishing, trochus and bêche-de-mer boats operating throughout the area, the Aboriginal culture bowed inevitably to that of the foreigners. Disease took its toll, and tribes drifted to the mainland settlements at Bowen, Mackay and Proserpine. For a while Dent Island became a refuge for Aborigines because of the lighthouse erected there in 1879. By early in the 20th century few Aborigines were left on the islands, though some remained camped near white settlements on the islands and were employed sometimes in daily work around the properties.

The Native Mounted Police have been held by some to be directly responsible for decimating the population of the islands, but this is difficult to substantiate. The logistics of conducting a successful island raid upon a people intimately familiar with the rugged terrain they occupied, and particularly the difficulty of maintaining the essential element of surprise where any approach had to be made by sailing boat, militate against the theory. Writings of the time do not support it. Indeed, when the Native Mounted Police raided a native camp on Shaw Island following the *Ellida* incident in 1861 it proved a farce that demonstrated the difficulties of overcoming the problems mentioned. Without their horses the police were deprived of an advantage they had on the mainland, and the odds were stacked more in favour of the Aborigines*.

The *Louisa Maria* raid made an undoubted, if ill-defined, impact, but any further contribution by the Native Mounted Police to the decline in the island population was more likely the result of raids on the mainland, where these police operated with great efficiency and undoubted ferocity.

Today it is very difficult to find any trace of the earlier Aboriginal culture. Museums have a scanty collection of artifacts from the area, and in a 'cave' in Nara Inlet there are rock paintings attributed to the Aborigines. Archaeological studies may shed more light.

*While the killings took place on Lindeman Island, by the time the police raid was organised several weeks later the Aborigines concerned had moved their camp to the base of Shaw Peak on Shaw Island, across Kennedy Sound. The police were unable to mount a surprise attack, and the Aborigines eluded them with ease on the rugged slopes of Shaw Peak, rolling stones down on the attackers and generally treating them with scorn. After a day of effort the police withdrew.

European discovery

'One continued safe harbour'

RAY BLACKWOOD

Early exploration

'Did Europeans visit Whitsunday waters before James Cook?' This is a question that will probably never be answered. Some ingenious theories have been put forward over the years suggesting that the Portuguese, at least, may have come this way, but these remain theories only. No hard evidence of such has been found.

Lieutenant James Cook, RN, 1770

The first clear page of European history in the Whitsunday islands was written in June 1770 when Lieutenant James Cook, RN, in HM Bark *Endeavour*, passed through the islands during his first voyage of discovery around the world. Hugging the coastline as closely as prudence would allow, Cook sketched in the eastern profile of New Holland (as Australia was then known), completing the circle of European discovery of the continent. This course brought him, on 1 June 1770, into southern Whitsunday waters, and on that night he anchored off what today is Mackay, proceeding north the next day to anchor off the area later to be named Port Newry.

In the distance to the north-west Cook saw what appeared to be a passage between the mainland and some high land that he took to be an island. Uncertain that there was a passage, he dropped anchor at 8.00 pm. That night the crew of the *Endeavour* observed the tide flooding in from the islands to the north-east, and Cook noted in his log that this indicated to him there was no passage to the north-west. At daybreak, however, he was apparently tempted to go and have a look anyway, and soon discovered that there was low land right across the apparent passage and that they were, in fact, within a large bay.

Thus repulsed, Cook dubbed the bay 'Repulse Bay'. He altered course to the east and, at about 10.00 am, rounded the prominent headland of Cape Conway to find lying before him a broad deep passage running to the north-west between the mainland and a chain of high islands. In the *Endeavour's*

Portrait by W. Hodges. Dixson Galleries, State Library of New South Wales

James Cook was born in Yorkshire in 1728. At 18 he became an apprentice on a coal ship plying the east coast of England from Tyneside to London – an excellent school of seamanship. He joined the Royal Navy in 1755, where his experience and innate ability saw him rise rapidly through the ranks. In 1768, as a lieutenant, Cook left England with orders to proceed to the South Seas to observe the transit of Venus with the sun (an event that provided an opportunity to calculate the distance from Earth to the sun). He had secret orders to then proceed in search of a great southern continent, which geographers for centuries had postulated but which had never been found because it never existed. This portrait is contemporary with his voyages of exploration.

Cook's 'Whitsunday's Passage' (the names he put on the chart are in black type). Cook labelled only one island, Pentecost (from the Greek meaning fifty), the association being that Pentecost is the Christian festival observed on the seventh Sunday (fiftieth day) after Easter, that is, Whit Sunday, commemorating the descent of the Holy Ghost upon the disciples on the day of Pentecost. Whit Sunday means literally 'white Sunday', referring to the ancient custom of wearing white robes at the feast of Pentecost.

Point Slade was named after Sir Thomas Slade, Surveyor to the Royal Navy and the builder of Nelson's *Victory*; Cape Hillsborough after Wills Hill, First Viscount Hillsborough and President of the Board of Trade; and Cape Conway after Henry Seymour Conway, Secretary of State.

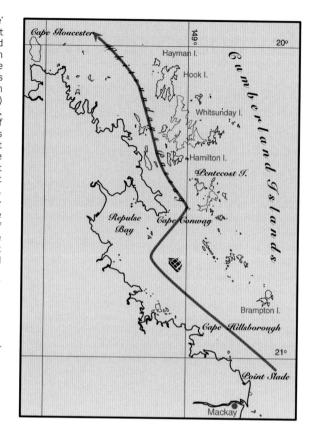

* Cook did not adjust his clock when he crossed the 180th meridian and therefore the true local time when he discovered Whitsunday Passage was Monday, 4 June.

log that morning the date was Sunday, 3 June* 1770, the day that year on which the Christian Church celebrated the Festival of Whit Sunday. Cook named the passage ahead of him 'Whitsunday's Passage', and though the possessive 's' was soon dropped, the name was to become one of the best known along the Queensland coast.

The *Endeavour* cruised through the Whitsunday Passage during the rest of that day and continued sailing all that night, so confident was Cook of the waters before him. At daylight the ship was abreast a 'lofty promontory' which Cook named Cape Gloucester but which later navigators were to find was in fact an island – today's Gloucester Island. Thus the *Endeavour* passed out of the Whitsundays and on to her fateful appointment with Endeavour Reef near Cooktown.

Of his Whitsunday's Passage Cook said:

It is form'd by the Main on the west and by Islands on the East, one of which is at least 5 Leagues in length*, our depth of water in running through was between 25 and 20 fathom every where good anchorage. Indeed the whole passage is one continued safe harbour, besides a number of small Bays and Coves on each side where Ships might lay as it were in a Bason, at least so they appeard to me for I did not wait to examine them as having been in Port so lately and being unwilling to loose the benefit of a light Moon. The land on both the Main and Islands especialy on the former is tolerable high and distinguished by hills and Vallies which are diversified with woods and Lawns that look'd green and pleasant[†].

Cook left behind a number of names drawn mostly from English royalty and political notables of the day. The islands lying to the east of his route he named Cumberland Isles after the then Duke of Cumberland, a brother to the reigning monarch, George III, and officialdom later was to define these as stretching from Snare Peak Island (21°06' south/149°56' east) in the south to Hayman Island (20°03' south/148°53' east) in the north. Another brother of the monarch, the Duke of Gloucester, was honoured in his naming of Cape Gloucester. In honour of those notables who in one way or another were responsible for his voyage, Cook named Point Slade, Cape Hillsborough and Cape Conway, but the only island to be named by Cook was Pentecost Island, which attracted his special notice because of its distinctive shape. In Cook's words it was 'more remarkable than the rest, being small in circuit, very high and peaked'. The reason for the naming is evident because of the biblical association between Whit Sunday and Pentecost (see caption on opposite page).

Further discovery

After the dust of Cook's visit had settled, the Whitsundays resumed their normal tranquillity. Port Jackson (where the city of Sydney is located today) was settled in 1788, and the livelihood and commercial welfare of that isolated outpost immediately became dependent upon trade with European outposts in the Far East. Fast and favourable routes were needed immediately.

The known routes to Australia at the time were around the bottom of the continent, where westerly winds were favourable to fast passages even if the distances were longer. However, return passages by the same routes were all 'uphill', so shorter and wind-favoured routes north-about across the top of Australia, dangerous though they were known to be, lured the bolder mariner.

* Cook's 'island' was two islands, today's Hook and Whitsunday, and Cook no doubt observed the narrow separation between the two, but in those days it was usual for closely grouped islands to be referred to as one island.

[†] The 'Lawns' he refers to were grasslands, probably maintained by the Aborigines' practice of burning.

Modern readers of passages from Cook's journals may be puzzled by the apparently haphazard capitalisation and irregular spelling. Cook's use of capitals has been described as 'unsystematic 18th century'; his spelling is often phonetic and quirksome, a bit of a Yorkshire broth laced with random variations that defy explanation. In letters, diaries and journals of the time it is not unusual to see such idiosyncracies, even in the writings of those with much more formal education than Cook had had. Indeed, compared with most of the informal or private prose of the period, Cook's is a model of clarity and consistency. In any event, they are not misprints.

At first the preferred route was north through the Pacific Ocean and around the north of Papua-New Guinea. However, one by one, intrepid souls dared the dangers of Torres Strait, between Australia and New Guinea, approaching it via the Pacific Ocean and the Coral Sea, *outside* the Great Barrier Reef.

Inevitably, the route to Torres Strait that Cook, however unwittingly, had followed – inside the Barrier Reef to Lizard Island, where he escaped to the open sea – was the one that attracted attention. William Bligh, cast adrift from HMS *Bounty* in 1789, filled in a little of what Cook had bypassed, but the inner route remained an unknown, though tantalising, alternative.

The first voyage via the 'inner route'

Strangely enough the first recorded voyage along the inner route was by the intrepid escaped convicts William Bryant, his wife Mary, their two children and seven other convicts who 'commandeered' a government boat from Port Jackson in March 1791 and set out for Timor and freedom. They succeeded in their escapade, though not in attaining freedom, and along the way they must have passed through the Whitsundays.

Lieutenant Matthew Flinders, RN, 1802

Meanwhile mariners of various pursuits – whalers, sealers, traders, adventurers – were probing at the Reef, and a body of knowledge was slowly evolving. It was to be pulled together in one comprehensive account, in 1802, by Lieutenant Matthew Flinders, RN. Flinders set sail in HMS *Investigator* from Port Jackson accompanied by HMS *Lady Nelson* under the command of Lieutenant John Murray, RN.

The prime purpose of Flinders's voyage was to survey the Gulf of Carpentaria and complete a circumnavigation of Australia. In the event, he only touched briefly at the Whitsunday islands, more by accident than design. Having reached the Percy Islands in early October 1802, he was by then weary of the reefs and anxious to get to the Gulf before the monsoon set in. So he decided to head for the open sea with the idea of passing through Torres Strait via Cook's route.

The birth of the 'Barrier Reef'

The thought had already developed in Flinders's mind that a continuous barrier of reefs might lie along this coast, and his journal of 5 October expressed these feelings. Thus the word 'Barrier' was born as a description of Australia's reef.

For several days Flinders tried to find a way through the reefs, but by 11 October he had to admit defeat and decided that the dangers of searching among the reefs for an open-

ing were too great. Instead, he would continue along the inner edge of the barrier until a clear opening presented itself. It is slightly ironic that had he persevered for another day or so, a little further north, it may have been Flinders, in 1802, and not HMAS *Flinders*, in 1982, who pioneered the opening of Hydrographers Passage. On 16 October Flinders made his only landing on a Whitsunday island, today's Calder Island.

Flinders found that the *Lady Nelson* was not equipped either in her sailing capabilities or in the experience of her commander to continue with him, so he ordered her back to Sydney. The *Lady Nelson* was designed for work in shoal waters, but her retractable keels had been damaged along the way, and this contributed to the vessel's sailing disability, particularly in windward work.

Flinders left no names in the Whitsundays but gave a series of alphanumeric designations to various groups of the islands; for example, he designated Scawfell Island 'L Island', and those islands close to it L1, L2, and so forth. In all, Flinders's passage through the Whitsundays was not a great event in historic terms, but the brotherhood of mariners owes him an eternal debt for his charting of the inner edge of the Barrier Reef, and many years were to pass before his chartings were refined by later surveys.

By the 1920s the Royal Australian Navy had taken over the surveys, though still for a while with Royal Navy commanding officers, and HMAS *Geranium* and *Moresby* carried on the task of refining charts and adding names. They again followed the time-honoured practice of giving names after members of the ship's complement. It was during this era that a new technology was introduced – aerial photography – and from 1926 to 1928, RAAF Flight 101, based at Bowen, assisted the *Moresby* in her surveys of the Great Barrier Reef. For this reason we see among those reefs the names of many of the airmen of Flight 101.

Matthew Flinders was responsible for one of the most complete investigations ever made of the Australian coast. Born in Lincolnshire in 1774, at school he pursued a curriculum designed to prepare him for medicine. But he was a Robinson Crusoe at heart, and in 1790 joined the Navy. He had a passion for exploration; friends quoted him as saying that if a plan for a voyage was read over his grave, he would rise up, awakened from the dead. It was he who advocated the name 'Australia' for this continent, and he coined the term 'Barrier Reef' as now applied to the 2900-odd coral reefs that comprise it.

White settlement
The Long Island wreck
The first 'settlers' in the Whitsundays, though not by choice, were the crew of the merchant vessel *Valetta*, which damaged itself on a reef at Scawfell Island in July 1825. During the two weeks that the vessel was being repaired, the crew set themselves up in huts ashore until the voyage was resumed. Within a day or so, the vessel was in trouble again and leaking badly. It was decided to put her ashore at today's Happy Bay on Long Island, and there the crew again set up

Continued on page 142

Exploration after Matthew Flinders

Lieutenant John Murray, RN, 1802

On 18 October Lieutenant John Murray in the *Lady Nelson* and Lieutenant Matthew Flinders in the *Investigator* were about 40 nautical miles east of Border Island. Having been instructed by Flinders to return to Sydney, Murray set his course to the south-west, coming to anchor that evening at 5.30 between two very high islands covered with pines. These were today's Linné and Goldsmith islands, and the anchorage was at the northern end of the narrow passage between the two.

Linné Island was alight in several places and, thinking they may be able to communicate with the Aborigines who had set the fires, Murray sent the first mate ashore to contact them. Linné is a very inhospitable island for most of its circumference, and it is clear the landing must have been made on one of the two small beaches on the western side facing Goldsmith Island. In the event, no Aborigines were seen, though part of a canoe was found and brought back onto the *Lady Nelson*. Murray expressed the view that, as the mainland was not far off, the natives now and then visited the islands and generally set them afire.

Contrary winds and her damaged keel kept the *Lady Nelson* at

the same anchorage for three days during which time Murray himself went ashore on Linné Island alone and unarmed in the hope he might be able to contact the natives he assumed were there, but none appeared.

Lieutenant Charles Jeffreys, RN, 1815

One of the most significant of the early voyages through the Whitsundays was that of Lieutenant Charles Jeffreys, RN, in HM Colonial Brig *Kangaroo*, en route from Sydney to Ceylon with a detachment of the 73rd Regiment which had finished its tour of duty in Australia. Jeffreys followed Cook's route along the Queensland coast, and on 14 May 1815 (Whit Sunday in that year) anchored in today's Port Molle, giving the anchorage that name after the then lieutenant governor of New South Wales, Colonel George James Molle.

Jeffreys spent three years in Australia in command of the *Kangaroo* which was not a Royal Navy vessel but a chartered colonial workhorse. He was on half pay, as was the custom at the end of the Napoleonic Wars when there was a surfeit of personnel. He was employed by the NSW Government carrying troops, convicts and supplies between Tasmanian ports and Sydney before and after his Ceylon assignment.

Jeffreys was to become notorious for the irritation and annoyance he caused to Governor Lachlan Macquarie by his disobedience and arrogance. Nevertheless, he made a most valuable contribution to maritime knowledge when, on continuing his voyage in 1815, he took the 'inner route' all the way to Cape York and charted waters not previously seen by Cook, Bligh, or Flinders, thereby opening a little wider the door to Torres Strait and the ports of the East.

Lieutenant Phillip Parker King, RN, 1819–1821

Important though Jeffreys's voyages were, he was not a naval surveyor, and his descriptions were broad and sometimes confusing. The fine detail of Whitsunday waters began to emerge when Lieutenant Phillip Parker King, RN, passed this way in three voyages, in 1819, 1820 and 1821. On each occasion he was accompanied by the botanist, Alan Cunningham, who later was to make a name for himself in Queensland exploration.

Phillip Parker King was the eldest son of Phillip Gidley King, governor of New South Wales at the beginning of the 19th century. Born on Norfolk Island in 1791, when his father was in command of the settlement there, King was the first Australian to explore the Queensland coast and the first to attain the rank of admiral.

On the first voyage, in HMS *Mermaid*, King followed closely in Cook's tracks, naming the Repulse islands, climbing the summit of South Repulse Island and noting signs of Aboriginal occupation on the beach on the south-east side where they had landed.

He also landed on the north side of Cape Conway, and Cunningham described a fine rill of water which ran from the steep hillside 'and disembayed itself into a bason contiguous to the beach and ultimately into the sea'. On the beach they

discovered remains of native bark huts and a wrecked bark canoe. This small beach, its 'bason' and its rill, still exist today, being the first beach north of the tip of Cape Conway and opposite Ripple Rock.

King and Cunningham landed on a rocky beach at the south-western end of Pine Island and climbed to the summit, commenting on the luxuriant grass through which they climbed, it reaching up to their middles, though today the island is heavily wooded with very little grass in evidence. King also noted the pines growing there (as they do today), naming the promontory Pine Head.

King observed that Cook's Cape Gloucester was in fact an island separated from the real cape by a strait a mile and a half wide, and accordingly he renamed it 'Gloucester Island' and transferred the name 'Cape Gloucester' to the point of mainland opposite the southern extremity of the island.

In July 1820 King, Cunningham and the *Mermaid* entered the Whitsundays for the second time, with King deciding to sail this time to the east of the main group of islands to broaden his knowledge of the area. As they sailed between the Edward group and the cluster of islands including Haslewood, Lupton and Worthington, they saw a group of seven natives firing grass on the side of a hill above which there was an abundance of pines. The natives waved to them, and one of them stood stationary on an elevated rock all the time the vessel was passing. This event must have been in the vicinity of Lupton Island or Pallion Point on Haslewood Island.

They passed close by the east of Deloraine Island, and at 4 pm rounded Hayman Island and sailed on to the north. It was on this occasion King named Mount Dryander, which stands prominently to the west. King also gave the name 'Pine Island' (today known as

Nicolson Island) to the small rounded island at the south-east corner of Haslewood Island.

King and Cunningham returned in June 1821 in HMS *Bathurst* and with the merchant vessel *Dick*, but made little comment about this passage.

King's voyages marked the end of the real exploratory phase and thereafter Royal Navy surveys continued on a routine basis to fill in the gaps and give names. By the time white settlement began in the early 1860s the waters were comparatively well known and charted.

Lieutenant Francis P. Blackwood, 1843–1844

Lieutenant Francis Blackwood filled in much of the coastline from Mackay north in HMS *Fly* but left behind only the name Midge Point, after the pinnace that assisted in the surveys. However, several of his descriptions have been retained as names, such as Low Rock and White Rock in Shute Harbour.

Commander George S. Nares, 1864–1867

Commander George Nares, in HMS *Salamander*, filled in the names of islands around the Whitsunday Passage giving many of them the names of officers and seamen among his crew, such as Hayman, Henning, Langford, Olden and Rattray.

Commander Henry M. Bingham, 1868

Commander Henry Bingham, in HMS *Virago*, filled in the area from Hamilton to Shaw islands and again drew on names of his officers and seamen, such as Lindeman, Maher, Mansell, Thomas.

Staff Commander E.P. Bedwell, 1878–1879

E.P. Bedwell, admiralty surveyor for the Queensland Government, performed one of the most complete 'tidy-ups' during 1878 in the chartered vessel SS *Llewellyn*, filling in most of the gaps remaining, particularly among the more outlying islands. He is notable for his giving of about thirty names from the then English county of Cumberland to follow on from Cook's original naming of the group 'The Cumberland Isles'.

Captain J.F.L.P. Maclear, 1881

Captain J. Maclear, in HMS *Alert*, surveyed Port Molle in 1881. There was pressure for making this a commercial port to service the grazing and agricultural industries of the interior. He was responsible for many of the names still ruling today in Port Molle and Shute Harbour, such as Trammel Bay, Shute Island, Rooper Inlet, Mount Merkara and Hannah Point.

Lieutenant G.E. Richards, 1885–1887

Lieutenant G.E. Richards added his share of names in surveys of the mid-1880s in HMS *Paluma*, such as Hook and Sinker reefs, Genesta and Puritan bays, to name but a few.

The mountainous Lake District of England's county of Cumbria (which incorporates the old county of Cumberland) has, some say, scenic parallels in the Whitsundays, although James Cook's naming the Cumberland islands probably had as much to do with political sensitivities as it did with appreciation of visual similitudes. The Cumberland tradition was carried on over one hundred years later, notably by Staff Commander E.P. Bedwell, when in his surveys of 1878–1879, he sprinkled many Cumberland names onto the map of the Whitsunday coast.

Some examples of the county of Cumberland names given to Australia's Cumberland Islands.

huts ashore. Their stay, however, was to be much longer, as *Valetta* was found to be beyond repair, and it was three months before the crew was rescued.

While it can be no fun to be shipwrecked far from home and with dubious hope of rescue, the crew of *Valetta* must have concluded in the end there were worse spots than Happy Bay in which to be wrecked.

The timber-getters

White settlement at Bowen and Mackay in the early 1860s saw also the commencement of settlement of the Whitsunday islands. At first this was in the form of timber camps, mainly at the south-western end of Whitsunday Island. Eugene Fitzalan had cutters and sawyers at work from 1861 to provide timber for government buildings in Bowen. This was the beginning of a timber industry among the islands which continued more or less nonstop until the early 1900s, and thereafter in more spasmodic fashion until the 1930s.

In 1865 an abortive attempt was made to set up a sawmill at Fitzalan Point on Whitsunday Island, but a shortage of water soon put paid to the idea, and the mill was moved to Bowen within a few months. However, in 1888 John Withnall and his family set up a successful operation at Sawmill Bay in Cid Harbour, serving the needs of Bowen and Mackay until 1904 when the mill was closed down.

The graziers

While the majority of islands in the Whitsundays are clothed in dense forests, a number are well endowed with natural grasslands. Soon after white settlement on the mainland, these had an irresistible allure for some who wanted to combine grazing with an island lifestyle. Unfortunately for some of these early hopefuls, the dream turned sour given the hard facts of island life, and their tenures proved short and unsuccessful. Eventually, there arrived on the scene those with more realistic expectations and the will to fulfil them.

The first settler

The important question 'Who was the first settler?' must, unfortunately, be answered with qualifications. By rights it should have been one Donald Coutts Gordon, whose family, in the 1870s, owned the land on which the town of Mount Morgan now stands and who, except for a quirk of fate, may have been the discoverers of that famous gold mine. Not realising the value which lay practically underfoot, they sold out to the Morgan brothers, and the rest is mining history.

In February 1883, Gordon applied for a lease of 'South Molle Island' and was granted a five-year pastoral lease from 1 July 1883. However, on receiving his lease, Gordon was

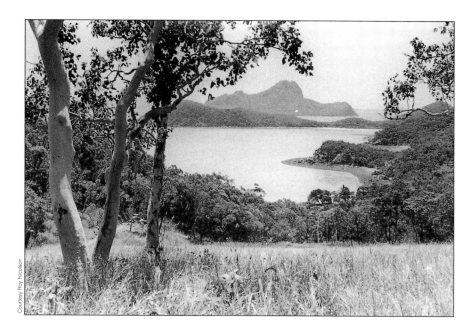

horrified to find it was over the wrong island! In a frantic exchange of correspondence with the Lands Department, it emerged that, in Gordon's mind at the time of his application, 'South Molle Island' was not today's island of that name but Long Island. In a time when island names were still emerging on admiralty charts, this misunderstanding is not unreasonable. Long Island, after all, embraces the southern part of Port Molle and could well have been regarded as 'South Molle Island', particularly as the island now known locally as South Molle Island was then, and still is, officially Molle Island. Indeed, in a testy telegram to the Department, Gordon asserted 'Long Island and South Molle Island are one and the same'. Eventually the mistake was straightened out and Gordon was granted a lease over Long Island from 1 July 1884, but in the 'first settler stakes' someone had beaten him to the line.

In any event, Gordon then seemed to lose interest in his island in the sun, and the lease was forfeited in 1886. It seems he never did occupy Long Island.

The other contender for the first settler honour was James Robertson Chisholm, an identity of those years from the Charters Towers–Hughenden district and finally the owner of the grazing property 'Stanley' on the Charters Towers Road about 20 kilometres from Townsville. He is best known for his writings in the *North Queensland Register* early in this

The grasslands of some of the Cumberland islands lured early graziers, along with dreams of an idyllic island life. Lindeman Island was one island so endowed; it attracted the attention of Henry Blake in 1886.

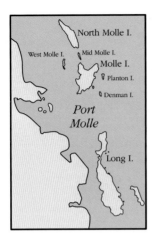

Port Molle was named in 1815 by Lieutenant Charles Jeffreys and thereafter it became a popular watering-hole for vessels making their way up the coast inside the Barrier Reef. The Molle islands weren't given individual names until the survey by HMS *Alert* in 1881. None was ever officially named 'South Molle Island', although Molle Island is popularly referred to as such.

century under the pen name 'Along the Line'; these were his stories about the people who lived and worked along the railway line between Townsville and Charters Towers and beyond.

While Gordon and the Lands Department were arguing over Long and South Molle islands, Chisholm applied for a lease over Cid Island, which was granted from 1 November 1883. Thus he can claim the honour. It is evident Chisholm placed sheep on Cid Island but did not occupy the island himself. He was joined in the lease by a George Proudfoot, and it may be the latter occupied the island as a resident manager. In any event the venture failed and the lease was not renewed.

Another would-be pioneer of that era was Herbert Henry Blake who, in 1886, applied for an occupation licence over Lindeman Island. Although a licence was approved, Blake proceeded no further. Little is known of this man, except indications are he may have been an uncle to Egbert Mabille (Jim) Blake, who became an identity on Rabbit and Outer Newry islands from the years immediately following World War I until 1941.

This initial flurry of pioneering interest by Gordon, Chisholm, Proudfoot and Blake seemed to dampen enthusiasm among others, and it was not until the mid-1890s that interest was kindled afresh, when Hugh Percival Kean obtained occupation licences over Long, Hamilton and the Molle islands. Kean was primarily a mining man with a lifelong but chequered career in that field during the golden days of Charters Towers's history, developing deposits of ironstone at Iron Island in the Duke Group and early discovering iron ore deposits at Yampi Sound in the west. Thus his interest in the islands was a little out of character, and though he placed sheep on his islands, his venture also was doomed to failure. After several years he disappeared from the scene to resume his mining interests.

To this point, then, the islands had 'seen them come and go', but an element of stability emerged in 1897, which saw the beginning of a more or less continual occupation of a hard-core group of islands for sheep-grazing. Today it is mainly those islands that are still occupied, though the sheep have been replaced by tourists.

Over the years, from 1897 until the State Government, in the mid-1930s, commenced a policy of declaring most of the islands national parks, there was barely an island that did not have tenure of one kind or another over it. For the most part these were held by dreamers, many of whom had been se-

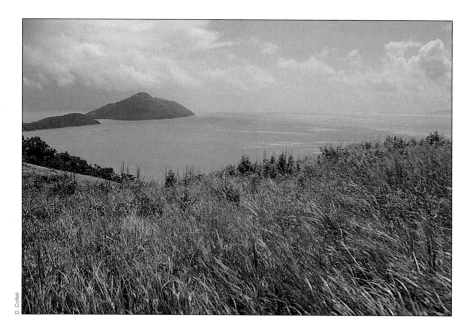

duced by E.J. Banfield's writings early in this century about his experiences on Dunk Island, and they aspired after the same apparently idyllic tropical life. Needless to say, most fell by the wayside, leaving successful occupation to a few hardy souls on some of the larger islands.

Meanwhile Hayman, Daydream, Dent and Long islands, which were later to become so important in the tourist industry, were mere adjuncts to the scene, with spasmodic attempts at settlement and some minor grazing ventures.

The island today known as South Molle has an abundance of natural attributes that brought it to the early attention of intending graziers and settlers, including its relative proximity to the mainland, its grasslands, sheltered anchorage and magnificent vistas.

The tourist resorts

The grazing ventures on the various islands were never successes, particularly as distance and transport costs added a burden, and for the most part the graziers lived a very modest life.

Towards the end of the 1920s a new wave of development began. Those were the days of a thriving coastal passenger trade, and it was a practice of many vessels to give their passengers a day ashore on a tropical island in the Whitsundays, and those islands with a settlement became a focal point. From this arose a realisation on the part of the settlers that here was a way of improving their lot and, increasingly, they began to cater for tourists.

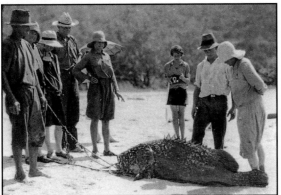

Very early tourists on Lindeman Island, December 1928, part of Monty Embury's first 'scientific expedition' to the Whitsundays. They camped in tents on the beach. Lach Nicolson (second from the right in the front row above) was later to take a guiding hand in managing the Lindeman Island resort, eventually taking over that role from his father, Angus. These early adventure holidays provided simple accommodation in natural surroundings, and the participants went home with unforgettable memories.

House guests at Lindeman Island resort, in earlier days

The Nicolsons of Lindeman

Angus Nicolson took up residence on Lindeman Island in late 1923, to be followed by his wife, Elizabeth, and their young family in late 1925. They were among the first to see the potential when, in 1929, in conjunction with a syndicate of Mackay businessmen led by the mayor of Mackay, Ian Wood, they began erecting cabins and facilities for tourists and encouraging longer stays. Air transport to an island was introduced for the first time, and it may rightly be said the Nicolsons were pioneers in the island tourist trade. Though the syndicate dropped out of the picture after several years, they pushed on with development, their family association with the island extending from 1923 to 1979, when Lachlan and Thora Nicolson and family departed the business scene, though Thora still resides on the island today.

Henry Lamond and the Molle Group

It was in 1927 that Henry G. Lamond took over the Molle Group and, while he would turn in his grave at the implication that he fostered the tourist trade in its infant days, his writings in popular magazines did much to bring the Whitsundays to the fore. Lamond did not directly cater for tourists by developing a resort, but South Molle Island, where he resided, was a popular day-stopover for passing ships.

Courtesy R. Nicolson

Angus Nicolson, pioneer of island tourism in the Whitsundays

European discovery 149

The original house on Grassy Island, which was constructed using bush poles and thatched grass, with white-wash bags for sides.

Daydream, Long and Grassy islands

Lee (Paddy) Murray and his wife, Connie, set up on West Molle Island which they named Day Dream Island (later known as Daydream Island) after their yacht of the same name. Walter Tronson transported his house from the Pomona area and commenced the resort at Happy Bay, Long Island. Bill Grant, a former bicycle and motor salesman, opened up at Palm Bay on the same island, and Boyd Lee did the same at Grassy Island.

One of the more innovative ventures was that of New South Wales schoolteacher, Monty Embury, who introduced the idea of 'scientific expeditions' during school holidays. Twice a year he gathered together groups of people with an interest in the flora and fauna of tropical waters; the expeditions were headed up by leading lights in the field of the natural sciences, who gave their audiences a 'hands-on' view of marine creatures. The first expedition was at Lindeman Island at Christmas 1928, but in the following years Embury set up a permanent base at Hayman Island, the forerunner of today's tourist resort there. Embury passed from the scene in 1935 when the Hallam brothers, Bert and Bob, took over Hayman Island and continued the tourist resort.

In 1937 Henry Lamond left South Molle Island, and Ernie (Pop) Bauer, his wife, Anna, and their family took over. During the following thirty-four years they built up one of the best known resorts in the region.

In those formative years a feature of resort development was the family company and, though there were the inevitable family arguments, it was this type of company that endured best in what was not always a bed of hibiscus. The Nicolsons did it for fifty-five years, the Bauers thirty-four years, the Mountneys of Happy Bay, thirty-five years, the Brooks at Palm Bay, twenty-two years, the Wallaces at Coral Art on Dent Island, forty years. Though the resorts tended towards the low-key, they were for their time an unforgettable experience for their guests.

Eventually the giants of the tourist industry saw the potential of the area and moved in to stake a claim. The 1947 takeovers, by Ansett, of Hayman and Daydream islands were not as successful as hoped, but nevertheless, at present, most of the resorts are in the hands of large companies that have brought to the tourist industry the standard of accommodation and service demanded locally and internationally if tourism is to succeed (according to contemporary thinking on tourism). With these takeovers ended the era of the family business that had dominated the tourist scene for so many years. While few would wish for a return to those days, those who experienced them would still carry with them some indefinable impressions perhaps lost for ever – citronella, sand between the toes, simple pleasures and, perhaps most of all, the Robinson Crusoe element.

Courtesy R. Nicolson

Monty Embury, school teacher and pioneer of eco-tourism, took his first adventure group to Lindeman Island in December 1928, a memorable holiday that included a taste of some fresh local seafood – a fine specimen of a Spanish mackerel.

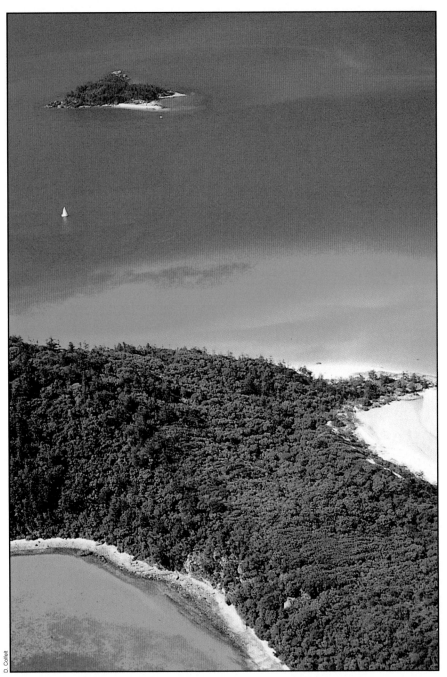

Tongue Point, Whitsunday Island (foreground), Esk Island (background)

Island highlights

This section gives brief descriptions of some of the Cumberland Islands between Gloucester Island and Brampton Island, the principal objective being to list those that offer the most opportunities for recreation. In some cases, islands have been included because they have a particular point of historical or other interest. The islands that have tourist resorts, and some of the larger islands that offer many opportunities for enjoyment, have been given greater attention. The information about each island is in three parts:

Location and access: gives the latitude and longitude, the distance (in nautical miles as the crow flies) and direction from the nearest principal mainland port, and the most ready means of getting to the island. In many cases this is by private vessel. Nautical miles rather than kilometres are used for distances over water because the nautical mile is the traditional unit of measurement at sea, it is fundamental to marine navigation, and it is the unit of measure used on all nautical charts and by all skippers of vessels plying the high seas or coastal waters. A nautical mile is equal to 1.85 kilometres, or 1.15 statute miles.

Description, historical notes: provides a brief description of the size, topography and vegetation of the island, notes about the origin of its name and, in the case of islands that have been inhabited or leased, a thumbnail history. Since most of the islands are national parks and are public property, only when an island is *not* a national park is any mention made of park status. Some islands have several different types of leases – for example, a resort lease surrounded by national park – and in these cases visitors who enter onto private leaseholds obviously need to have some sensitivity to the rights of the lease owner, but they are certainly not precluded from enjoying the part of the island that is national park. Resort leases stipulate that the public may not be denied access to the national parks.

Points of interest: outlines highlights of the island – details of island resorts (where appropriate), walking tracks, diving and snorkelling opportunities, camping opportunities and facilities (if any), anchorages, and other points about wildlife or vegetation that may be of note.

Akhurst (Arkhurst) Island

Location and access: 20° 04'S, 148° 52'E, 0.3 nautical miles west of Hayman Island (connected to it by a reef), 15 nautical miles from Shute Harbour. Access is by private vessel.

Description, historical notes: Akhurst is a tiny (8 hectares), rocky islet, 50 metres in elevation, capped with hoop pines. It was named in 1866 by Commander G.S. Nares, RN of HMS *Salamander* after a member of *Salamander*'s crew, William Akhurst, who was the Acting Boatswain 3rd Class. Through a transcription error the name became 'Arkhurst' on modern charts.

Points of interest: Akhurst is chiefly of interest to birds and is one of the Whitsundays' many rocky islets that provide roosting and nesting sites.

Armit Island(s)

Location and access: 20° 06'S, 148° 39'E, 10 nautical miles north-north-west of Airlie Beach. Access is by private vessel.

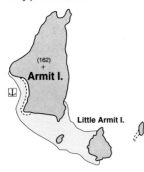

(162)
+
Armit I.

Little Armit I.

Description, historical notes: Armit is actually a group of three islands connected by a reef, with a solitary rock to the east. The main island is 40 hectares in area with maximum elevation of 162 metres, an attractive island with closed rainforest on the western side and vine forest on the east which is of sig-

nificance because it is a dry type related to mainland scrubs that are being cleared and are disappearing. The group was named in 1866 by Commander G.S. Nares of HMS *Salamander* after Sublieutenant Robert M. Armit, RN, one of his crew. In the late 19th century Armit was alleged to be inhabited by a ghost, an ancient mariner who, from time to time, appeared and disappeared. Boyd Lee held the lease in the early 1930s but did nothing with it.

Points of interest: The island is a nesting site for Torresian imperial pigeons (see page 65), and the rock to the east a roosting site for raptors, particularly the peregrine falcon. To avoid disturbing the birds, do not approach closer than 150 metres during the nesting season (October–March). **Anchorage** is available off the western beach.

Black Island

Location and access: 20° 05'S, 148° 54'E, about 15 nautical miles north-north-east of Shute Harbour. Access is from Shute Harbour or Abell Point marina on day-cruise vessels, or by private vessel.

Description, historical notes: Black is a small, wooded island (2 hectares, elevation 23 metres), just west of Hook Island and immediately south of Hayman Island. It sits on a coral reef that extends for some distance to its north and south.

Points of interest: The island is a destination for commercial day-charter boats from the mainland, and for guests at Hayman Island where, since the 1950s, it has been called 'Bali Hai'. Bali Hai was the name of James Michener's island in *Tales of the South Pacific*, one that has since been much used by those conjuring up images of the south seas and which enjoys the same status on the 'tropical' scene as the coconut palm or Gaugin's nut-brown maidens with red flowers in their long black hair. However, there are no coconut palms or black-haired maidens on Black Island, but there are beach

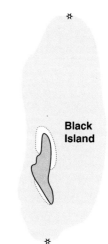

Black Island

thick-knees (*Burhinus mangirostris* – see page 64) and oystercatchers (*Haemotopis longirostris* and *H. fuliginosus*) – see page 63). **Anchorage** is available on the western side. A **coral-viewing** submarine sometimes operates around the Black Island reef.

Border Island

Location and access: 20° 10'S, 149° 02'E, 2.5 nautical miles east of Whitsunday Island, about 12 nautical miles east-north-east of Shute Harbour. Access is by private vessel.

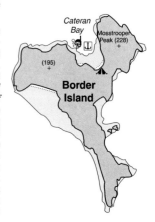

Cateran
Bay
Mosstrooper
Peak (228)
+

(195)
+

Border Island

Description, historical notes:
Border is a somewhat Y-shaped, rocky island (about 389 hectares), deeply embayed on its northern side by Cateran Bay and with plunging cliffs along its east side. Mosstrooper Peak, its highest point, rises 228 metres. Border is largely covered in eucalypt forest and woodland with emergent hoop pines, and *Xanthorrhoea* grasslands on the eastern saddle. The island was named in 1879 by Staff Commander E.P. Bedwell, RN, of SS *Llewellyn*, one of many that he dubbed with names from the old English county of Cumberland. At that time the island was the most northerly of the unnamed islands of the Cumberland Group, so Bedwell thought it appropriate that it carry the name Border as applying then and now to those counties on either side of the border between England and Scotland. Cateran Bay and Mosstrooper Peak also relate to the earlier history, they being names given to bands of irregular troops which roamed the English–Scottish border during the troubled days of the 16th and 17th centuries (see also the entry for Deloraine Island). The island is not very hospitable, one of the more remote; it nevertheless has seen attempts at settlement. In 1930 an occupation licence was granted to Edmund Spry, of Lord Howe Island, though nothing came of this. In 1931, under a scheme to place people suffering unemployment because of the depression, J.C. Tripcony, of the well-known boatbuilding family of Breakfast Creek, Brisbane, was given an informal lease, but, again, nothing came of it.

Points of interest: The fringing reef in Cateran Bay is well developed and provides good **snorkelling and scuba diving** when conditions are suitable. A pleasant sand beach at the head of the bay is a **bush-camping** site for small numbers (with no facilities). Cateran Bay provides **anchorage** for yachts, although it can be blustery and rolly. Yachts must anchor seawards of white pyramid-shaped buoys that delineate the edge of the fringing reef.

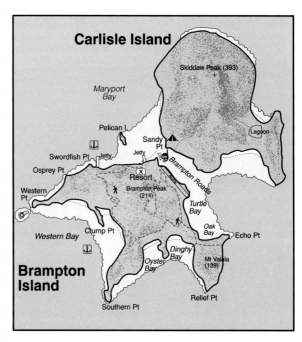

Carlisle Island

Skiddaw Peak (393)

Maryport Bay

Pelican I.

Sandy Pt

Swordfish Pt

Osprey Pt

Western Pt

Western Bay

Clump Pt

Resort

Brampton Peak (214)

Turtle Bay

Oak Bay

Echo Pt

Dinghy Bay

Oyster Bay

Mt Vakala (199)

Brampton Island

Relief Pt

Southern Pt

Brampton, Carlisle islands

Location and access: 20° 48'S, 149° 17'E, 19 nautical miles north of Mackay, 41 nautical miles southeast of Shute Harbour. Access is by commercial air from Mackay, by Roylen Cruises catamaran from Mackay Outer Harbour, or by private vessel.

Description, historical notes:
Brampton and Carlisle are joined together by a reef and narrow sandy channel, and it is possible, at most low tides, to walk between the islands. Brampton is large (709 hectares), hilly (highest elevation 234 metres) and covered in open eucalypt forest with areas of dense lantana and hoop pines on rocky outcrops. Carlisle has an even higher peak, the towering Skiddaw Peak (393 metres), and its vegetation is primarily eucalypt forest with some areas of rainforest, melaleuca swamp and mangroves.

This complex of islands was first noted by Lieutenant Matthew Flinders, RN of HMS *Investigator*, in 1802, when he gave it the alphanumeric designation L1, Scawfell Island being his L Island. With Flinders, on that occasion, was Lieutenant John Murray, RN in HMS *Lady Nelson* and, as noted elsewhere, Murray was some days later to give the first written description of the complex.

In 1860 G.E. Dalrymple, Commissioner of Crown Lands for Kennedy, landed on the main beach on Brampton Island, in the course of a voyage in HMS *Spitfire* to the Burdekin River and Port Denison, and saw about fourteen Aborigines with four canoes drawn up on the beach. He gave a detailed description of the construction of the canoes.

The present island names were given in 1879 by Staff Commander E.P. Bedwell, RN, of SS *Llewellyn*, in the course of his allocation to the area of about thirty names from the old English county of Cumberland,

Brampton and Carlisle both being places in Cumberland.

Settlement of the complex, mainly on Brampton Island, commenced in 1916 when the Busuttin family of St Bees Island obtained a lease and commenced raising stock – chinchilla rabbits, Waler horses for the army, and sheep. In the early 1930s this venture was to become a tourist resort under Arthur and Jess Busuttin, then passed through various hands – Carapark Hotels, Motels of Australia, Tom McLean of Roylen Cruises – before being taken over in 1985 by Trans Australia Airlines via their subsidiary Australian Resorts Pty Ltd which now is owned by Qantas.

Carlisle Island has remained comparatively untouched over the years, but its claim to fame is the wreck, at its north-west corner, of the SS *Geelong*, in 1888, with the loss of two lives. The remains of the vessel are still visible to divers (all shipwrecks in Queensland are protected by the Shipwrecks Act and may not be 'souvenired').

Points of interest: The **resort** on Brampton Island has 108 rooms, a freshwater swimming pool, saltwater swimming pool on the beach, café, main dining room with *à la carte* section, games room, main bar and entertainment lounge, boutique, six-hole golf course, three lighted tennis courts, and an archery range. Water sports of all descriptions are conducted from the all-tide sand beach in front of the resort.

Anchorage is possible at several bays around the island, including off the main jetty for yachts wishing to visit the resort. There are many sandy beaches in secluded coves around the island. A **snorkel trail** is located off the eastern side of the main resort beach in the channel between the islands. Trips to the Great Barrier Reef (Credlin Reef) are available several days a week on a fast catamaran from Mackay and by aeroplane. Brampton is a national park, with a system of graded walking tracks that is regarded by many as the most scenic track system in

the Cumberland Group, with many spectacular views particularly over the southern bays of the island. The **walk to Brampton Peak** starts at the end of the golf course and offers excellent views over the resort. It is possible to virtually do a **circuit of the island**, with side tracks to Turtle Bay, Oak Bay (so named because it is fringed with she-oaks, Echo Point, Dinghy Bay (the beach is accessible only by dinghy), and on around the island back to the resort.

Carlisle Island has a national park **campsite** on the western beach directly across from the resort. Transport can be arranged through the resort. The campsite has toilets, tables and cooking facilities. Other campsites (without facilities) are located a little further north towards Maryport Bay.

Cid Island

Location and access: 20° 16'S, 148° 55'E, at the entrance to Cid Harbour, Whitsunday Island, 7 nautical miles east-north-east of Shute Harbour (see Whitsunday Island for illustration). Access is by private vessel.

Description, historical notes: Cid is a ragged and cliffy island, steep and wooded with two prominent hills, Babieca Summit and Bolton Hill, that rise to 204 metres. It is right next to Whitsunday Island, which makes it appear small even though it is a quite respectable 388 hectares. It was named in 1866 by Commander Nares of HMS *Salamander*, the reason unknown. Nares had a habit of naming islands after members of his crew, which wasn't the case with Cid. Why he should have named it after the legendary El Cid of Spanish history defies imagination, although the fact that he chose that name fired the imagination of a Royal Australian Navy survey party sixty-six years later, in 1932, who named 'Babieca Summit' after El Cid's horse. The island was one of the first to be occupied for other than timber-getting, a lease having been granted in 1883 to J.R. Chisholm of Charters Towers, who

made a brief and unsuccessful attempt to raise sheep, perhaps in days when the island carried much more open grassland than today. From the early 1900s there was a string of tenures with settlers residing mainly on the western side, where there is an attractive beach and bay today called Homestead Bay. A reasonably substantial dwelling and wells existed there.

Points of interest: Anchorage is available in Homestead Bay on the western side, and the beach there makes a good picnic spot. Cid is a good island to explore. It's quite big enough, and it has a wide diversity of vegetation, for example, the large melaleuca swamp on the north-west corner. There are excellent views of the Whitsunday Passage to be had from the high ground, but it's not so large an island that one can get lost, or not for very long, anyway.

Daydream Island

Location and access: 20° 15'S, 148° 49'E, 2.6 nautical miles north-east of Shute Harbour. Easiest access is by the water taxi from Shute Harbour or Hamilton Island, or by private vessel.

Description, historical notes: Daydream is a long, narrow island (about 1 kilometre long and 300 metres wide) that has resort development on its northern and southern ends, with a vine forest and hoop pine covered hill in the middle. Daydream used to be known as West Molle Island and was, since the earliest times of island settlement, included in the lease for the Molle Group, along with North Molle, Mid Molle, South Molle, Planton and Denman islands. It had no natural water and was merely a somewhat useless appendage to the main holding.

In 1930 Major Lee (Paddy) Murray and his wife, Connie, arrived from Sydney in their 15-metre yacht *Day Dream* looking for an island paradise on which to start a resort. They subleased from the then holder of the main Molle Group lease, Henry

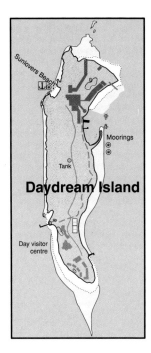

Daydream Island

World War II called Eric Catherwood away. He died in New Guinea, and the resort passed to pioneer Qantas pilot Skip Moody, but lack of tourists during the war forced closure until 1946.

In 1948 Ansett Transport Industries moved into the scene via their subsidiary, Barrier Reef Islands Pty Ltd, buying the leases to both Hayman and Daydream, but Daydream proved a failure and was closed in 1953. All the buildings and equipment were removed, and the island lay desolate until the early 1960s, when a local syndicate made an abortive attempt to revive it as a caravan park, with caravans to be transported by barge.

Daydream was resurrected when Gold Coast entrepreneur Bernard Elsey rebuilt the resort in 1967 –1968, only to have it destroyed in cyclone Ada in January 1970. Elsey, however, rebuilt again, and over the following years the venture had a chequered career until, in 1981, Jim Kennedy, who previously had owned South Molle Island and the Tangalooma Resort, breathed new life into it.

Facilities at the resort until this time were relatively modest. In 1988 a new concept emerged when Western Australian businessman Peter Laurance and his Pivot Group bought the lease and, in conjunction with Jennings Industries Ltd, began a major redevelopment, building facilities of international standard on the previously untouched northern end of the island. Pivot later sold out its interest to Jennings, and to-day the resort is managed for Jennings by Southern Pacific Hotel Corporation, under the Travelodge name.

From its very earliest days Daydream was plagued by the lack of natural water, and as its facilities expanded, water had to be barged in, at first from North Molle Island and later from Shute Harbour, but in 1990 the problem was solved for all time, when a pipeline was laid to the island from the mains at Shutehaven.

Lamond, who lived on South Molle Island, and commenced building some small corrugated iron units on Daydream. They called the island Day Dream, after their yacht, though this later was to become Daydream by default. In official records it remained West Molle until 1988 when the name was officially changed to Daydream.

In the early days the resort relied on visits from passenger vessels servicing the Queensland coast. These would drop off visitors on the way north for a short stay and would pick them up on the return trip, or they would simply deposit their entire complement of passengers for a day on a tropical island. *Day Dream* ferried passengers between ship and shore. The Murrays stayed only a couple of years, handing over to Eric Catherwood and his wife, Nell, who formally bought a separate lease from Lamond in 1934 and continued developing the resort. *Day Dream* passed to the Catherwoods in the deal.

Points of interest: The **Daydream Island Travelodge Resort** occupies the northern part of the island and the old resort, now a day-visitor area, covers most of the southern end. The new resort has 301 modern rooms. Because of the tiny size of the island, views from many of the rooms are like those one would get on an ocean liner; ships coming up the Whitsunday Passage virtually steam right past the window. The northern end of the island has its own pool and pool bar, spa, gym, shop and two restaurants and is for resort guests only. A boardwalk on the eastern side of the island connects the resort to the day-visitor facility, where there is another swimming pool, pool bar, tavern, souvenir shop, boutique, restaurant, coffee shop and bakery. There are two lighted tennis courts (for guests only) and a basketball court. Daydream's all-tide coral shingle beach on the south-western side is the centre for water sports, snorkelling and glass-bottom boat trips. A diving instructor conducts both introductory resort courses and certificate courses for scuba divers. **Moorings** are available for visiting yachts just south of the breakwater and small marina on the eastern side. Sunlovers Beach, a crescent of coral sand enclosed by steep hills and hoop pines, is nestled into the north-western corner, and it provides an escape to what is, for all intents, a desert isle beach but is only a five-minute walk from the bustling resort. Sunlovers Beach is also visited by the occasional day-cruise boat and itinerant yacht (visiting yachts should anchor outside of the moorings). The bay has several coral outcrops and bommies for **snorkelling**. A high-speed catamaran calls by the resort marina to pick up passengers for a trip to the Great Barrier Reef.

Deloraine Island

Location and access: 20° 10'S, 149° 04'E, 1.5 nautical miles east of Border Island and about 18 nautical miles east-north-east of Shute Harbour. Access is by private

vessel (it's a difficult place to anchor).

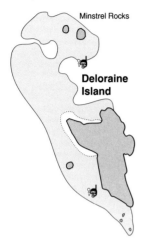

Minstrel Rocks

Deloraine Island

Description, historical notes: Deloraine is a small (14 hectares total area, maximum height 35 metres), remote, heath-covered island on the north-eastern fringe of the Whitsundays. It is cliff-faced and has deep water right against its eastern side, with a reef connecting it to Minstrel Rocks less than 0.5 nautical miles north; a further mile north is Jester Rock, a 'keel-breaker' lying just beneath the surface. This combination of geography makes the area around Deloraine excellent mackerel fishing territory. The island's name is another given by Staff Commander E.P. Bedwell, RN, in 1879, drawing on the romantic side of the troubles between England and Scotland in the 16th and 17th centuries (see Border Island). William of Deloraine, or Deloraine as he more commonly was known, was 'A stark moss-trooping Scot ... as e'er couched Border lance by knee', a semi-legendary figure of Sir Walter Scott's poem *The Lay of the Last Minstrel* which relates Deloraine's exploits in Border during those troubled times.

Points of interest: A lovely, remote island with excellent reef for **diving** but a very poor anchorage (weather conditions must be ideal, and even

then it is difficult because the bottom drops off precipitously and it's easy to get an anchor snagged on coral). **Game fishing** takes place in surrounding waters.

Denman Island

Location and access: 20° 17'S, 148° 51'E, 0.5 nautical miles off the south-east side of South Molle Island, 3.5 nautical miles from Shute Harbour (see South Molle Island for illustration). Access is by private vessel.

Denman, only 33 hectares, is covered with hoop pine. It has a sandy beach on its north-west corner.

Points of interest: Camping, Robinson Crusoe style, is available for a very small number, with no facilities. Just north-west of the beach is an **anchorage** that provides surprisingly good protection from the south-east, but as this is a current-swept area, it's not a particularly good overnight anchorage.

Dent Island

Location and access: 20° 21'S, 148° 56'E, immediately west of Hamilton Island, 8.5 nautical miles east-south-east of Shute Harbour. Access is by day-cruise boat from Hamilton Island, or by private vessel.

Description, historical notes: Dent is a sizeable (425 hectares), mountainous island, one of a handful in the Whitsundays that is not a national park, with several special private leases and a lighthouse reserve. It is largely covered by grassland.

It was named in 1866 by Commander G.S. Nares, RN of HMS *Salamander* after Lieutenant Albert Dent, RN. Early charts showed Dent Island as one with Hamilton Island under the name Passage Island, but Nares' surveys separated the islands and gave them their names.

In 1879 a lighthouse and ancillary residences and buildings were built on the western side of the island to guide ships through the Whitsunday

Passage, and because of this, Aborigines of the area tended to gravitate to the island, about forty men women and children being camped there in 1881. For the keepers, life was isolated and hard, this attested to by the tiny graves of two children of those early days adjacent to the light.

With its extensive grasslands, Dent attracted graziers, and from 1905 leases were granted to a series of holders – Michael Ahern, William Galbraith, E.S. Abell. Nothing really was done with the island until in 1933, when John James O'Hara of Proserpine took it over and placed cattle on it, his family's tenure to last until 1968. They built two successive mustering/holiday huts behind the beaches on the north-west of the island, and in 1939 John

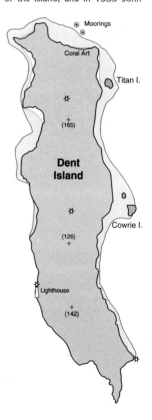

Moorings

Coral Art

Titan I.

(165)

Dent Island

Cowrie I.

(126)

Lighthouse

(142)

O'Hara and his wife retired to the island and built a house on the northern side where today's Coral Art stands.

On John O'Hara's death in 1943 management passed to his sons, and at times caretakers occupied the house until, in 1961, Bill and Leen Wallace acquired a lease over a small area around the house which they bought from the O'Haras for their residence. They began to develop their Coral Art business, which they still conduct today. In 1961 also, the southern half of the island was excised from the grazing lease, formalising what had long been an ill-defined Commonwealth Lighthouse Reserve over that area.

Meanwhile the grazing lease passed from hand to hand after the O'Hara tenure ended in 1968 – R.W. Vigar, Sebastian Properties, Peter Faust and, eventually in 1988, Keith Williams, whose idea was to develop a health resort and golf course as an adjunct to his Hamilton Island resort. He later acquired also the southern area when the Government decided to relinquish its reserve there. However, when the Hamilton Island resort went into receivership, plans for Dent Island were suspended.

Points of interest: The Dent Island **lighthouse** and its associated buildings – sheds, workshop, houses – and other paraphernalia reeks of maritime history. **Coral Art**, owned and operated by Bill and Leen Wallace, occupies a unique building at the top of the northern beach, a construction they built themselves based on a Samoan fale, but with some interesting flourishes. The floor is made from thick, irregularly shaped slabs of glass that were originally brought out from England in sailing ships and used in the first buildings at Sydney University. Bill Wallace bought 300 sheets when those buildings were demolished. Coral Art sells all manner of shell jewellery and shells and is full of artifacts from throughout the Pacific. The Wallaces are fonts of local lore. Two **moorings** are available just off the fringing reef, the western one of which is available for use by private yachts.

Double Cone Island

Location and access: 20° 06'S, 148° 43'E, 9.5 nautical miles north of Airlie Beach. Access is by private vessel.

Description, historical notes: Double Cone is in two halves connected by a reef, together 41 hectares in area, the eastern summit 108 metres high, the western 59 metres high. From the mainland the island sits on the horizon like two blue volcanic cones. The vegetation is dense and low. The island was named by Commander Nares of HMS *Salamander* in 1866, he either having run out of crew member names for islands, or perhaps having among his crew the original cone-head.

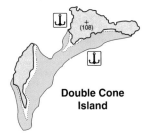

Double Cone Island

Points of interest: The island is a particularly significant nesting site for the Torresian imperial pigeon (*Ducula spilorrhoa*), of which there are about 2500 pairs. The Torres Strait pigeon, as it is also called, is a species that has been so heavily hunted on the mainland that it is facing extinction. Other bird species nesting on Double Cone are the beach thick-knee (*Burhinus mangirostris*), the white-bellied sea eagle (*Haliaeetus leucogaster*), and the osprey (*Pandion haliaetus*). (See pages 61 to 65 for more information about these bird species.) To protect the Torres Strait pigeons the island is closed (out of bounds) from October through March. Temporary daytime **anchorage** is available in suitable weather on the western or southern side of the eastern island, except when the island is closed.

Edward Island

Location and access: 10° 15'S, 149° 10'E, 22 nautical miles east of Shute Harbour. Access is by private vessel.

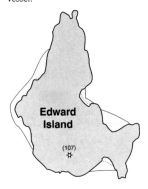

Buddibuddi I.

Description, historical notes: Edward is the easternmost of the northern Whitsundays, a cliffy island with steep gullies, 65 hectares in area, 106 metres high. It was named in 1879 by Staff Commander E.P. Bedwell, RN of SS *Llewellyn*, though the reason is not known. This is one of a group of islands that was the 'string of rocky islets' within which Lieutenant P.P. King, RN sailed in HMS *Mermaid* in 1820 as he passed to the east of Haslewood Island. In 1967 a navigational light was placed on Edward Island as one of a string of new lights erected along the central Queensland coast to guide ships outside the Whitsunday Group, shortening their trip and avoiding the shallower water east of Silversmith Island, which presents a hazard to larger vessels using the Whitsunday Passage.

Points of interest: Off these rocky outlying islands is the favoured territory of game fishers. There is some good coral in very clear water for the intrepid diver.

Eshelby Island

Location and access: 20° 01'S, 148° 38'E, 15.5 nautical miles north-north-west of Airlie Beach. Access is by private vessel.

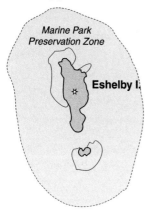

Marine Park Preservation Zone

Eshelby I.

Description, historical notes: Eshelby is a lighthouse reserve, a remote, small (14 hectares), rocky island with a light that stands 56 metres above sea level. Eshelby is a major sea bird rookery. The island was named in 1866 by Commander Nares, after Sublieutenant Alfred E. Eshelby, RN.

Points of interest: Perhaps 10 000 bridled terns nest on Eshelby, with smaller numbers of crested and lesser crested terns, black-naped terns, common noddies and wedge-tailed shearwaters. The island has a small pisonia forest. Because of its importance as a sea bird rookery, Eshelby is in a marine park Preservation Zone, which means that anyone approaching closer than 500 metres, if not pecked to death by the birds, will be pecked to death by the authorities.

Esk Island

Location and access: 20° 14'S, 149° 02'E, just under a nautical mile east of Tongue Point, Whitsunday Island, 15 nautical miles east-north-

east of Shute Harbour. Access is by private vessel.

Description, historical notes: Esk is a small (24 hectares) island, maximum elevation 34 metres, eroded by waves into small cliffs and sandy coves, with a deep saddle in the middle and forested with hoop pines. It was named by Staff Commander E.P. Bedwell, RN, along a theme of the turbulent history of Cumberland and Scotland (there is an Esk in both Cumberland and in Scotland).

Points of interest: Esk, up until the present, has been of interest to humans chiefly because it marks the beginning of French Shoal and the need to mind one's p's and q's navigationally when heading south towards Solway Passage or Whitehaven Beach. It is also undoubtedly interesting to sea birds and should be given a wide berth for this reason during the October–March nesting season.

Gloucester Island

Location and access: 20° 01'S, 148° 28'E, 11.5 nautical miles east of Bowen, 21 nautical miles north-west of Abell Point. Access is by private vessel.

Description, historical notes: Gloucester is a large (3970 hectares), high (577 metres), rugged, grey granite island in an area where most granite islands are pink. It is sparsely vegetated with open forests of eucalypt and wattle. James Cook named it Cape Gloucester in 1770 after the Duke of Gloucester, a brother of King George III, the reigning monarch. Philip King, RN, in HMS *Mermaid* in 1819, found out that it was really an island. Its ruggedness and lack of water have historically given it a relatively peaceful life, occasionally being used as an overnight anchorage for vessels passing along the inner route to Torres Strait in the old days when travelling at night was hazardous, or by fishing trawlers getting out of the weather.

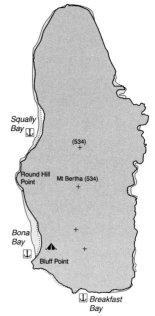

Squally Bay

(534)

Round Hill Point Mt Bertha (534)

Bona Bay

Bluff Point

Breakfast Bay

Points of interest: Surveys show that Gloucester has rich floral diversity with a number of species that are threatened on the mainland. The island is the only one where a colony of the endangered, elusive Proserpine rock-wallaby may be found. Gloucester has several **anchorages**, at Bona Bay on its south-western corner (often used by trawlers, with which one might negotiate to obtain a fresh fish), and at Breakfast Bay, on its southern side in the peaceful Gloucester Passage that separates the island from the mainland. Bona Bay is a national park **campsite**, on a lovely sand beach, with toilets and picnic tables.

Goldsmith Island

Location and access: 20° 41'S, 149° 09'E, 30 nautical miles south-south-east of Shute Harbour, 27 nautical miles north-east of Mackay. Access is by private vessel.

Description, historical notes: Goldsmith is a sizeable island (648 hectares) deeply embayed on its north and south with well-developed

fringing reefs that dry a long way out at low tide. The highest point is on the northern end (194 metres). Vegetation is a mixture of low open eucalypt woodland and grasslands. (See Sir James Smith Group for discussion of the origin of the name.)

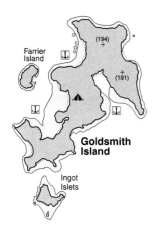

Goldsmith Island

Ingot Islets

Points of interest: Goldsmith has several **anchorages**, two on the north-western side and one on the south-east. A **campsite** with toilets and picnic table is located on a beach at the northern end of the bay that faces Farrier Island. The southern anchorage is exposed during the trade winds season but, in late spring and summer, is a beautiful spot in which to escape northerly winds, with a large fringing reef and very broad expanse of sand. Good reef fossicking.

Grassy Island

Location and access: 20° 09'S, 148° 37'E, 9 nautical miles northwest of Airlie Beach. Access is by private vessel.

Description, historical notes: Grassy is round and volcanic (area 105 hectares, maximum elevation 150 metres) with a wide bay and extensive fringing reef on the southern side. It was given its name by Commander Nares in 1866, possibly because he'd run out of crew

after which to name islands but, in any event, because it was grassy. Grasslands on Whitsunday islands are not an unusual feature, although they were more prevalent in years gone by, perhaps the result of burning by Aborigines which has since ceased, forests regaining the upper hand. In 1929 A.F.E. (Boyd) Lee and his wife and family assumed the island lease, building at first a large grass house and then a variety of outbuildings and basic accommodation for trippers from the mainland, who were transported from Cannonvale on the Lees' boat *Reliance*. The Lees farmed goats, kept cattle and planted bananas. Boyd was one of a well-known family from Cannon Valley, famed for their crocodile-catching ventures, and he thus earned the nickname 'Alligator'. Norman W. Caldwell, shark-catcher and author (e.g. *Titans of the Barrier Reef*), spent several years on the island from 1930 before moving to Hayman Island in 1938.

Points of interest: Anchorage is available off the sand beaches on the western side of the island. The bay on the southern side, enclosed by two coral and sand spits, is very popular with wading birds in summer. Beach thick-knees (*Burhinus*

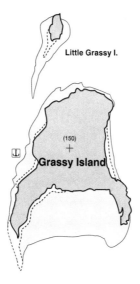

Little Grassy I.

(150)
+
Grassy Island

mangirostris – see page 64) nest within the high tide debris. Little Grassy Island, about 0.4 nautical miles north, is covered with closed forest and is a sea bird nesting site. Edwin Rock lies immediately north of that and is a popular roosting site for cormorants. Avoid disturbance of sea birds on these islands by not approaching closer than 150 metres during the nesting season (October–March).

Boyd Lee

Gumbrell Island

Location and access: 20° 06'S, 148° 34'E, 12 nautical miles northwest of Airlie Beach. Access is by private vessel.

Description, historical notes: Gumbrell is a rectangular island (105 hectares, 91 metres high) with two granite peaks and a sandy area at the south-east corner. It is densely vegetated with low scrub and, on the steep western slope, rainforest. It was named, along with most of these northern islands, by Commander Nares of HMS *Salamander* in 1866, after a member of the crew, Edward James Gumbrell, 2nd Captain of the Forecastle.

Points of interest: A remote island.

(a)

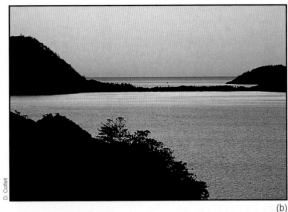

(b)

(a) Border Island (north-eastern saddle); (b) Neck Bay, Shaw Island (viewed from Lindeman Island); (c) the southern bay on Goldsmith Island looking south towards Brampton and Carlisle islands; (d) the Hayman resort swimming pool.

(c)

(d)

162 *The principal islands*

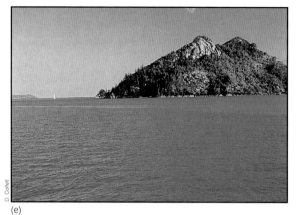

(e)

(f)

(e) Lindeman Island resort swimming pool; (f) Spion Kop, South Molle Island; (g) Catseye Bay, Hamilton Island and the Hamilton resort complex; (h) Nara Inlet, Hook Island.

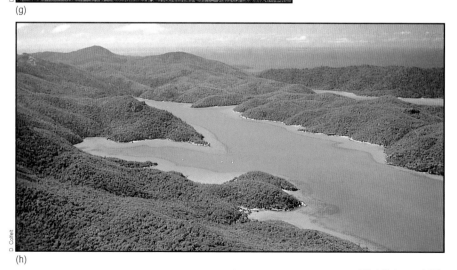

(g)

(h)

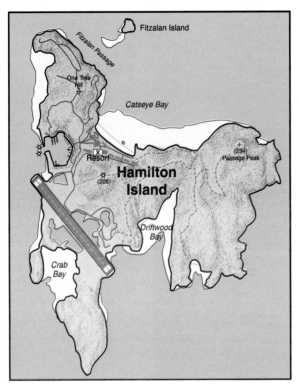

Fitzalan Island

Fitzalan Passage

One Tree Hill

Catseye Bay

Resort

(234)
Passage Peak

Hamilton Island
(205)

Driftwood Bay

Crab Bay

Hamilton Island

Location and access: 20° 21'S, 148° 58'E, just south of Whitsunday Island, 10 nautical miles east-south-east of Shute Harbour. Hamilton has a jet airport with direct flights from Sydney, Brisbane, Melbourne and Cairns. Access by sea is by the island catamaran ferry from Shute Harbour, or by cruise boats that depart from Mackay a few days a week, going to the island via Brampton and Lindeman islands, or by private vessel.

Description, historical notes: Hamilton is a large (709 hectares), hilly island, much of it covered in dense eucalypt forest. The western side used to have large areas of grasslands, much of which are now occupied by the resort. These were probably maintained by Aboriginal fires before the advent of Euro-

peans. The island has a 234-metre promontory on its eastern extremity, Passage Peak, which dominates the landscape. Hamilton has a number of deep bays around its perimeter, most of which are completely filled with fringing reef.

The origin of Hamilton's name is not certain but it was probably given by Commander G.S. Nares, RN of HMS *Salamander* in 1866 after a Hamilton on board the ship, but who Hamilton was is not known.

On earlier charts Hamilton was shown as a single island, called 'Passage Island', lumped together with today's Dent Island. This is where 'Passage Peak' came from. It was not until Nares' survey that the two islands were shown separately on admiralty charts.

Hamilton is one of the few islands never declared a national park. The abundance of grass attracted grazi-

ers from the 1890s, though they had only minor success. Percy Kean, J.A. Gorringe, T.A. Walmsley, H.C. Sterry, Frank Wylde Ball – all had tried their hands by the 1920s, Ball building the island's first substantial dwelling, on the saddle behind what now is Hamilton Harbour. In 1928 Dr John Macdonald of Ayr took over as an absentee landlord putting a series of caretakers on the island, with unimpressive results.

Macdonald retired to the island in 1947, but he died in 1950, and then the island passed to Skip Moody, who, in the 1940s, had owned the lease to Daydream Island. No doubt with memories of his time on Daydream, Moody began to build a small resort, but costs defeated him.

Thereafter another series of owners took over – A.B. Littler, R.W. Vigar (twice) and Sebastian Properties. In 1975 the most significant event in the island's history occurred, when Keith Williams of Gold Coast fame and Ford dealer Bryan Burt bought the grazing lease, initially with the idea of raising deer on the island. Burt, however, died shortly afterwards. Reindeer were raised for a time, but Keith Williams went on to build one of Australia's biggest and best-known tourist resorts, along with a man-made harbour and small town on the western side opposite the resort, a jet airport, a high-rise hotel and private condominiums, a number of privately owned villas, and a fifteen-storey tower of penthouses that can be readily seen from the mainland 18 kilometres away. The first phase of the resort was officially opened by the Premier of Queensland, Sir Joh Bjelke-Petersen on 18 December 1982, and another 'official opening' took place with a big party on 8 December 1984. Construction continued pace, and plans were announced for another luxury resort on the northern end of the island, and for the annexure of Dent Island (renamed by Williams, without official sanction, Hamilton West) and the building there of a golf course, condominiums, health resort and a man-made harbour. The financial

bubble burst in the late 1980s, financial problems overtook Williams and Hamilton finally went into receivership. It stands today, with high-rise buildings glowing in the sun, as a monument to individual drive and ability on the part of its founder. The island is now owned by Hamilton Island Enterprises, a public company, and the resort is managed by Holiday Inns.

Points of interest: Hamilton Island has a community of about 1200 who reside on the island (in addition to resort guests and other visitors). It has its own school, a full-time doctor and nurse, and it thus stands apart from the typical island and resort, having more services and activities than one finds in many a coastal town. The **Hamilton Holiday Inn Crown Plaza Resort,** a hotel served by many independent concessionaires as much as it is a resort, faces Catseye Bay where there is a wide sand beach and expanse of fringing coral reef that dries out at most low tides. It is dominated by a 350-room hotel, Hamilton Towers, and the adjacent multi-storey private condominiums (Whitsunday Towers East and West) all of which have spectacular views north-east towards Whitsunday Island. Other hotel accommodation is in two-storey blocks (Bougainvillea and Allamanda lodges, each with sixty rooms), and fifty-one buré-style individual units that are set amongst old paperbark trees on a grassy lawn behind the main resort pavilion. The central complex has a huge, meandering swimming pool with a thatch-roofed bar in the middle. A dolphin pool is located just outside the main dining room window. There is a beach bar and restaurant, a fine-dining restaurant called The Outrigger, an entertainment centre, beauty salon and several shops. A short distance from the high-rise hotel is a convention centre that caters for up to 1100. On the slope behind the main resort is the Health and Racquet Club, with gymnasium, two squash courts, and six lighted tennis courts. Electric buggies can be hired to drive around the island. The photo shop offers same-day photo processing. Visits to the Great Barrier Reef are available on a fast catamaran or by helicopter. The water sports centre on the beach has catamarans, surfskis, and sailboards for hire, and a number of water and beach activities take place there, including water skiing, parasailing and tandem parachuting. Snorkellers enjoy paddling around the fringing reef, where fish life is colourful and plentiful.

Across a narrow saddle on the western side of the island is **Hamilton Harbour,** dominated by the fifteen-storey Yachtharbour Towers that sits on the saddle between the resort and the harbour. The harbour has a 150-berth marina surrounded by a bustling village. Hamilton's harbour has become a marine centre in its own right, with a shipyard and all marine services – travellift, engineering, refrigeration, diesel and electrical maintenance. Marina berths and moorings are available for itinerants. There are showers and toilets for visitors. Other facilities include an arts and crafts gallery, four yacht charter companies, bakery, fish and chips shop, dive shop (which offers scuba courses ranging from introductory dives to full certificate courses), boutiques, a nightclub/disco, several restaurants, electric buggy hire, pub, grog shop, general store, and post office. A number of day-cruise boats operate from the marina, as do game-fishing charter boats.

Not far beyond the airport is a golf driving range where driving and chipping lessons are available. On the northern peninsula of the island is a native Australian fauna park, church, and a number of private villas which have spectacular views either along the south side of Whitsunday Island or out over the Passage.

The island has a number of **walks,** perhaps the most spectacular being the ascent to Passage Peak. This walk starts at the far end of the resort beach, following a dirt track along the shoreline until, near the eastern end of the island, a track veers to the right, winding up the hill and joining another track that comes across the centre of the island, then winds its way to the summit. It's not a long walk, but it is fairly steep at the end. Anyone in reasonable physical condition shouldn't find it too arduous, but take along a bottle of water. The views from Passage Peak are tremendous.

Haslewood Island

Location and access: 20° 17'S, 149° 05'E, just east of Whitsunday Island and separated from it by the sometimes turbulent Solway Passage, 16 nautical miles east of Shute Harbour. Access is by private vessel.

Description, historical notes: Haslewood is a large (777 hectares), wooded island with many patches of grassland and some sizeable areas of acacia forest. A very large fringing reef connects it to Lupton Island on its east. The north-east extremity of the island is a narrow peninsula connected to the main island by a low, narrow grassy neck separating Windy Bay on the north from Waite (White) Bay on the south.

The island was named in 1879 by Staff Commander E.P. Bedwell, RN of SS *Llewellyn* after Sublieutenant Frank Haslewood, RN. Waite Bay was probably also named after a member of the crew. Like some other *Llewellyn* names, it later got transferred to the charts incorrectly, as White Bay.

Because of its beautiful setting on Whitehaven Bay, Haslewood Island has long attracted the romantics who would have had an island life, and from 1901 a long series of leases were granted – Charlie Anderson and Mick Adlem, Fred Shardlow and John Rowan, Vern McCulkin and Fred Faithful, Boyd Lee, Albert Woller and Rupert Smith, A.J. Carden-Collins, S.E. Polglass, Dr John Macdonald. All had the idea of raising sheep but none was successful, the most persistent being Macdonald, who held the island from 1926 to 1940 but had to admit defeat. Today remnants of a small dwelling can be found at the northern end of Stockyard Beach, on the western side.

Because of the pure silica sand that carpets the whole of the Whitehaven area, in 1962 a mining lease was granted over much of the deposit to the Bowen Mineral Company, and this included part of Haslewood Island which was mooted as a stockpile site and ship-loading point. Fortunately, nothing came of the proposal.

Points of interest: On the western side is the white silica sand Stockyard Beach (which has recently also been referred to as Chalkie's Beach); it is the same lovely sand that is on Whitehaven Beach, on Whitsunday Island directly opposite, a legacy from earlier geological times and 'out of place' in the Whitsundays. This is a popular spot with yachts, and **anchorage** is available just off a break in the fringing reef. Anchorage is also available at Windy Bay on the north, and at Waite Bay on the south, the latter being suitable in late spring and summer months when the south-east trades have abated. The massive fringing reef at Waite Bay, which connects Haslewood Island and Lupton Island, has a high conservation value as it is probably responsible for seeding other fringing reef systems in the area. It provides plenty of diversion for **divers, snorkellers and reef fossickers** for, at low tide, a vast expanse of reef dries out, resembling a moonscape and leaving

countless shells, sea cucumbers, giant clams and crabs exposed, with fossicking fishes, soft corals and all other manner of intertidal reef life going about their business in reef pools. When the tide comes back in, a host of marine life comes in with it. This area is a Marine National Park 'B' Zone, where everything, including dead shells, is protected. Haslewood has some vegetation unique among the islands – a stand of peppermint gums (*Eucalyptus exserta*) found on the lower slopes of a valley behind Waite Bay. It is also probably the last island with a small remnant population of wild pigs.

Hayman Island

Location and access: 20° 03'S, 148° 58'E, about 16 nautical miles north-east of Airlie Beach and Shute

Harbour. Access is from Hamilton Island (18 nautical miles to the south) where the Hayman launch meets incoming flights, or by private vessel.

Description, historical notes: Hayman is a large (322 hectares), high (247 metres), pink granite island at the northern end of the Whitsunday Passage. It is dissected by numerous small gullies and embayments, with plunging cliffs on the east face. The vegetation today has been moulded by previous fire history and the presence of goats and is primarily open eucalypt woodland, with extensive areas of grassland and some hoop pine forest. On the south side of the island is a massive expanse of fringing coral reef. Tiny Akhurst (Arkhurst) Island is joined to Hayman on the west by a coral reef.

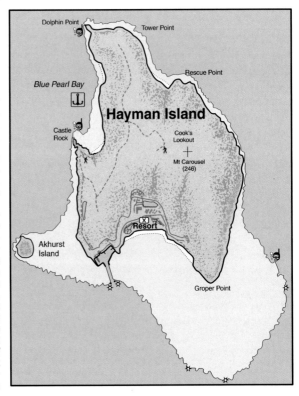

Hayman is one of a handful of Whitsunday islands to remain under private leasehold. The island was named by Commander Nares of HMS *Salamander* in 1866, after Thomas Hayman, Sailing Master. Since 1906 it has been held under various tenures, primarily by those hopeful of grazing sheep, but Boyd Lee (previously of Grassy Island) was the only one with any success in grazing, and that was with goats. In 1931 the Hayman lease was taken over by a New South Wales schoolteacher, Monty Embury, who developed it as a base for a series of scientific expeditions during school holidays. He sold the lease in 1935 to the Hallam brothers, Bert and Bob, who established a full-time resort. In 1936 there was much excitement when the author Zane Grey made the island his headquarters while making a film about sharks, *White Death*. Author Norman Caldwell lived there for a time in 1938 after leaving Grassy Island. Barrier Reef Resorts Pty Ltd, a subsidiary of Ansett Transport Industries, bought the lease in 1948 and Reginald Ansett set out to establish a major international resort, one quite apart from the folksy, family-style resorts that typified the Whitsundays at the time. Completion was speeded up to coincide with a planned visit to Australia (and to Hayman Island) by King George VI, Queen Elizabeth and Princess Margaret. The royal visit never eventuated due to illness on the part of the king, but by then the island had obtained a charter to call itself 'Royal Hayman', and from that time onwards it did so. Hayman became a magic name in Australian tourism and for years was top of the pile of Australian island getaways. The advent of the spanking new resort on Hamilton Island in 1984, and the senescence of Hayman's facilities, meant it was no longer really in company with the world's smartest establishments, which prompted the managing director of Ansett Transport Industries, Sir Peter Abeles, to close it up in 1985 and completely demolish it. The new Hayman re-

opened twenty months and some $300 million later, a magnificent, no-expenses-spared, five-star international resort that was subsequently elected to membership of the exclusive 'Leading Hotels of the World'.

Points of interest: Hayman's luxurious **resort** faces its southern beach and reef, with 203 rooms and eleven penthouses in East and West Wings linked by scenic walks and lavishly landscaped gardens. Each room is beautifully appointed, with private terrace or balcony and original art on the walls. The resort is filled with antiques and artifacts from around the world, and it has half a dozen international restaurants serviced by a huge kitchen and a bakery that creates fresh continental pastries and confectionery. There are six lighted tennis courts, a half tennis court, golf target range, eighteen-hole putting green, two squash courts, health club, three swimming pools, and a scuba-diving training centre. Water sports are conducted from the beach in front of the resort – catamarans, windsurfers, paddle skis – and there are outboard dinghies available to explore the surrounding islands. A **man-made harbour with floating marina** is located on the south-western corner of the island (visitors should seek permission to land before arrival). A game-fishing charter boat is stationed in the marina. Hayman has a purpose-built dive boat for excursions to the Barrier Reef. The resort operates two luxurious launches which meet guests arriving at Hamilton Island airport, taking them on a champagne cruise while check-in procedures are completed en route to the island.

Walking tracks climb the hills behind the resort to Blue Pearl Bay, to Dolphin Point and to Cook's Lookout, providing sweeping views. The walking tracks on Hayman are open to the public. They are accessible from Blue Pearl Bay.

Wild goats can still be seen roaming Hayman's rocky hillsides. Blue Pearl Bay, on the north-west side of the

island, offers **anchorage** for yachts and good **scuba diving and snorkelling** (at Castle Rock and Dolphin Point – see 'Diving and snorkelling', pages 105–6).

Henning Island

Location and access: 20° 19'S, 148° 56'E, just west of the entrance to Gulnare Inlet, Whitsunday Island, and 8 nautical miles east of Shute Harbour. Access is by private vessel or day-cruise boat from Hamilton Island.

Henning
Island

Geographers Beach

Description, historical notes: Henning is a narrow, wooded island, 40 hectares in area, largely covered with dense vine forest and hoop pines. It has extensive coral reefs on its east which extend some distance to the south-east. The island was named in 1866 by Commander G.S. Nares, RN of HMS *Salamander*, after William H. Henning, Assistant Paymaster, who had the misfortune to lose the sight of one eye as the result of a shooting accident while in Whitsunday waters.

Small though it is, this pleasant little island has been sought after by would-be Robinson Crusoes over the years, and leases over it were granted from the 1920s through to 1937 though, in the event, few of the holders lived there. Dr John Macdonald, who owned a lease over Hamilton Island, grew bananas there in the 1930s, and today remnants of a

small caretaker's dwelling can still be found behind Geographers Beach on the western side. Visitors to the island in the early 1930s were mystified to find a car sitting on the island, the fact later emerging that its engine was intended to power a small sawmill which never eventuated.

Points of interest: Henning has a pleasant sand beach on its north-east corner – one of the few beaches among the islands that is accessible at all tides. A shallow spit connects the island to a rocky outcrop just west of the northern tip, a spot favoured by pelicans and ospreys (keep more than 150 metres distant during the osprey nesting season May–August). Geographers Beach is a **bush-camping** site (no facilities, accessible at high tide only). There are excellent views from a large grassy knoll 200 metres east of the beach. The huge mound nests of the orange-footed scrub fowl (*Megapodius reinwardt*) can be seen behind the beach.

Hook Island

Location and access: 20° 07'S, 148° 55'E, about 9 nautical miles north-east of Shute Harbour. Access is from either Shute Harbour or Airlie Beach/Abell Point marina by commercial vessels taking day-trippers to destinations around the island, or by private vessel. Access to the resort and underwater observatory in Hook Passage is by ferry from Shute Harbour.

Description, historical notes: Hook is a massive island, approximately 13 kilometres long and 6 kilometres wide (an area of some 5180 hectares), with lofty, rugged peaks and deep embayments. Hook Peak, near the centre of the island, is 451 metres above sea level, the highest point in the Whitsundays. It is not infrequently shrouded in cloud. Vegetation ranges from closed rainforest (showing affinities with wet tropical rainforest) to eucalypt and hoop pine forest on rugged slopes. It has some huge isolated boulders on its slopes that

Hayman Island
Butterfly Bay
Manta Ray Bay Pinnacle Cove Pinnacle Pt
Maureen's Cove
Luncheon Bay
Mt Sydray (376)
Hook Peak (408)
Black I.
Mackerel Bay
Crayfish Beach
Stonehaven Anchorage
+(232)
Hook Island
Saba Bay
+ (238)
Aboriginal cave with paintings
Nara Inlet
Macona Inlet
Whitsunday Island
Resort + (269)
Underwater Observatory

are close enough to jump from one to the other but there is nothing but 'no-man's land' underneath them – intrepid bushwalkers beware.

The island's name was not given by any particular individual but rather evolved from local usage. It arises from the shape of the island, not as it is shown on charts today but as portrayed on charts from 1819 through to the 1860s. In those early days naval surveyors were chiefly concerned with a safe waterway and merely showed representative shapes of islands that had not been surveyed in detail. Hook Island, in those days, appeared as a very dis-

tinct hook (see illustration). 'Hook' was adopted in the 1860s as the official name.

The island has had a rather quiet history. Aborigines hunted and fished there at least 8000 years ago. A number of timber leases were granted to Europeans in the early part of this century, and in the 1920s a timber camp was sited on the beach opposite Hayman Island and run by the Abell brothers of Jubilee Pocket on the mainland (as Airlie Beach then was known). In the early 1930s a start was made on a small tourist resort in Stonehaven, but the depression put paid to that,

Hook Island as it appeared on British Admiralty charts from 1820 to 1863, as drawn by King

and only the frames of several buildings saw the light of day. A more successful venture commenced in the 1960s when the Hook Island underwater observatory was constructed at the south-east tip of the island. This was opened in November 1969 and was proposed as a visiting point for the Queen during her 1970 visit to Australia, but cyclone Ada, of 17–18 January 1970, scotched that idea. The observatory weathered the disaster with minimal damage, but the devastation to the Whitsundays as a whole caused the idea of a visit by the Queen to be abandoned.

Points of interest: Two deep, fjord-like embayments, Nara and Macona inlets, on the southern side of the island offer excellent all-weather **anchorages**. These inlets penetrate the island for a distance of over 4 kilometres and are flanked on both sides by hills that rise over 250 metres. **Aboriginal cave** shelters can be found at a number of locations in these hills, and a track to one such shelter in Nara Inlet, with rock paintings on its walls, has been constructed for the convenience of visitors. The cave is about 90 metres above a small beach near the terminus of the inlet, on the right, a not-difficult walk for anyone in reasonable health.

An **underwater observatory** and small, informal **resort** is located in the narrow passage between Hook and Whitsunday islands. The resort has a **camping** area as well as twelve cabins with bunks, shared-amenities block, restaurant/coffee shop, kiosk, barbecue facilities and small bar. The underwater observatory provides an opportunity to view coral effortlessly from an underwater metal tube with windows, and fish life is always plentiful even when visibility is adversely affected by swift tidal currents that flow through the passage. The observatory also operates a coral-viewing sub. **Diving** is available at the resort, and **moorings** are available for visiting yachts.

The many bays elsewhere around Hook Island offer some of the most exciting **anchorages** in the Whitsundays, including the large Stonehaven anchorage in the north-west side of the island. Stonehaven offers good protection from most winds and can accommodate a good number of vessels. It was named in 1926 by Captain J.A. Edgell, RN in command of HMAS *Moresby*, after Lord Stonehaven, Governor General of Australia from 1925 to 1930. Many of the bays on northern Hook Island have excellent fringing reef development for **divers and snorkellers** to enjoy. Butterfly Bay, Maureen's Cove, Luncheon Bay, Manta Ray Bay, and the Pinnacles have some of the best fringing reefs in the islands and are among the best island dive sites ('The Pinnacles' is rated as the best dive in the islands – see 'Diving and snorkelling', page 107). **Bush camping** for a small number is permitted at tiny Crayfish Beach at the bottom of Mackerel Bay (no facilities), and special-interest groups may be issued a permit to camp at Raleigh Beach at the southern end of Maureen's Cove (tables, toilet).

Langford Island

Location and access: 20° 05'S, 148° 52'E, about 14 nautical miles north-north-east of Shute Harbour

and Airlie Beach. Access is by commercial day-charter vessels departing from Shute Harbour or Abell Point marina, or by private vessel.

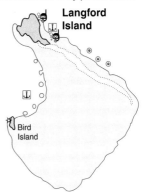

Langford Island

Bird Island

Description, historical notes: Langford is a little less than 2 nautical miles south of Hayman and west of Hook Island. It is a relatively small (about 10 hectares), rocky, wooded island, 56 metres high, but is unique in some respects, being something of a cross between a continental island and a coral cay. An extensive sandspit extends to the south-east of the island, and a massive (250 hectares) coral reef spreads out to its south and south-east. A small, foot-high sand island (One Foot Island) sits on the end of the spit. The prevailing south-easterlies and currents have piled up a cay of coral sand at the foot of the continental island. Langford was named in 1866 by Commander Nares of HMS *Salamander* after William Langford, Gunner 2nd class. The island was the subject of a study in 1896 by the American naturalist and oceanographer, Andrew Agassiz.

Points of interest: Langford is a popular destination for day-cruise yachts from Shute Harbour and Abell Point marina, which moor along the eastern side of the sandspit and reef. Passengers enjoy **swimming** and stretching their legs on the beach; towards the island, there is a good opportunity to explore an environmental transition from a reef system to a mangrove system. **Snorkelling and scuba**

Highlights 169

diving are available off the beach and at a site on the north-eastern side of the island. Temporary daytime **anchorage** is possible on the eastern side of the island and on the western side of the reef.

Lindeman Island

Location and access: 20° 27'S, 149° 03'E, 17 nautical miles southeast of Shute Harbour. Lindeman has a grass airstrip which is used by the air taxi based at Whitsunday airstrip and by charter flights from Mackay. Access by water is via launch from Hamilton Island, Shute Harbour and, on weekends, by cruise boat from Mackay, or by private vessel.

Description, historical notes: Lindeman is a large (790 hectares) island mostly covered by eucalypt forest with patches of rainforest on its northern half with large areas of grassland on its southern half. It is divided into two ranges of hills, dominated by Mount Oldfield (212 metres) on the east and a series of hills running up the north and north-west tips. There is a large flat area in the south-central part, which provided the opportunity for the airstrip; almost at the southern end of the island this flat drops precipitously to the beach. Around its perimeter, the island has numerous wide bays, many with pleasant sand beaches.

The Aborigines called the island 'Yarrakimba' ('snapper bream' – the fishing was evidently good there). It was given its current name in 1868 by Commander H.M. Bingham, RN of HMS *Virago*, after Sublieutenant George S. Lindeman, RN, who was a nephew of Dr Henry Lindeman, founder of the Lindeman Wine Company at Cawarra in the Hunter Valley of New South Wales.

Some notoriety attached to the island in 1861 when two men from the *Ellida* were killed by Aborigines after allowing themselves to be taken ashore in native canoes. A subsequent raid by the Native Mounted Police found that the offenders had moved their camp to Shaw Island,

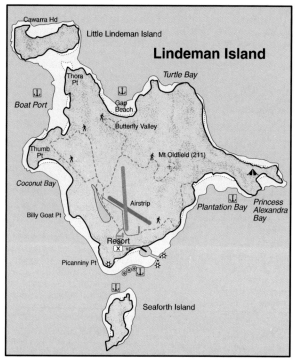

Lindeman Island

and attempts to come to grips with them failed because of the rugged terrain. Because of the reliable supply of water at the southern corner, that area was the site of an Aboriginal camp from time to time and, later, a homestead, and then the resort.

In 1898 Abraham Adderton and his wife, Sarah, took up grazing sheep on the island, their tenure lasting twenty years. They sold to Tom Matthews-Frederick in 1918 who, in turn, sold to Billy Nicklin, whose cousin, Frank, was later to become Premier of Queensland. Neither did anything of significance with the island. However, in 1923 Elizabeth Nicolson bought the lease and with her husband, Angus, and their three children, took up residence. This was a dramatic turning point in the island's history.

While continuing with grazing, the Nicolsons turned to tourism. In the late 1920s, in conjunction with

Mackay Tours Ltd, they built eight grass cabins and began bringing tourists to the island, an operation which was to expand to the international resort it is today. The association with Mackay Tours ended after several years, and the Nicolsons proceeded alone to develop the resort with their children Lachlan, Archie and Betty, who joined them in its running. Lachlan eventually took managerial control, assisted by his wife, Thora, who was still living on the island in 1995. In 1941 Betty married launch skipper Tom Evetts, and thus another family association was added, as they and their six children took their place in the running of the resort.

In 1974 the island became the focus of attention for the larger tourist operators and P&O bought a 50 per cent share by buying out some family shares. P&O began a major redevelopment, with Lachlan and Thora Nicolson staying on as man-

aging director and secretary. By 1979 P&O had bought out the Nicolsons and had assumed full control, only to sell in 1983 to the Queensland State Government Insurance Office (SGIO), which saw the purchase as an investment. SGIO sold its share in 1986 to Sydney entrepreneur Peter Adelstein who extensively redeveloped the resort. In the interim, a State Government proposal that a large part of the island be sold as freehold to East-West Airlines raised a storm of public protest, and after several months East-West withdrew from the scene.

The French tourist company Club Med bought the resort in 1990 and began another major expansion, reopening it in November 1992.

Points of interest: The **Club Med Lindeman Island Resort** is one of many of these famous village resorts spread around the world, staffed by keen young people from all over the globe. The attractive central resort complex is a large pavilion with a swimming pool immediately in front and the beach immediately in front of that. The central complex incorporates the main bar, dining room, boutique and entertainment centre. Glass panels protect those lazing by the pool from the brisk south-east trade winds that sometimes blow onto the beach. Modern resort units are right at beachside with views out to Seaforth Island, or are set against the hill with good views out towards Kennedy Sound and Shaw Island. A colony of fruit bats occupies a small patch of rainforest just behind the central pavilion, and rainbow lorikeets cackle in the palm trees and sit on the chairs at poolside.

Club Med Lindeman has excellent sporting facilities by the airstrip, including five lighted tennis courts (and a sixth which is under cover), basketball court, archery range, another large swimming pool, children's pool, nine hole golf course (definitely *not* a chip-and-putt course), and golf club with bar and grille. Water sports are conducted on the beach in front of the resort, including sailing (catamarans, sail-

boards) and paddle skis.

Lindeman Island has an **extensive system of graded walking tracks,** and the natural attributes of the island are recognised by the Queensland Department of Environment and Heritage, which has assigned a **ranger** who **conducts guided walks and gives interpretive talks** about the island. The **Mount Oldfield walk** (4.5 kilometres one way) offers spectacular views and provides a good orientation to the island and its surrounds. The walk climbs through open eucalypt forest, through thick vine forest, and across expansive grasslands. On top of Mount Oldfield grass trees (*Xanthorrhoea* sp. – see pages 58–9) stand like sentries with tall spears pointed skywards. As one observer has described it: 'From the summit the southern Whitsundays are strewn across a shining sea which, in early morning and late afternoon, shimmers like beaten metal'. North of Lindeman, Pentecost Island crouches like a lion (according to some).

The **loop walk** takes in the northwestern beaches, headlands and forests of the island, the least disturbed areas, going to Coconut Beach and to Boat Port. This walk can be done as a circuit (8.5 kilometres) or as a walk to one or the other place (Coconut Beach is 2.1 kilometres one way, Boat Port 3.3 kilometres). The track goes along the eastern side of the dam (an excellent spot for bird watching, particularly in early morning or late afternoon, past a forest of poplar gums (*Eucalyptus platyphylla*), a graceful tree with heart-shaped leaves and white bark that lifts and rolls away to expose new salmon-cream bark. In the forks of these gums sometimes grows a mistletoe that attracts the beautiful Whitsunday azure butterfly (*Ogyris zosine zolivia* – see page 70). To get to Coconut Beach the track goes left beyond the dam, across the northern end of the golf course, through dry woodland of wattles and eucalypts, then along the steep ridge above Coconut

Beach, passing through a cool, damp section of rainforest. Coconut Beach is a pleasant sandy strand fringed by tropical and beach vegetation. A picnic table is just behind the beach (please note: all rubbish must be taken back with you).

To Boat Port (1.1 kilometres further on) the track climbs through open woodland to higher country, and a stone path leads to the beautifully protected beach at Boat Port, very peaceful when the south-east trades are piping in at the resort. Boat Port was used by the Nicolsons as a landing spot when they were building the original resort. Orange-footed scrub fowls (see page 64) may be heard raking noisily through loose litter behind the beach.

A **track to Gap Beach via Butterfly Valley** (3 kilometres one way) goes through open woodland down through a sheltered rainforest gully, and it is places like these where forest butterflies often congregate, particularly the blue tiger (*Danaus hamatus* – see page 71), the reason why it is called Butterfly Valley.

The **walk to Plantation Beach** (4 kilometres one way) meanders over gentle grassy slopes some of which have been regularly burned since Aboriginal occupation. Pandanus trees (see pages 55–7) growing here are fire survivors, too; their buds are protected by the spiral packing of the leaves. The track descends towards the sea through moist gullies and dense vine forests of umbrella trees, sandpaper figs and hoop pines. Plantation Beach is a wide expanse of sand with graceful, whispering casuarinas at its back margin.

Lindeman has a number of **anchorages** – Boat Port, Gap Beach and Plantation Bay. Bush camping is permitted at Princess Alexandra Bay, named for the daughter of the Duke and Duchess of Kent after her stay on the island in 1959. The resort has a number of **moorings** which are available for use by visiting yachts.

Highlights 171

Linné Island

Location and access: 20° 41'S, 149° 11'E, 32 nautical miles south-east of Shute Harbour (about midway between Mackay and Shute Harbour). Access is by private vessel.

Description, historical notes: Linné is a sizeable (405 hectares), wooded, volcanic island that rises to 284 metres and which has an inhospitable coastline for most of its circumference, with the exception of two pretty sand beaches on its western side. It used to have considerably more grasslands than it does today and was undoubtedly fired regularly by the Aborigines. The island was named by Staff Commander E.P. Bedwell following on from Lieutenant Philip King's earlier naming of Linné Peak, after the famous Swedish botanist and naturalist Carl von Linné, who is perhaps better known by the Latin version of his name, Linnaeus. Linné formulated the system of botanical classification using Latin names for genus and species (binomial nomenclature) which is now universally employed for naming all living species, plant or animal. Linné Island was the first of the Cumberland Islands to be visited by a European (see entry for Sir James Smith Group in this section, and also page 140).

Points of interest: An anchorage, albeit a somewhat 'rolly' one, is available on the western side which is sometimes used by trawlers sheltering from blustery south-easterlies.

Long Island

Location and access: 20° 22'S, 148° 51'E, 4 nautical miles east-south-east of Shute Harbour. Access is by water taxi from Shute Harbour, or by private vessel.

Description, historical notes: Long island, as its name suggests, is an elongated (9 kilometres from top to bottom), relatively narrow island separated from the mainland by a deep, narrow channel. It is quite hilly, the east coast rocky with bluffs, except for a few low, sandy saddles about a quarter the way down, where advantage of the flat land has been taken to build holiday resorts. The vegetation is quite dense, largely vine forest and eucalypt forest.

Because it lies so close to the mainland, Long Island escaped the notice of the early navigators, such as Cook and King, the first official mention of its separateness appearing in 1836 when HMS *Zebra* anchored in Port Molle. This report was followed soon after by a survey by HMS *Fly* in 1843 and thereafter the island appeared on admiralty charts, though the name Long Island did not appear until the 1860s, being given in a cartographic office and not attributable to any particular person.

The first European inhabitants were the fifty-seven souls from the *Valetta*, which had damaged itself on a reef at Scawfell Island in July 1825 while on its way from Port Jackson to Calcutta. Despite repairs at Scawfell Island, once the voyage continued the ship began to leak alarmingly and was beached in today's Happy Bay to undergo further repair. In the event this proved fruitless and the crew were to spend about three months in huts behind the beach before they were rescued. It is most likely that the well that was found there in later years, and wrongly dubbed 'Flinders Well', was dug by these people.

Some remains of the *Valetta* still lie under the silt in front of the beach at Happy Bay, these having been excavated and examined by the Queensland University in 1983.

European interest in the island commenced in 1884, when D.C. Gordon was given a lease, but it is evident he did nothing there. He was followed by Percy Kean, in 1895, and Sarah Adderton (whose husband had the lease to Lindeman Island), in 1898, Mrs Adderton holding it until 1916 without doing anything. Thereafter the lease passed through several hands without any activity until taken over in 1921 by Carl Altmann, and later by his mother, Frances, of the well-known Altmann family of the Proserpine area. The Altmanns were to reside on it until 1931, building a residence at Happy Bay and growing bananas there and at Banana Bay on the south-west side of the island. Bananas were transported to Cannonvale in their boat *Senix*, and therein lay the genesis of a mail-run to the islands that

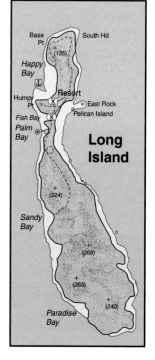

the Altmanns ran for many years. Upon Mrs Altmann's death in 1930 the island was subdivided into three segments and each sold separately, the northern to brothers Harry and Francis Wilding, about whom very little is known, the centre to Bill Grant, and the southern to Tom Hurford, who spent a reclusive nineteen years at what today is called Paradise Bay. This move saw the beginning of tourism for the island, as Bill Grant began immediately to develop a resort he called Clear View Gardens, later to be called Palm Bay. His move was followed in 1934 by Walter Tronson, who took over from the Wildings and began developing a resort at Happy Bay, as he dubbed it. From then on both resorts were to cater continuously for tourists, though not without their problems along the way and the inevitable closure during World War II. Paradise Bay joined in in spasmodic fashion from 1962.

Happy Bay changed hands several times before its takeover for 35 years by the Mountney family in 1949, theirs to be one of the family success stories of the area. Development under the Mountneys changed the resort from a local resort to one of national standing until, in 1984, they sold out to Mytarc Pty Ltd, and again the ownership merry-go-round commenced – Mytarc, Whitsunday 100, Contiki, The Island, Radisson Long Island Resort, and Whitsunday Long Island Resort owned by Club Crocodile Holdings. During the earlier Contiki tenure the resort upgraded to international standard.

Meanwhile, Palm Bay also was changing hands – Timothy Croft, Peter Rasmussen – until again a family company emerged for the long haul. The Brooks family took over in 1949 and remained associated until 1971, when again ownership passed rapidly from hand to hand – Colin Drake, Coral Sea Enterprises, John Mountney in partnership with Tony Bull and, finally, the international tourist operator,

Page McGeary Holdings. This resort has always remained a low-key development and today retains the same 'away-from-it-all' flavour under the control of Page McGeary, who took it over in 1988 initially as a stopover for packaged Australia Pacific Tours but now promote it as Palm Bay Hideaway, with only fourteen rooms, no TV, no phones, no newspapers, no worries.

Points of interest: The **Whitsunday Long Island Resort** is situated at Happy Bay, a family resort with 156 rooms, large courtyard pool and pool bar, a second, 28-metre swimming pool behind one of the blocks of units for lap-swimmers, a café, barbecue, buffet and à la carte restaurant, nightclub/disco, boutique, and two lighted tennis courts. All manner of water sport activities take place from the wide beach in front of the resort. Twelve **moorings** are available for visiting yachts.

The **Palm Bay Hideaway** is about 1 kilometre south of Happy Bay, a low-key retreat with bungalows, central dining area and bar, general store, barbecues, small swimming pool and supernumerary kangaroos wandering about. Palm Bay has a man-made lagoon with eight **moorings** for visiting yachts inside the lagoon and two moorings outside the lagoon.

Long Island has 13 kilometres of **graded walking tracks**. The **Circuit track** (3.5 kilometres) goes north from the resort along the eastern shore, giving views across to Dent and Hamilton islands, then north to a large banyan tree, circling back to the northern end of the beach at Happy Bay, where a wreck of an old junk lies on the shore. The **Palm Bay track** is a 2.2 kilometre easy walk, with a possible detour along the way to Humpy Point, where beautiful, elevated views of Palm Bay are available. The track goes through dense vine forest before descending into the saddle where the Palm Bay resort is nestled. On the **track to Sandy Bay** (about 5 kilometres) there is a turn-off, about ½ kilometre from Palm

Bay resort, which takes a circuit to the east, giving views of the passage, then continues through vine forest to Sandy Bay, with plenty of wildlife to look at and listen too.

Long Island is the only island on which the mound-building Australian brush-turkey (see page 64) can be found.

Lupton Island

Location and access: 20° 16'S, 149° 06'E, immediately east of Haslewood Island, 18 nautical miles east of Shute Harbour. Access is by private vessel.

Description, historical notes: Lupton is a modest-sized (134 hectares), rocky island (maximum elevation 136 metres) linked to Haslewood Island by a massive fringing reef of some 190 hectares which becomes a vast 'moonscape' at low tide. The island is mostly grass-covered and probably was maintained that way for a long time through burning by Aborigines, although it is also very exposed to salt spray whipped up by the south-east trade winds. In 1820 Lieutenant Philip King on HMS *Mermaid* sailed by this area; on board was the botanist Allan Cunningham, who reported seeing seven Aborigines firing the grass on an island he did not specifically identify (but it must have been either Haslewood, Lupton or Worthington). Lupton was named by Staff Commander Bedwell on the chartered steam vessel *Llewellyn* during his 1878–79 survey of the Whitsundays, probably after a civilian or naval member of his crew.

Points of interest: The fringing reef offers fascinating exploration (see Haslewood Island). The reef on the east side of Lupton Island offers good **snorkelling and diving**, although anchorage is available only in the mildest weather. Trochus shells used to be taken from this area, which is now designated Marine National Park 'B', a 'look but don't take' zone.

Newry Group

Location and access: 20° 51'S, 148° 56'E, about 2 nautical miles from Victor Creek, Port Newry (see illustration on page 83). Access by private vessel.

Description, historical notes: The Newry Group is a cluster of small islands very near the mainland just north-west of Seaforth. They demonstrate a number of different vegetation types – tall mangroves, open eucalypt forest, hoop pine forest, and scrublands. The views from the islands are quite uninterrupted – just islands and the mountainous mainland backdrop. Lying so close to the mainland in well-protected waters, they are relatively easy to access.

Rabbit Island is the largest (348 hectares), the whole western side of which, from the north-west to south-east tip, is mangroves. It has a population of introduced koalas. There are several **campsites** on the eastern side, the principal site being on the south-east corner, with toilets, water, and picnic tables. Bush camping is available at two other sites further north on the eastern side. **Newry Island** is a round wooded island with narrow fringing reef. It has a **day-visitor facility** with picnic tables, water and toilets. **Camping** is also available for special interest groups on **Outer Newry Island**, in an old squatters hut. This is a rocky island with thick pine trees on the south side. There is a rock pool on the eastern side with some coral. **Camping** is also available on **Mausoleum and Rocky island**s.

Nicolson Island

Location and access: 20° 18'S, 149° 06'E, immediately south-east of Haslewood Island, 17 nautical miles east of Shute Harbour. Access is by private vessel.

Description, historical notes: Nicolson is a small (30 hectares) island rising to 108 metres, covered by a magnificent stand of hoop pines. No doubt this is what prompted Philip King, RN in HMS *Mermaid* (1820) to name it Pine Island. The island was renamed in 1961, in honour of Angus Nicolson, original founder of the Lindeman Island resort, to avoid confusion with today's Pine Island.

Points of interest: Mariners travel inside this island (between Nicolson and Haslewood) as a shortcut to Waite Bay, although care needs to be exercised to avoid a dangerous bommie off the southern tip of Haslewood.

North Molle Island

Location and access: 20° 14'S, 148° 49'E, 4 nautical miles north-north-east of Shute Harbour. Access is by private vessel.

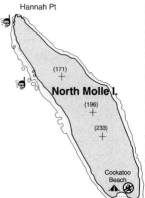

Description, historical notes: North Molle is a sizeable island (259 hectares), one of six islands in the Molle Group, one where large areas that were previously grasslands are rapidly being reclaimed by forest. It has an undulating ridge with steep grades and few embayments. The south end has a grassy sand flat and beach.

Points of interest: Cockatoo Beach on the southern end is a national park **campsite** with toilets, water, shelter and tables (fires are prohibited). Access is at high or near high tide only. Just south of Hannah

Point, the northern tip of the island, is a coral shingle beach, and at the southern end of this beach are some large coral bommies that can provide diversion for **snorkellers**, particularly at neap tides when visibility in these current-swept waters tends to be better than at other times. This is an all-tide beach, but the anchorage drops off steeply and is subject to currents. Hannah Point offers some interesting **diving**; as with many such promontories in the Whitsundays, watch out for strong currents.

Olden Island

Location and access: 20° 06'S, 148° 34'E, 13 nautical miles north-west of Airlie Beach. Access is by private vessel.

Description, historical notes: Olden is a mostly low, grassy island of 48 hectares with steep bluffs on the eastern and northern sides and large patches of closed forest on the southern side. It was named by Commander Nares of HMS *Salamander*, after Henry Olden, Boy Second Class.

Points of interest: Anchorage is available off the pleasant south-western beach, where there is a **bush-camping** site. A small rock close by the south-east of the island is a nesting site for gulls and black-naped terns; keep more than 150

metres distant during the nesting season (October–March) to avoid disturbing the birds.

Pentecost Island

Location and access: 20° 24'S, 149° 02'E, 3 nautical miles south-east of Hamilton Island, 15 nautical miles east-south-east of Shute Harbour. Access is by private vessel.

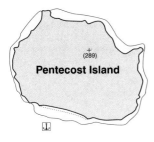

Pentecost Island

Description, historical notes: Pentecost is a precipitous, round island of 105 hectares rising to a noticeable 289 metres. It was named by James Cook, the only island he named. Cook noted that it was 'more remarkable than the rest, being small in circuit, very high and peaked'. Pentecost comes from the Greek word 'fifty', the association being with the religious festival, the Feast of Pentecost, celebrated on the fiftieth day after Easter, that is, Whit Sunday, the day that Cook named it. Pentecost is, geologically speaking, a porphyry dyke.

Points of interest: The island has been likened to a 'lion couchant' (it was referred to as Lion Island for some time), and some see a Red Indian head when the island is viewed from the west. **Daytime anchorage** is available off the western end of a beach on the south side – a pretty and lonely spot for a picnic.

Pine Island

Location and access: 20° 23'S, 148° 54'E, immediately east of southern Long Island, 7 nautical

miles south-east of Shute Harbour. Access is by private vessel.

Description, historical notes: Pine is a smallish (81 hectares), forest-covered, cliffy island with hoop pines on its southern head, which rises to 96 metres. Lieutenant Philip King, RN, in HMS *Mermaid*, named Pine Head (its southern end) but not until 1885 when it was surveyed by HMS *Paluma* did it get its name of today. At the time King saw it there were hoop pines on Pine Head as there are today, but the rest was grasslands, no doubt created by the Aborigines' burning.

Points of interest: Daytime **anchorage** is available in suitably light weather off the coral shingle beach on the north-west side. Pine Island is possibly most appreciated today because it stands out at a distance and is used by mariners both as a transit to find the entrance to Gulnare Inlet on Whitsunday Island and to avoid Proud Rock at the entrance to Macona Inlet, Hook Island.

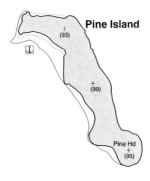

Pine Island

Planton Island

Location and access: 20° 16'S, 148° 51'E, 0.25 of a nautical mile east of northern South Molle Island (see South Molle Island for illustration). Access is by private vessel.

Description, historical notes: Planton is a small (33 hectares) 'desert isle' with hoop pine forest and a sandy beach on the north-west corner.

Points of interest: This island can provide a desert isle experience for campers (there are no facilities). A daytime anchorage is available off the south-western side, in suitably light northerly weather.

Rattray Island

Location and access: 20° 00'S, 148° 33'E, 18 nautical miles north-north-west of Airlie Beach. Access is by private vessel.

Description, historical notes: Rattray is a pile of rocks 111 metres high with wind-sheared vegetation, isolated and surrounded by currents. It was named by Commander Nares of HMS *Salamander* after the ship's surgeon, Alexander Rattray MD, RN.

Points of interest: Anchorage is available off the western side of the island. As with the waters surrounding any of these outlying northerly islands, trolling for pelagic fishes can be rewarding.

Repair Island

Location and access: 20° 18'S, 148° 47'E, 450 metres from the jetty in Shute Harbour. Access is by private vessel.

Description, historical notes: Repair is a tiny island, right in Shute Harbour, covered by eucalypt forest with patches of mangroves around much of its periphery. It is surrounded by a fringing reef that is more than twice its size. Its name probably comes from the fact that a Royal Australian Navy survey team repaired one of their boats on it in 1932.

Points of interest: Repair is one of three islands in the Whitsundays where significant numbers of Torresian imperial pigeons (see page 65) nest each year from October through March, a species that has been largely hounded off the mainland and for which the islands are a last refuge. During the nesting season visitors should keep well away to avoid disturbing the birds.

Repulse Islands

Location and access: 20° 36'S, 148° 52'E, 19 nautical miles south-south-east of Shute Harbour. Access is by private vessel.

Description, historical notes: There are three islands in this group, North Repulse (120 hectares), East Repulse (97 hectares), and South Repulse (40 hectares). The islands were first noted by Cook in 1770, who named Repulse Bay in which they lie. Cook sailed into the bay thinking it was the way north but found out otherwise and, having been thus repulsed, so named the bay. The islands' name did not emerge until Lieutenant P.P. King, RN in HMS *Mermaid* followed in Cook's footsteps in 1819. King and Allan Cunningham landed on South Repulse Island, on the beach on its south-east, and climbed to its summit. They noted evidence of Aborigines having visited the same beach.

The main interest in the islands over the years lay in a deposit of high-grade limestone which occurs at the southern tip of East Repulse, and from 1898 there were intentions to mine this for agricultural purposes, with mining leases issued from 1909 through to 1947. The only serious attempt to mine the deposit, however, emerged in 1914 when the Pioneer River Farmers and Graziers Association formed a subsidiary company to mine the deposit and burn it in kilns on the island for transport to Mackay. There was some mining and stockpiling of limestone over the following several years, and a kiln was built on the island, but the venture fizzled out. Today the stockpiles are still in evidence and the kiln lies somewhere under the adjacent hillside.

Points of interest: South Repulse's beach with fringing reef is a **bush-camping** site (no facilities). The reef has many submerged coral heads and needs to be approached with care. Access to this island in small boats is probably easiest from the marina at Laguna Quays just opposite on the mainland. Torresian

imperial pigeons (see page 65) nest on North Repulse; care should be taken not to disturb the birds during the nesting season, October–March.

Saddleback Island

Location and access: 20° 04'S, 148° 32'E, 16 nautical miles north-west of Airlie Beach. Access is by private vessel.

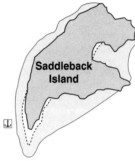

Description, historical notes: Saddleback is a small island (45 hectares) with double peaks (maximum elevation 180 metres) separated by a pronounced saddle. The south-west extremity is a low grassy spit with sand beach. It was named by Commander G.S. Nares, RN in HMS *Salamander* in 1866. Its only claim to historical fame lies in the 'Saddleback Hotel', a fairly respectable shack that was built on it by some Bowen residents in the 1940s as a weekend and holiday retreat. The island being a national park, this caused some official heartburning over the years that followed, involving some fine points of law as to what should be done with it. The problem disappeared in 1980 when the building was burnt down in mysterious circumstances.

Points of interest: Anchorage is available off the south-west spit, where there is a **bush-camping** site with picnic table.

Seaforth Island

Location and access: 20° 28'S, 149° 02'E, just south of Lindeman Island, 17 nautical miles south-east

of Shute Harbour (see Lindeman Island for illustration). Access is by private vessel, or by boat from the Lindeman Island resort.

Description, historical notes: Seaforth is a small (20 hectares), pink granite island named by Commander Henry Bingham, RN of HMS *Virago*, in 1867, possibly after one of his crew. It is sometimes referred to as 'Royal Seaforth', the result of a short visit to the island by Queen Elizabeth II and the Duke of Edinburgh in 1954.

Points of interest: Seaforth has a pretty beach on its north-west where there is sufficient shelter for safe **anchorage**. Another beach on the eastern side is rather exposed to the weather. Coral on the southern end of the island is well developed, but it is difficult to appreciate coral in this area, which is subject to big tides and currents that keep local waters somewhat cloudy with sediments from the adjacent mainland river systems.

Shaw Island

Location and access: 20° 29'S, 149° 05'E, just south-east across Kennedy Sound from Lindeman Island, 20 nautical miles south-east of Shute Harbour. Access is by private vessel.

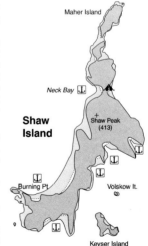

Description, historical notes: Shaw is a large (1659 hectares), volcanic, pink granite island with the third highest hill in the Whitsundays (Shaw Peak, 408 metres). It has skeletal granite soils and is covered with sparse open forest. The island is broken topographically into five blocks separated by narrow saddles. There are deep embayments all around the coast, many with mangroves and extensive sand flats that impede access to beaches at low tide. Many bays have well-developed fringing reefs.

In June 1819 Lieutenant P.P. King RN in HMS *Mermais* passed through on the first of three voyages he was to make through the Whitsundays. He named the high peak of the island after George Shaw, a prominent English naturalist.

Despite its size and lovely location Shaw Island has never attracted other than fleeting attention by settlers, its mainly granite structure and lack of grassland and water militating against development. From 1910 on some tenures were granted – Claude Annesley and Katie Jillett, J.E. Langford and Allen Short, but nothing came of these. One proposal for a tourist resort was made in 1934 by Tourist Resort Promotions Ltd but the Government refused the application

Points of interest: Shaw has some **beautiful beaches**, particularly those on the southern shoreline, some of which are nesting sites for turtles. There are **anchorages** in bays on both sides of the island. The northern shore of Burning Point has a broad sand beach and sand flat, a site that is sometimes used by **commercial camping** groups. **Bush camping** is permitted at Neck Bay, on an attractive beach on this narrow isthmus.

Shute Island

Location and access: 20° 18'S, 148° 48'E, 0.75 of a nautical mile from Shute Harbour jetty. Access is by private vessel.

Description, historical notes: Shute Island protects Shute Harbour on its eastern side, a well-forested, 55-metre-high island with hoop pines and eucalypts and some rainforest species. It is cliffy on its eastern side. The name Shute has been in use since 1881 following a survey of Port Molle by HMS *Alert* and was probably named after one of the *Alert's* crew.

Points of interest: Shute Island has a good all-tide beach on its north-western corner.

Sir James Smith Group

Location and access: 20° 40'S, 149° 07'E, 28 nautical miles south-east of Shute Harbour. Access is by private vessel.

Description, historical notes: The Sir James Smith Group includes the Anchor Islands, rocky and inhospitable, as well as Goldsmith (see separate entry), Linné, Tinsmith and the Ingot Islets. With the exception of Goldsmith these have not often been visited by humans.

In June 1819 Lieutenant P.P. King, RN, in HMS *Mermaid,* passed through on the first of three voyages through the Whitsundays. On board was the botanist Allan Cunningham, who was later to make a name for himself as an explorer. Out of deference to Cunningham, King gave a number of names along the Queensland coast after well-known figures of the time in the field of natural sciences, the Sir James Smith Group, Linné Peak within that group, and Shaw Peak, looming prominently to the north, being three examples.

Sir James Smith was a prominent botanist of the time and president of the Linnéan Society in London, which was founded to collect and disseminate botanical information around the world. Carl von Linné (Linnaeus), after whom the society was named, was a Swedish botanist acclaimed as the 'father' of the

science of botany, while George Shaw was a prominent English naturalist also associated with the Linnéan Society.

Later surveyors, particularly Bedwell, were to play on King's naming by allocating to islands in the group titles all relating to the trade of the Smith, for example, Goldsmith, Silversmith, Tinsmith, Hammer, Anvil, Ingot Islets, Forge Rocks, Coppersmith Rocks. The exception is Linné Island, whose name flowed on from King's naming of its peak, and that island had the honour of being the first in the Whitsundays on which a recorded landing was made by a white man. In 1802 Lieutenant John Murray, RN and members of his crew from HMS *Lady Nelson* made several landings on the beaches on the western side of Linné, noting evidence of Aboriginal visits and retrieving a wrecked canoe.

South Molle Island

Location and access: 20° 16'S, 148° 50'E, 3 nautical miles east-north-east of Shute Harbour. Access is from Shute harbour by the island ferry, or by private vessel.

Description, historical notes: South Molle Island (officially 'Molle' but commonly called 'South' Molle) is the largest (420 hectares) of a group of six islands that make up the Molle Group (a seventh, Goat Island, lies very close to South Molle on its east side connected by a reef and obviously considered to be part of South Molle). South Molle is dissected on all sides by steep gullies with steep spur ends cut into bluffs. It has extensive areas of grasslands which predate European occupation of Australia, as well as open eucalypt forest on rocky slopes, small patches of dense vine forest, and hoop pine forest in damp gullies. A number of prominent hills (Spion Kop (154 metres), The Horn (176 metres), Mount Jeffreys (194 metres) and Lamond Hill (133 metres)) afford spectacular views of the Whitsunday Passage and surrounding islands.

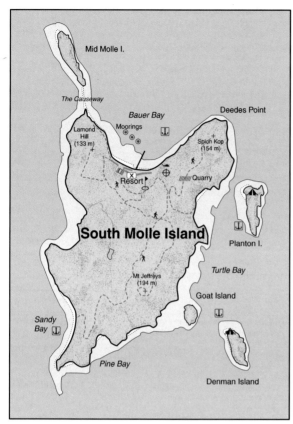

Mid Molle I.

The Causeway

Bauer Bay

Deedes Point

Lamond Hill (133 m)

Moorings

Spion Kop (154 m)

Resort

Quarry

South Molle Island

Planton I.

Mt Jeffreys (194 m)

Turtle Bay

Goat Island

Sandy Bay

Pine Bay

Denman Island

F.C. Johnson, and West Molle to Eric Catherwood.

A total change of scene occurred in 1937 when the Bauer family took over the lease to the remaining four islands from Lamond. They pioneered a tourist resort on South Molle, a venture that has had a remarkably successful history, with a few ups and downs, such as closure during World War II, and cyclone Ada in 1970, which devastated the resort. Like the grazing lease, the tourist venture was to see a succession of owners, but it was the Bauers and their thirty-four years of residence who set the tourism concept for the island firmly on its course. They were followed by Peter Vaggelas, Ron and Elaine Gould, and Jim Kennedy before the inevitable entrance of major developers who were to remove forever the 'family' atmosphere which initially was so much a feature of all the early resorts in the Whitsundays.

The first of the new breed was the Telford Property Fund which took over in 1980 but soon they were having financial problems and, in 1986, Ansett Transport Industries took a sublease from the Trustees and at its expiration continued on as managers. The resort today belongs to the Jewel Hotel Group.

The Aborigines used to call the island Whyrriba, which meant 'stone axe', the reason being that there was a quarry on the island that yielded good cutting stones. The name 'Molle' was first brought to the area in 1815 by Lieutenant Charles Jeffreys, RN in HMCS *Kangaroo*, when he named Port Molle after the then Lieutenant Governor of New South Wales, Colonel George James Molle. In the 1840s the name 'Molle Islands' became attached to the six islands which guard the northern side of the Port, and in 1881 each received individual names of Molle, North Molle, Mid Molle, West Molle (today's Daydream), Planton and Denman.

North and South Molle islands both were blessed with a luxuriant natural coverage of grass which attracted those who would mix an island lifestyle with grazing, and though all six islands were included in the leases when formal settlement began in the 1890s, only North Molle and South Molle were put to economic use. Over the following forty-odd years there was a lively succession of lease holders, all of whom grazed North and South Molle islands with varying degrees of success – Percy Kean, W.J.B. Forster, Allan and William Cooke, H.C. Sterry, Douglas Debney, A.J. Carden-Collins, and Henry Lamond.

Lamond broke the sequence in the early 1930s by selling off North Molle and West Molle as separate units under separate leases, North Molle to a west Queensland grazier,

Points of interest: South Molle is well known for its family-style village **resort** with 202 rooms, nine-hole golf course, golf bar, two lighted tennis courts, squash court, gym, spa, kiosk, large swimming pool, resort dining room and *à la carte* restaurant. **Diving** instruction is available, and the beach in front of the resort is the centre of water sport activities except at low tide when the reef exposes. **Moorings** are available for visiting yachts; payment of the mooring fee entitles visitors to use resort facilities, including showers. **Anchorage** is also available in the eastern part of the bay. Trips to the Great Barrier Reef are available on a fast catamaran that stops by the island to pick up passengers.

An outstanding feature of this national park island is a system of **graded walking tracks**, among which are walks to some of the island's lofty promontories which offer quite spectacular views. The walk to **Spion Kop** (3 kilometres), which is the rocky knob on the north-east tip, and the walk to the highest point of the island, **Mount Jeffreys** (2.2 kilometres), both begin behind the first green of the golf course. After a short climb through open eucalypt forest and then rainforest, the track branches to the left to Spion Kop, winding up a grassy hill, making its way along a ridge covered with grass trees that offers magnificent views over Planton and Denman islands and on down the Passage. The track then passes through the ancient Aboriginal stone quarry, where a pile of stones lies above and below the track. This particular stone, called a chert, fractures easily when struck with another stone, forming more or less wedge-shaped fragments with at least one sharp and jagged edge. Patient honing on another rock yielded the Aborigines a very effective and durable cutting edge. They broke off fragments from the main body until a suitable piece was obtained; using a special percussion technique, they were able to produce a particular type of flake that could then be styled into a very functional implement for cutting or scraping. Today the area is littered with thousands of discards from this process. Visitors are reminded that this is a national park, and the taking of souvenirs is prohibited. The track continues to climb, up past The Horn, and it stops at the base of Spion Kop (which is Afrikaans for 'lookout hill'). After a final, short scramble one gets to the summit of this bare volcanic intrusion with hoop pines growing on its top. Spion Kop offers majestic views of all the surrounding islands and back over the resort and Bauer Bay. The branch of the track to Mount Jeffreys winds between hills, ascending easily to the southern summit of the island, the scenery being

mostly grassland, with the occasional primitive cycad on a steep slope and hoop pines emerging from dense rainforest gullies. The view from Mount Jeffreys is simply breathtaking.

A **walking track to Lamond Hill** (about 2 kilometres) begins near the beach at the western end of the resort, where a trail ascends a series of steps through vine forest, passing underneath a giant 'walking' fig tree (the roots of which are propped across the path for a span of some 20 metres!), then switching back several times and offering occasional views over Bauer Bay. The track emerges from vine forest into eucalypt forest with grass understorey, vibrant blue sky showing increasingly through white-trunked gum trees, and one is entertained all along the way by butterflies, sweet-smelling vines, rainbow lorikeets, sulphur-crested cockatoos, and kookaburras. The track emerges on a rocky ridge, with the resort and the northern Whitsunday Passage at its feet. South Molle also has walking tracks to Sandy Bay and Paddle Beach.

Tancred Island

Location and access: 20° 18'S, 148° 47'E, 0.5 nautical miles from the Shute Harbour jetty. Access is by private vessel.

Description, historical notes: Tancred is a small wooded island in Shute Harbour that sits on a well-developed reef about three times its size. It was named in 1932 during a Royal Australian Navy survey after one of the survey team, Lieutenant George Dalton Tancred, who later (in World War II) earned a Distinguished Service Cross for his success in doing some rather hazardous survey work.

Points of interest: There is a small **bush-camping** site on the northern beach, sheltered and very easily accessible from the mainland (at high or near high tide). The coral reefs in Shute Harbour are very well developed, and Tancred's has a high

species diversity and average live coral cover of about 80 per cent (based on a survey of 1992). Branching thickets of *Porites cylindrica* are a feature along the northern reef slope. If snorkelling, watch out for currents.

Thomas Island

Location and access: 20° 33'S, 149° 07'E, 24 nautical miles south-east of Shute Harbour. Access is by private vessel.

Description, historical notes: Thomas Island (404 hectares) is a wooded, pink granite island, deeply embayed with four beautiful sand beaches on its northern side and one on its south-eastern side. It was named in 1868 by Commander H.M. Bingham, RN of HMS *Virago* after Lieutenant James C. Thomas, RN. In October 1859 Henry Daniel Sinclair of the vessel *Santa Barbara*

called in at the island on his way to Rockhampton after discovering Port Denison. He was attacked by several Aborigines, who lured him away from his shipmates after an initial display of friendliness. Sinclair was rescued by his crew and, though badly hurt and shaken, survived the affair.

Thomas is yet another island where dreams of a tropical lifestyle have emerged but foundered. From 1921 tenures were granted to William Powell of Bowen and to James Cock, also of Bowen, but nothing eventuated. An American couple in 1959 applied for a lease for a marina, but this was refused. In 1968 naturalist Les Christy from Mackay proposed that the island be made a flora and fauna reserve, but this, too, came to nought. The island is, nevertheless, a national park.

Points of interest: Thomas Island's relative remoteness gives it a 'private' quality. Protected **anchorages** are available on the northern side (although they are swelly when southeast winds are fresh), and there is also anchorage on the south-eastern side (when the trade winds season is over). The latter is a beautiful bay and beach, with stunning views south to Brampton and Carlisle islands. **Camping** is permitted (facilities include toilet and picnic table).

Whitsunday Island

Location and access: 20° 16'S, 148° 59'E, about 9 nautical miles east of Shute Harbour. Access is from Shute Harbour or Abell Point on commercial day-cruise vessels, or by private vessel.

Description, historical notes: The largest island in the Cumberlands (10 935 hectares), Whitsunday is about 18 kilometres long and 14 kilometres at its widest point. It is deeply embayed with several inlets penetrating over 4.6 kilometres into the interior. Whitsunday Peak towers 425 metres over the Passage. Vegetation is immensely diverse, with closed wet tropical rainforest, hoop pine forest, eucalypt forest,

mangrove swamps, some dense stands of palms, acacia forest on silica sand (Whitehaven Beach), melaleuca swamp and some other unusual vegetation on the dunes behind Whitehaven Beach.

Contrary to some popular beliefs, James Cook did not name this island but rather 'Whitsunday's Passage', from which 'Whitsunday' eventually became attached to the island as a matter of common usage, it first appearing on charts in the 1860s. Cook's chart shows only one island where today's Hook and Whitsunday islands lie, and this he described correctly as at least five leagues (about 15 nautical miles) in length. In those days it was common practice to refer to closely grouped islands as one, which explains Cook's chart and the length he quoted.

Whitsunday Island has been spared development, though from 1860 on it was the prime source of timber

for the growing town of Bowen. The main timber-cutting area was at the south-east corner of the island, around Gulnare Inlet and Cid Harbour. A small sawmill was erected in 1865 at Fitzalan Point on the southern tip of the island but lasted only a few months before water shortages forced its transfer to Bowen.

In 1889 John Withnall moved a sawmill he had at Preston to Cid Harbour, and for the next 15 years he produced sawn timber for Bowen and Mackay. The site of the mill and his residence is today commemorated in Sawmill Beach in Cid Harbour, and remnants of the time – bricks, rail lines and remains of a boiler – still can be found there.

The Townsville timber firm of Rooney and Co. displayed a direct interest in the island in 1891 when it obtained an occupation licence over 160 acres at the head of

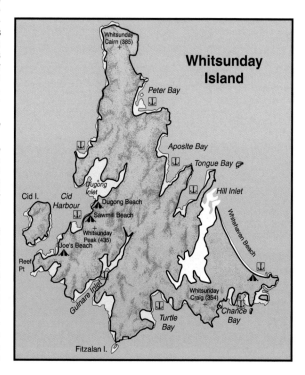

Whitsunday Island

Gulnare Inlet for the purpose of spelling working bullocks, this possibly in conjunction with Martin Cunningham who cut timber in that area for many years. This tenure, however, did not last more than several years.

In August 1878 at or near Cid Harbour Aborigines attacked and burnt the vessel *Louisa Maria,* wounding the master and killing the cook. This resulted in a retribution raid by Native Mounted Police from Bowen several weeks later in which some Aborigines were shot but, unfortunately, details of that raid cannot be found.

After the Battle of the Coral Sea in May 1942, four of the participating vessels returned to Cid Harbour to refuel before continuing south, staying for only a matter of hours. In local folklore this episode has become blown up into a major naval exercise involving almost the entire US Pacific fleet. The story was abetted by the fact that twelve months later Cid Harbour was briefly a base for a US–Australian task force

Because of the reliable water supply at and around Sawmill Beach, it was the site of an Aboriginal camp from time to time, but there is no reliable information to indicate how big it was or whether it was a permanent camp.

Points of interest: **Cid Harbour** is the largest **all-weather anchorage** in the Whitsundays and is formed by Cid Island on the west and Whitsunday Island on the east. A number of sand beaches line the eastern side of Cid Harbour – Dugong Beach, Sawmill Beach immediately to it's south, and Joe's Beach about 3 kilometres further south. These are popular **camping** sites, with toilets, picnic tables and, at Dugong and Sawmill beaches, water. Fires are prohibited on these beaches. **Dugong Inlet** in Cid Harbour gets its name from the fact that in earlier times it was frequented by dugongs, marine mammals that graze on seagrasses (see page 66) and which may still occasionally be observed there. Whitsunday is the only island to have a population of the unadorned rock-wallaby (*Petrogale inornata*) which may have been isolated from the mainland for 10 000 years. This wallaby has been reported at Sawmill, Dugong, Joe's, Whitehaven and some other beaches, too. Nari's and Dugong beaches have mound nests of the orange-footed scrub fowl (*Megapodius reinwardt*) (see page 64), which may be found at the back of the beaches. The island has a number of other **anchorages** dotted right around its perimeter which can be used in suitable weather (those along the southern shore are

generally unsuitable from April through October due to the prevailing south-easterly trade winds). Almost all of these offer opportunities for **diving and snorkelling.** One of the island's most spectacular assets is on its eastern side, a 6-kilometre stretch of pure white silica sand called **Whitehaven Beach**, an all-tide beach that is very popular with day-cruise boats, campers and yachtsmen (it is also popular with sand flies, so make sure to have insect repellent handy when going ashore). The vegetation on and behind the dunes of Whitehaven is unusual for the islands. At the northern end of Whitehaven is **Hill Inlet**, lined with mangroves and which penetrates the island profoundly; at high tide it can be traversed for some distance in a shallow-draft boat. Hill Inlet is an important area for migratory birds passing through on their way south from Siberia and Alaska to their wintering sites in Australia – some thirty species have been recorded at various times, such as the eastern curlew, bar-tailed godwit, ruddy turnstone to mention a few. Another deep mangrove estuary is on the western side of island, **Gulnare Inlet**, which can be explored for many kilometres by dinghy at high tide. Remains of an old logging tramway can be found in an estuary that runs off the right side of the inlet, just beyond the point at which the inlet is navigable at low tide.

Giant toadfish (*Lagocephalus scleratus*)

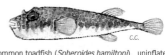

Common toadfish (*Spheroides hamiltoni*), uninflated

Stars and stripes toadfish (*Arothron hispidus*), inflated

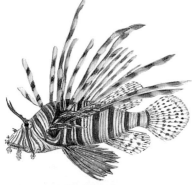

Butterfly cod (*Pterois volitans*)

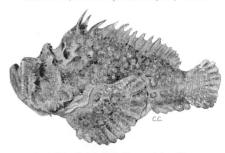

Estuarine stonefish (*Synanceia horrida*)

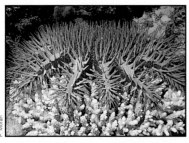

Crown-of-thorns starfish (*Acanthaster planci*)

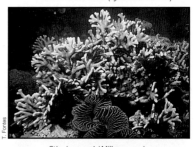

Stinging coral (*Millepora* sp.)

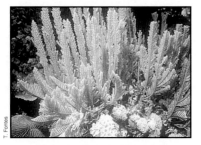

Stinging fern (*Aglaophenia cupressinia*)

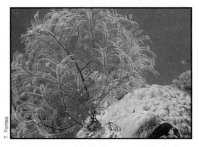

Stinging white hydroid (*Lytocarpus philippinus*)

Tips for tropical travellers

Hints for avoiding a few hazards that may be encountered in warm tropical waters, most of which are avoidable.

Oyster cuts and coral grazes

By far the most common mishap for Whitsunday travellers is a cut or graze received while in the water or on a beach. Any cut inflicted below the high tide mark in the tropics can become infected *in minutes* and, if not treated properly, can develop into a major infection. The problem is caused by marine bacteria, which multiply extremely rapidly in the warm and salty human host, and it is also due to contamination with 'gunk' that invariably gets into these wounds and which produces an allergic reaction in some people. To prevent coral grazes and oyster cuts from becoming a problem:

- **Clean oyster and other shell wounds thoroughly (with a toothbrush if necessary) to remove all pieces of shell and foreign matter.**
- **Apply a disinfectant immediately, preferably one which has an alcohol or aqueous base, such as 'Betadine', 'Savlon' (liquid), 'Hibiclens' or mercurichrome, or one in a powder form (creams are not as good in the tropics where moisture can be the enemy of healing).**
- **Keep applying disinfectant frequently until it is obvious that infection is under control (pain or heat at the site may indicate that infection is still present). If pain persists, seek medical attention.**

Ear infection

Ear infection sometimes occurs in those who spend a lot of time in the water and particularly among those inclined to have 'waxy' ears. Commonly referred to as 'tropical ear', it is caused by too much water in the ears too frequently, so that the ears become 'waterlogged' (never dry properly) and bacterial or fungal infection sets in. Those who have a ten-dency to ear trouble and who will be spending time in the water should have their ears examined by a doctor before going on holiday. A pair of mouldable ear plugs (which fit comfortably) may help.

Sunburn

The Queensland sun gives those who live in the sunshine state the dubious honour of having the highest incidence of skin cancer in the world. The sun is *very* strong in the Whitsundays and can burn even in mid-winter. A broad-brimmed hat and lots of water-resistant sunscreen are essentials, and a lightweight, long-sleeved shirt is a useful item to have when the damage has been done and further damage ought to be avoided.

Minor barotrauma

Pressure-induced ear problems are very common in divers. If you experience difficulty equalising pressure on the aeroplane when travelling to the Whitsundays, you should be warned that you may have problems when diving. Don't dive if you have difficulty equalising.

Fish poisoning (ciguatera)

The word ciguatera comes from a Spanish word 'cigua' and was coined by a Cuban ichthyologist, F. Poey, in 1866 from the name of a small mollusc that causes digestive and nervous disorders when eaten. The ciguatoxin is believed to originate from a motile algae (a dinoflagellate, *Gambierdiscus toxicus*) which is passed along the food web via small herbivorous fishes that consume it along with their normal diet of algae. Predatory tropical reef fishes and reef-feeding pelagic fishes eat the little fishes and thereby accumulate the toxin. Because ciguatoxin is firmly tissue-bound, very little is excreted, and it thus can reach high concentrations in larger carnivorous fishes. *Gambierdiscus toxicus* proliferates around coral reefs where the coral has been damaged (by storms, heavy rainfall, the crown-of-thorns starfish, humans, anchor damage,and so forth). Thus, from time to time, many different species of fish may be affected by ciguatoxin and, therefore, published lists of the species implicated are really of little use because there are few edible species that have not been ciguatoxic at one time or another. The best idea is to check with local fishermen as to which fish to avoid in a particular area.

Certain species of fish in Queensland are known to be frequently toxic and these should *always* be avoided: Chinaman fish *(Symphorus nemato-phorus)*, paddletail or red snapper *(Lutjanus gibbus)*, red bass *(Lutjanus bohar)* (see illustrations on page 95), and moray eel *(Gymnothorax sp.)*. Because of the cumulative nature of the poison, it is possible to ingest a dose that is not sufficient to produce symptoms on one occasion, and then on a subsequent occasion to develop a full-blown case after eating an amount that would not normally cause any problem.

Symptoms – abdominal pain, nausea, vomiting and diarrhoea – develop 2–12 hours after ingestion (usually in about 5 hours). Numbness or tingling about the mouth and in the extremities are common, and victims often experience a characteristic inversion of hot and cold perception (ice cream and cold drinks burn the mouth and throat, a cold can of beer feels hot). Muscle aches and pains are common. Sometimes victims say their teeth feel like they're falling out of their sockets and that they have a metallic taste in the mouth. Rash is common. Recovery usually occurs in 48 hours to 1 week. Tingling and disturbance of temperature perception may last much longer. A large dose of poison may produce subsequent allergic reactions, particularly to fish. In the

event of ciguatera poisoning:

- **If the victim is conscious, induce vomiting; stick fingers down the throat or administer an emetic (syrup of ipecac). If a large amount of toxin has been ingested symptoms can be life-threatening and medical attention should therefore always be sought.**

To avoid ciguatera:

- **Never eat Chinaman fish, red bass or red snapper, paddletail, moray eel. And always ask the locals which fish to avoid.**

- **Avoid eating any fish larger than 4 kilograms; bigger fish are likely to have larger accumulations of toxin.**

- **Don't eat repeated meals from the same fish.**

- **If there are more than the usual number of dead sea birds around, don't eat any fish for several weeks.**

Toadfish

Toadfish (also called puffers, puffer fish, blow-fish, toados) are inherently poisonous and should never be eaten. They also sometimes *behave* in a poisonous manner, which is explained below.

Toadfish belong to the family tetraodontidae, which are 'four-toothed', referring to their four fused teeth. They typically lurk in shallow coastal waters where they hunt for crabs and molluscs, crunching these up with their powerful parrot-beaklike teeth. Toadfish are capable of inflating themselves like a basketball, a practice that perhaps intimidates would-be predators but which certainly makes them very difficult to swallow. Well before Christ, puffers were known to be poisonous. Hieroglyphics of 2700 BC mention the toxicity of Red Sea puffers, and there are biblical warnings against eating fish with no scales (puffers have no scales). The Greeks and Chinese knew of the danger. The poisonous constituent, called tetrodotoxin (TTX, tetraodontoxin), is concentrated in the liver, ovaries, viscera and skin of the fish; nine millionths of one gram (per kilogram of body weight) is enough to kill one mouse in two. It is allegedly the substance that voodoo practitioners in Haiti use to create zombies – those who have apparently died but who remain alive

or, at least, conscious, later to become the 'walking dead'. In Japan, toadfish, which they call fugu, is eaten by the adventuresome in restaurants where specially trained and licensed chefs prepare and present it in delicate floral patterns. Traces of tetrodotoxin produce a pleasant tingling sensation in the mouth which has been likened by enthusiasts to a white Burgundy of a good year, and the sense of danger obviously heightens the experience. The hitch is that if one ingests more than a 'trace', one will first experience tingling and numbness about the mouth and lips, perhaps with a little nausea, progressing to numbness of the tongue and face, followed by slurred speech and progressive muscular paralysis and, ultimately, respiratory paralysis and, perhaps, death. It is unlikely that, forewarned, one will ever be poisoned by a toadfish, but obviously these fish should never be eaten.

Toadfish have also been known to behave in a poisonous manner. The common toadfish (*Spheroides hamiltoni*) is about 12 centimetres long, but another species, the giant toadfish (*Lagocephalus scleratus*), grows to perhaps 96 centimetres long, with proportionately large, powerful teeth and with the arrogance that often accompanies the attainment of power. Giant toadfish have, in years gone by, conducted campaigns of terror in the Whitsundays, biting off the occasional toe (in Shute Harbour, and one in an estuary north of Airlie Beach) and removing the odd golf-ball-sized chunk from a leg (in Cid Harbour). They've occasionally even had the gall to terrorise house guests on the Hayman Island reef. You have to be very unlucky to have a run-in with a giant toadfish – about as unlucky as being hit by a bolt of lightning – but nevertheless it pays to observe the following caution:

- **Always wear something substantial on your feet when wading in shallow coastal estuaries and inlets (this includes when launching boats at ramps).**

Envenomation

A number of species of animals in the Whitsundays are armed with toxic venoms and, unlikely as an encounter is with any of these, it is wise to un-

derstand what to do should it happen. A procedure known as pressure-immobilisation is now widely accepted in first aid for venomous bites and stings, and no longer are heroics such as making incisions and sucking out the poison considered appropriate. Pressure-immobilisation simply involves applying pressure generally to the bite and surrounding tissues, which restricts the flow of venom through the circulatory system. Immobilising the affected limb prevents systemic spread of the poison. Pressure-immobilisation is indicated in all cases of bites and stings *which are not immediately painful* (pain signifies that local tissue damage is taking place, and in these cases the procedure is not always recommended). It is recommended in all cases of snake bite, cone shell stings (see below), some jellyfish stings (if practicable). It is not recommended for fish envenomations. In carrying out pressure-immobilisation:

- **Apply a broad crepe bandage (or any flexible material) over the site of the bite as soon as possible. Don't struggle with removal of pants or shirt if this requires a lot of movement of the affected limb. In cases of bites to the trunk, administration of pressure-immobilisation is more difficult but may be used if it doesn't impair breathing. In bites to the groin and neck, it is probably not feasible.**

- **Bandage over the wound and upwards (away from the toes or fingers) as tightly as you would bind a sprained ankle, extending the bandage as high as possible. If the victim complains of discomfort it probably means that the bandage is too tight and it should be readjusted.**

- **Bind a splint firmly to as much of the limb as possible (up to the elbow in the case of an arm).**

- **Reassure the victim. Seek medical assistance.**

- **Bandages should be left in place until the victim is in capable hands and emergency resuscitation measures have been prepared.**

Sea creatures

Sharks

Many newcomers to the tropics are phobic about sharks, and let it be said at the outset that sharks have never been a problem in the Whitsundays, that is, no attack has been reported in the area in spite of the very large number of visitors that go there each year. The sharks most frequently seen are timid black-tip reef sharks (*Carcharhinus melanopterus*) and unaggressive white-tips (*Triaenodon obesus*), and occasionally divers encounter the odd hammerhead (*Sphyrna* sp.) or tiger shark (*Galeocerdo cuvier*). The Whitsundays are located on a broad part of the continental shelf, where everyone in the sea gets plenty to eat. Nevertheless, prudence is advisable when dealing with potentially dangerous animals in their own environment.

Sharks and other fishes are sensitive to low-frequency vibrations and may investigate the source of these to see if it is wounded and, therefore, easy prey. Don't do wounded fish impersonations by thrashing around in the water making large splashes. Sharks have an acute sense of smell, too, so it's advisable not to swim if you have a bleeding wound and not to urinate in the water. Don't swim near dropoffs nor adjacent to deep channels, and avoid swimming from late afternoon onwards. Snorkel or dive in a group or with at least one other person. If spear fishing (where this is permitted – see page 27), remove speared fish from the water *immediately*. Never tether fish close to the body.

Stonefish

Stonefish (*Synanceia horrida, S. verrucosa*) are the most diabolically ugly creatures one is ever likely to encounter. However, their ugliness is of little concern as it will rarely meet the eye, they being so perfectly disguised that they are virtually impossible to see. Stonefish are usually about 20 centimetres long. Their scaleless skin is covered with 'warts' and slime. They look as though they have run into a brick wall at full speed, resulting in the shifting of most of their bulk forward on their frame, the pugging of their face and the accordion-plaiting of their brow. They lie in shallow water, the rubble on reefs or on muddy shores, where they scoop out a rest-

ing place with their large pectoral fins and wait for an unsuspecting fish to come by. When one does come by, it is 'inhaled' as if by a rock with hideous upturned mouth, so fast that if you blinked you missed it. Stonefish have 13 dorsal spines that become erect when it is disturbed and which are capable of penetrating a sandshoe. Each spine has a venom sack, and if stepped on, the skin around the spine is depressed causing venom to 'explode' upwards into the foot. It's a completely involuntary action on the part of the fish. Wounds so inflicted are excruciatingly painful, the effects of which may last for weeks. There is laboratory evidence that the venom can produce loss of function in all types of muscle. The wound is usually accompanied by acute swelling spreading up the limb and which may persist for many weeks. In the event of a stonefish encounter:

- **Control of pain is most important. Do not apply pressure-immobilisation. The venom is protein; soaking the affected limb in hot water (up to 50°C) has been found useful in relieving pain.**
- **Antivenom is available and probably should be administered in all but mild cases.**
- **Always wear substantial footwear when reef walking or when on rubble around mainland beaches. Never run in these areas.**

Butterfly cod (lionfish, zebrafish, fire cod)

Butterfly cod (*Pterois volitans*) are found around coral reefs. They are curious creatures and will sometimes approach divers in the water, pointing their long, lancelike dorsal spines in front of them as they get near. These spines have glands which produce venom akin to that of one species of stonefish. It produces a severely distressing sting which usually subsides within a couple of hours (although it can last for several days). Local effects of the sting are usually the most significant (vomiting and fever are sometimes reported). If you tangle with a butterfly cod:

- **Immerse the wound in hot water (up to 50°C). Do not use pressure-immobilisation.**

Stingrays

Stingrays are very common in the Whitsundays particularly on sandy bottom. They are, biologically, flattened sharks that have taken to bottom-dwelling. They have flat teeth modified for crunching up molluscs and crustaceans, and they are often found lying on the bottom where they flick sand onto their back, which makes them very hard to see. Stingrays are very timid and will always run away if they have a choice; if you step on one and pin it to the bottom, it will probably lash out with its tail which, unfortunately, has a barbed, venomous comb that can cause a very painful wound. As much damage, if not more, is done by the physical trauma caused by the spines as is done by the stingray venom itself, which, like that of the stonefish, is protein. The wound may be ugly, painful, and it will invariably be contaminated with animal tissue and foreign matter which needs to be cleaned out. Proper treatment is usually beyond the capability and the resources of the average holiday-maker, and medical attention for these wounds is a good idea. Considering the great number of rays that are about, it is surprising that there are so few wounds inflicted by them. To avoid stingrays:

- **Always shuffle your feet in sandy areas. Probing the sand in front of you with a walking stick is an effective means of 'sweeping' your path.**
- **If diving, don't cruise close over a sandy bottom but a metre or so above it.**
- **Pressure-immobilisation is not recommended.**
- **Wash the wound and clean it out thoroughly to remove venom and foreign tissue that may be in it.**
- **Hot water may be useful in controlling pain.**

Box jellyfish

Box jellyfish (*Chironex fleckeri*) are sometimes referred to as sea wasps, an inappropriate name that trivialises the danger they pose. The are probably the world's most venomous jellyfish and, as far as swimmers are concerned, are the scourge of north Queensland mainland waters, where they are present from November to April or May. In the Whitsundays the

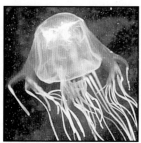

Box jellyfish (*Chironex fleckeri*)

peak season is March–April. They are not a problem on the islands. Box jellyfish breed in mainland rivers and estuaries and come down to the coast in late spring where they patrol the adjacent beaches, just outside the surf line, looking for small shrimps, which are their favourite food. They are, as one might suspect, cuboid in shape and can grow as big as 20 centimetres on each side with up to fifteen 3-metre-long tentacles on each quadrant. They are agile swimmers and reportedly avoid dark objects in the water (that is, they try to get out of a swimmer's way if they can, which it is not always possible to do, for example, when a swimmer runs down the beach and headlong into the water).

Box jellyfish pack a lethal wallop and they have been responsible for a number of deaths. They are frequently encountered on glassy, overcast days, sometimes after bad weather. The sting is excruciatingly painful and leaves bands of weals 4 millimetres wide with a characteristic frosted cross-hatching. Children are very susceptible because their skin is thin and because they receive a relatively high dose of venom (measured in milligrams/kilogram of body weight). In the event of a box jellyfish sting:

- **Get the victim out of the water and lying down on the beach. Douse any adhering tentacles with household vinegar for 30 seconds before attempting to remove them (vinegar inactivates the stinging cells that have not already fired; it does nothing for the stings already inflicted).**
- **Do not rub the stingers with sand.**
- **Be prepared to give resuscitation. Seek medical help.**

- **Pain is usually only temporarily relieved by topical applications.**
- **Antivenom is available; early administration will help reduce the incidence of scarring.**

To avoid box jellyfish stings:

- **Listen for jellyfish alerts and observe signs on beaches during the November–May season.**
- **During the season, when swimming on mainland beaches (if not in a stinger-free enclosure) wear protective clothing or a stinger suit.**
- **Don't rush headlong down the beach into the water.**

Other jellyfish

Temperate and tropical waters have a number of other jellyfish that are best avoided, two of which warrant particular mention – the bluebottle (*Physalia physalis*, also called the Portuguese man-of-war) and the irukandji (*Carukia barnesi*). The bluebottle has an inflated, pale blue, translucent bag that blows along the surface acting as a sail for a colony of specialised animals, some of which are the sail trimmers and some the executioners (the latter being the deep blue stingers, some of which are quite long). The sting is painful and produces a characteristic line of separate oval weals, white in the centre with red edges. Should you have a run-in with a bluebottle:

- **Wash the sting area with water.**
- **Apply cold packs for 10 minutes; re-apply them if skin pain persists.**
- **Get medical attention if symptoms persist.**

The irukandji is a very small jellyfish (2–2.5 centimetres) with tiny red dots on the surface. A cuboid, it has four solitary tentacles, white and hairlike when extended, and can produce a unique syndrome with delayed symptoms 20–30 minutes after the sting. Initially only mildly painful, the sting develops into a 'goose pimple effect' with mild redness around the site, perhaps 5–7 centimetres wide. About half an hour later a symptom complex develops – limb pains, severe backache, abdominal and chest pains, perhaps accompanied by nausea, vomiting, restlessness. Because of this post-sting syndrome, victims should not go back into the water for at least 2

hours. If similar symptoms are experienced within an hour of swimming in the summertime, the possibility of irukandji sting should be considered. In the event of an irukandji sting:

- **Douse the sting with vinegar followed by the application of a vinegar-soaked pad and compression bandage. Send for medical aid immediately.**
- **Don't go back into the water for at least 2 hours. In case of severe abdominal pain or backache which occurs within 2 hours of leaving the water, especially if a jellyfish sting has been noted, suspect irukandji before submitting to surgical removal of the appendix or exploratory abdominal surgery (this has happened!).**

Cone shells

Cone shells (*Conus* sp.) are numerous in Australian waters (some seventy species), about seven of which are potentially dangerous to man (see illustrations on page 120). They have beautifully patterned and coloured shells, although their beauty is not always obvious due to a thick green covering of slime.

Cones are carnivorous gastropods that inhabit shallow intertidal waters of coral reefs, where they remain buried or under a rock by day and come out at night to do their marauding. They eat worms, fish, other gastropods and octopuses, all of which they immobilise with a poisoned 'harpoon'. This barbed tooth, of up to 1 centimetre length, is firmly held in the end of the proboscis and is jammed into their prey while venom is squeezed through the tooth cavity. Each barbed tooth is used only once, which is usually enough, although cones have a quiverful of them held in reserve. Cones can distend their proboscis to envelope an object about their own size. They have an acute sense of smell which they locate by sampling the water with a tubelike siphon.

The species that eat fish are potentially most dangerous to man, but since you cannot ask them what they eat, it is best to assume that, whatever that cone is that you shouldn't have in your hand, it is potentially lethal. A myth has been perpetuated that cones can safely be held by the thick end; they can reach *either* end

from the cleft in their shell, so don't pick them up without barbecue tongs and don't slip them into your pocket. The sting is sometimes very painful, and it may be followed by incoordination and muscular weakness, blurred vision, difficulty in swallowing, slurred speech; the ultimate symptom is respiratory paralysis. Some sixteen fatalities have been reported. In the event of cone shell envenomation:

- **Immediately apply pressure-immobilisation and be ready to give resuscitation. Keep the bandages in place until medical assistance and resuscitation equipment are available. Prolonged resuscitation may be required.**

To avoid getting stung:

- **Don't pick up *cones* with bare hands.**

Crown-of-thorns starfish

The crown-of-thorns (*Acanthaster planci*) is a predator of corals and in recent decades has been responsible for considerable damage to reefs in the Great Barrier Reef region, primarily from Lizard Island to Townsville but in the Whitsundays as well. The starfish is a normal part of the reef community and is but one of a number of coral predators. However, it is the only one that is known to cause physical damage on such a large scale.

The starfish is to be avoided by humans because its spines can inflict a painful, venomous wound if they penetrate the skin. Allergic dermatitis has also been reported by people who have simply handled the starfish. In the event of an encounter:

- **Remove any loose spines by pulling them straight out so as to avoid snapping them off in the wound; embedded spines will probably require medical attention.**
- **Immersing the wound in hot water may alleviate pain.**
- **Apply a local antibiotic, such as neomycin, to the wound and continue applications until the wound is healed.**
- **Dermatitis may be alleviated by a hydrocortisone ointment.**

Sightings of crown-of-thorns should be reported to the Great Barrier Reef Marine Park Authority, PO Box 1379, Townsville, Qld 4810.

Sea snakes

Virtually unknown in the Atlantic Ocean, there are some thirty-two species of sea snakes recorded in northern Australian waters. Sea snakes look like their land brethren but have flaps over their nostrils and a paddlelike tail which aids their swimming. Their nostrils, flattened tail and scaly appearance helps to differentiate them from eels. They can absorb about one-fifth of their oxygen requirements directly from the water and are capable of extended (2-hour), deep (100 metre) dives. They shed their skin frequently, perhaps every 2 weeks, which solves their anti-fouling problems. Most are born alive at sea.

Many divers say that sea snakes worry them more than do sharks – not that either causes much trouble for divers on the Barrier Reef. Sea snakes are seldom aggressive (except possibly during the mating season, in winter) but they are very curious, and they are fascinated by elongated objects and will sometimes entwine themselves around divers' equipment, such as their auxiliary breathing hose, and this can be somewhat unnerving. The advice given is simply to inflate one's buoyancy vest a little so as to lift one off the bottom, and the snake will usually go away. It is not advisable to provoke sea snakes, for they can become aggressive, and then they are extremely persistent. Their swimming changes from leisurely and undulating to very rapid, their head hardly moving at all, and they come spearing in. The usual defence is to kick them off with the fins, which is quite effective, provided one can keep it up for long enough; sea snakes don't always go away after the first pass.

Many myths persist about sea snakes. It is often heard that, because they have short fangs (2.5–4.5 millimetres) and (usually) small mouths, they can't bite very effectively. The truth is that their fangs are adequate to penetrate the skin, and they can open their small mouths wide enough to bite a flat table-top. Even a small snake can bite a man's thigh. Sea snakes can swallow fish that are more than twice the diameter of their neck.

Sea snake venom is highly toxic and appropriate for the job it is intended to do – to immediately immobilise fish so that they can't swim away and to

make them completely relax so that the snake can swallow them easily with dorsal spines flattened.

Most sea snake bites occur on trawlers, when the snakes are sometimes hauled in with the catch. Only a very small percentage (4–5 per cent) of sea snake bites are fatal to man, probably because the snakes voluntarily control the injection of venom, and if they do not intend eating something, they often don't bother to waste venom on it. Sea snakes are not a problem in the Whitsundays.

Where first-aid measures are not taken, symptoms of bites occur within half an hour and include visual disturbance, muscular weakness, pain, progressing in severe cases to paralysis and respiratory failure.

- **Antivenom is available for treatment of sea snake bites.**
- **Pressure immobilisation and resuscitation are the recommended first aid.**

Stinging hydroid, fern

Stinging hydroids (*Lytocarpus* spp., *Aglaophenia* spp.) are fern-like 'plants' that aren't plants at all and which pack a sting that belies their appearance. The white stinging hydroid in particular has a penchant for finding the gaps in divers' wet suits, and any contact can produce an extremely uncomfortable sting with rash and, in more severe cases, gastrointestinal symptoms. In the event of contact with a stinging hydroid:

- **Apply cold packs for 10 minutes. Re-apply if skin pain persists.**

Fire coral, stinging coral

Fire coral (*Millepora* sp.) looks like greenish-brown staghorn coral with white/yellow tips. It has thousands of minute 'pores' (hence the name) through which it can poke its stinging cells (nematocysts). If touched with bare skin *Millepora* can produce an uncomfortable burning itchy sting with swelling and, in severe cases, associated nausea and vomiting. If you get into a scrape with *Millepora*:

- **Apply cold packs for 10 minutes. Re-apply them if skin pain persists.**

A

Abeles, Sir Peter 167
Abell brothers 168
Abell, E.S. 157
Abell Point 20, 21
Abell Point marina 20, 21
Aboriginal
 artifacts 127, 128, 129, 130, 136
art 127, 136
Aborigines 124-36, 139, 143, 155, 159, 161, 168, 170, 172, 173, 175, 177, 178, 179, 180, 181
Acanthaster planci 182, 187
Ada, cyclone 157 169, 178
Adderton, Abraham 170
Adderton, Sarah 170, 172
Adelstein, Peter 171
Adlem, Mick 166
Agassiz, Andrew 169
Aglaophenia cupressinia 182, 187
Ahern, Michael 158
Airlie Beach 9, 20, 82
airports, serving the Whitsundays 20
airstrip, Whitsunday 21
Akhurst Island 154, 166
Akhurst, William 154
Alectura lathami 64
Alert, HMS 126, 146, 143, 177
algae 42, 45, 46, 60
cementing 46
encrusting 42
in coral reef formation 42
role in coral reefs 42, 45-6
symbiotic relationship with corals 42, 45-6
symbiotic relationship with clams 118
Altmann, Carl 172, 173
Altmann, Frances 172, 173
Anchor Islands 177
Anchorage 154, 155, 156, 157, 158, 159, 160, 161, 166, 167, 169, 170, 171, 182, 175, 176, 177, 178, 180, 181
anchoring *see* boating
Anderson, Charlie 166
Annesley, Claude 177
Ansett Transport Industries 157, 167, 178
Ansett, Reginald 165
ant
 green tree (*Oecophylla smaragdina*) 71
 sugar (*Camponotus* sp.) 70
Anvil Island 177
Araucaria cunninghamii 17, 54, 55, 58, 59, 155, 156, 168, 171, 174
Archer, Colin 132
Ardea sacra 63
Argusia argenta 55, 56, 57
Argyrosomus hololepidotus 91
Arhopala centaurus 71
Arkhurst Island, *see* Akhurst Island
Armit Islands 154
Armit, Robert M. 154
Arothron hispidus 182
Atractoscion aequidens 91
Australian brush turkey (*Alectura lathami*) 64, 173
Australian Pacific Tours 173
Australian Resorts Pty Ltd 156

B

Babieca Summit (Cid I.) 156
Bahadschia argus 121
Bait Reef 15, 27, 47, 49, 108
Bali Hai 154
Ball, Frank Wylde 164
Banfield, E.J. 147
Banks, Joseph 53
bareboat yacht charter, *see* boating
barotrauma 183
bar-shouldered dove (*Geopelia humeralis*) 61, 63
barracouta 95
Barrier Reef, Great
 see also Great Barrier Reef
 origin of name 140
Barrier Reef islands 11
Barrier Reef Islands Pty. Ltd. 157
Barrier Reef Resorts Pty. Ltd. 167
Bathurst, HMS 143
Bauer family 178
Bauer Bay (S. Molle I.) 74, 179
Bauer, Anna 151
Bauer, Ernie (Pop) 151
Beach thick-knee (*Burhinus mangirostris*) 64, 154, 159 161
bêche-de-mer (trepang) 119, 121, 136
Bedwell, Staff Cmdr E.P. 143, 144, 155, 15^, 158, 159, 160, 165, 172, 173, 177
Bingham, Cmdr Henry M. 143, 170, 176, 179
birds
 avoiding disturbance of nesting 29
 highlights 62-65
 migratory 181
 nesting season 29
bivalve 118
Bjelke-Petersen, Sir Joh 164
Black Island 154
Black kingfish (*Rachycentron canadus*) 91
Black spot tusk fish (*Lethrinus schoenleinii*) 90
Blackboy (*Xanthorrhoea* sp.) 58, 59
Blackwood, Lt Francis P. 143
Blake, Egbert Mabille (Jim) 146
Blake, Herbert Henry 146
Bligh, William 40, 140
blue bottle (*Physalia physalis*) 186
Blue Pearl Bay (Hayman I.) 22, 167
blue tiger *see* butterflies
boating 73-8
 anchoring 28, 76
 bareboat yacht charter 76-7
 'bullets' 76
 crewed charter 78
 cruising itinerary 77
 facilities and services
 launching ramps 75
 marinas 75
 slipping 75
 in the marine park 78
Boat Port (Lindeman I.) 171
Bolton Hill (Cid I.) 156
Bona Bay (Gloucester I.) 160
Boomerang 130
Border 158
Border Island 46, 154
Bounty, HMS 140

Bowen 131, 134, 141, 144, 176, 180, 181
Bowen Mineral Company 166
box jellyfish (*Chironex fleckeri*) 185-6
brain coral, *see* coral
Brampton Island 155-6
Brampton Peak 156
Breakfast Bay (Gloucester I.) 160
Broad Sound 18
Brooks family 173
Brooks, the 151
brush turkey, Australian (*Alectura lathami*) 64, 173
Bryant, Mary 140
Bryant, William 140
Bull, Tony 173
Burdekin plum (*Pleigynium timorense*) 55, 56
Burhinus mangirostris 64, 159, 161
Burhinus neglectus 64
Burning Point 177
Burt, Bryan 164
Busuttin, Arthur and Jess 156
butterflies
 blue tiger (*Danaus hamatus*) 71, 171
 common Australian crow (*Euploea core*) 71
 oakblue (*Arhopala centaurus*) 71
 Whitsunday azure (*Ogyris zosine zolivia*) 70, 171
Butterfly Bay (Hook I.) 106, 169
butterfly cod (*Pterois volitans*) 182, 185
Butterfly Valley (Lindeman I.) 171

C

Cacatua galerita 65
Calder Island 141
Caldwell, Norman W. 161, 167
camping 79-85
 campfires 81
 campsites 82-3
 equipment and food 80-1
 hygiene in the bush 84
 minimal impact 84
 permits 26, 79
 transport to the islands 80
Camponotus sp. 70
cannibalism 131, 134
Cannon Valley 161
Cannonvale 9, 10, 20, 161, 172
canoe, Aboriginal 126-7
Cape Conway 13, 126, 137, 138, 139, 142
Cape Gloucester 138, 142, 160
Cape Hillsborough 74, 83, 128, 129, 138, 139
Cape Hillsborough National Park 81
Carapark Hotels 156
Carden-Collins, A.J. 166, 178
Cardwell cabbage (*Scaevola sericea*) 55
Carlisle I. 155, 156, 180
Carukia barnesi 186
Casuarina equisetifolia 55
Cateran Bay 155, 157
Catherwood, Eric 157, 178
Catherwood, Nell 157
Catseye Bay (Hamilton I.) 165
Catseye turban (*Turbo petholatus*) 120

Chalkie's Beach *see* Stockyard Beach
Charonia tritonis 120
Chelinus undulatus 90
Chelonia midas 68
Chinaman fish (*Symphorus nematophorus*) 95, 183
Chironex fleckeri 185-6
Chisholm, James Robertson 145, 146, 156
Chlorodesmis fastigiata 60
Choerodon cephalotes 90
Choerodon venustus 90
Christy, Les 180
Cid Harbour 57, 58, 60, 66, 132, 134, 144, 146, 156, 180, 181
Cid Island 181
ciguatera (fish poisoning) 94, 183-84
Clear View Gardens 173
Climate *see also* weather
 effect of ice ages on 51
 effect of plate movements on 52
 of the Whitsundays 15
Club Crocodile Holdings 173
Club Med 171
Cnidaria 41
Cock, James 180
Cockatoo Beach (N. Molle I.) 174
cockatoo, sulphur-crested (*Cacatua galerita*) 65, 179
Coconut Beach (Lindeman I.) 171
cone shells (*Conus* sp.) 120, 186
Contiki 173
continental drift, theory of 32
 see also plate tectonics
continental islands, meaning of term 14
Conus geographus 120
Conus textilis 120
Conway, Cape *see* Cape Conway
Conway, Henry Seymour 138
Conway National Park 9, 74, 83, 85
Conway Range 9, 35
Cook, James 9, 13, 125, 128, 137, 138, 139, 160, 172, 175, 180
Cooke, Allan and William 178
Coppersmith Rocks 177
Coral 41-9
 animal 41-3
 brain 44
 biological calssification 41
 collecting 27
 colour of 115-16
 fire 187
 growth forms 44
 mushroom 44
 planula 43
 plate 44
 polyp 41, 42, 43, 44, 115
 reefs
 biological zones 45
 conditions for growth 41
 fringing 45, 116
 origins 44-5
 platform 45
 visiting a 113-23
 reproduction 43
 slipper 44
 staghorn 43
 stinging 182, 187
Coral Art (Dent I.) 151, 159
corallite 42

Coral Sea 37, 181
 Battle of the 181
Coral Sea Enterprises 173
coral tree (*Erythrina variegata*)
 56, 57
coral trout (*Plectropomus* sp.)
 86, 87, 90
Cormorants 161
Coryphaena hippurus 91
county of Cumberland *see*
 Cumberland, county of
cowrie shell (*Cypraea* sp.) 120
crabs *see* crustaceans
Crayfish Beach (Hook I.) 169
Credlin Reef 156
Crinium pedunculatum 57
crinum lily (*Crinium*
 pedunculatum) 57
crocodile
 estuarine saltwater (*Crocodilus*
 porosus) 69
 -catching 161
Crocodilus porosus 69
Croft, Timothy 173
crown-of-thorns starfish
 (*Acanthaster planci*) 182, 187
crustaceans 122
 crabs
 ghost (*Ocypode*
 ceratophthalma) 122
 green (*Thalimata* sp.) 122
 hermit (*Dardanus megistos*)
 119, 122, 123
 portunid (swimming) 122,
 123
 rock 123
Cumberland, county of 13, 144,
 155, 160
Cumberland, Duke of 139
Cumberland Group 155, 156
Cumberland Islands 139, 172
 named by Cook 9, 13
 names 144
 official definition of 13
 used synonymously with
 'Whitsunday Islands' 13
Cumberland Isles 13
Cumbria, county of 144
Cunningham, Allan 142, 143,
 173, 176, 177
Cunningham, Martin 181
curlew, eastern 181
curry fish (*Stichopus variegatus*)
 121
cycad 179
cyclone
 Ada 157, 169, 178
 season in the Whitsundays 15
Cymatiidae 120.
Cypraea caurica 120

D

Dacelo novaeguineae 65
Dalrymple, G.E. 128, 130, 155
Danaus hamatus 71
Dardanus megistos 119, 122,
 123
Day Dream 150, 157
Day Dream 156
Daydream Island 147, 150,
 151, 156-7, 164, 178
Daydream Island Travelodge
 Resort 157
Debney, Douglas 178
Deloraine Island 143, 157-8
Deloraine, William of 158
Denison, Port *see* Port Denison
Denman island 156, 158, 178,
 179
Dent Island 126, 135, 147,

151, 158-9, 164, 173
Dent, Lt Albert 158
Diadema setosum 121, 123
Diadematidae 121
Dicaeum hirundinaceum 70, 71
Dick, MV 143
Dinghy Bay (Brampton I.) 156
Dingo Beach 73, 75, 82
diving and snorkelling 97-111
 around the islands 103
 island sites 105-108
 reef sites 108-111
 in the Coral Sea 103
 opportunities in the
 Whitsundays 97
 safety 103
Dolphin
 bottlenose (*Tursiops truncatus*)
 66
 spinner (*Stenella longirostris*)
 66
Dolphin fish (*Coryphaena*
 hippurus) 91
Dolphin Point (Hayman I.) 161
Double Cone Island 159
Drake, Collin 173
Dryander, Mount 143
Ducula spilorrhoa 65, 154,
 159, 175, 176
dugong (*Dugong dugon*) 60,
 66, 130, 181
Dugong Beach (Whitsunday I.)
 181
Dugong Inlet (Cid Harbour) 181
Duke and Duchess of Kent 171
Duke of Cumberland 139
dyke 35, 175

E

Earlando 82
ear infection 183
East-West Airlines 171
echinoderms
 sea cucumber
 curry fish (*Stichopus*
 variegatus) 121
 Holothuria atra 121
 Holothuria spilota 121
 leopard fish (*bahadschia*
 argus) 121
 lolly fish (*Holothuria atra*)
 121
 prickly red fish (*Thelenota*
 ananas) 121
 Stichopus chloronotus 121
 sea urchin, needle-spined
 (*Diadema setosum*) 121
 starfish
 blue (*Linckia laevigata*) 121
 brittle star (*Ophiaracachnella*
 gorgonia) 122
 brittle star (*Ophiomastix* sp.)
 122
Edgell, Cpt J.A. 169
Edward group 143
Edward Island 159
Edwin Rock 161
eel grass 60
egret, eastern reef (*Ardea*
 sacra) 63
El Cid 156
Ellida 29, 125, 130, 132, 133,
 136, 170
Elsey, Bernard 157
Embury, Monty 148, 150, 151,
 167
Endeavour 137, 138
Endeavour Reef 138
envenomation, treating 184
epaulette shark (*Hemiscyllum*

ocellatum) 122, 123
Epinephelus tauvina 90
Epinephelus tukula 90
Eretmochelys imbricata 68
Erythrina variegata 56, 57, 58
Eshelby Island 160
Eshelby, Alfred E. 160
Esk 160
Esk Island 152, 160
estuary cod (*Epinephelus*
 tauvina) 90
Eucalyptus exserta 166
Eucalyptus platyphylla 55, 171
Euploea core 71
Evetts, Tom 170

F

Fairey Reef 110
Faithful, Fred 166
Fantasea Reef World 110, 112
Faust, Peter 159
fingermark (*Lutjanus johnii*) 90
fire
 Aborigines' use of 53-4, 164,
 172, 173, 175
 campfires 81
 influence on Australian flora
 53
 in the marine park 26
 fire cod *see* butterfly cod
fire coral (*Millepora* sp.) 187
fish
 bag and size limits 90-1
 helping those released to
 survive 94
 identification 90-1
 poisoning 94-5
fish feeding
 not recommended 29
fishes
 protected species 93
fishing 87-95
 bag and size limits 90-1, 94
 game 89
 identification and
 measurement (crabs) 93
 identification and
 measurement (fishes) 90-1,
 94
 in the marine park 26
 reef 87-8
 restrictions 26, 93
 spear 27, 93
 tackle 87, 92
 trolling rigs 92
Fitzalan, Eugene 144
Fitzalan Passage 180
Fitzalan Point 132, 144
Flinders, HMS 141
Flinders, Lt Matthew 41, 140,
 141, 142, 155
Fly, HMS 128, 143, 172
flora, evolution of
 Australian 51-3
flying fox, black (*Pteropus*
 alecto) 67, 171
Forster, W.J.B. 178
fringing reef, *see* coral reefs
fruit bat 67, 171
fugu 184
fungia 44

G

Galbraith, William 158
Gambierdiscus toxicus 183
Gap Beach (Lindeman I.) 171
gastropods *see* molluscs
GBRMPA, *see* Great Barrier
 Reef Marine Park Authority

Geelong, SS 156
Geographers Beach (Henning I.)
 167
geology of the Whitsundays 31-
 9
Geopelia humeralis 61, 63
George III, king 139, 160
George VI, king 167
Geranium, HMAS 141
giant triton *see* molluscs
Glaucosoma scapulare 90
Gloucester, Cape, *see* Cape
 Gloucester
Gloucester, Duke of 139
Gloucester Island 36, 79, 138,
 142, 153, 160
 gelolgical origin of 36
Gloucester Passage 160
goanna, sand (*Varanus gouldii*)
 69
Goat Island 177
goat's foot convolvulus
 (*Ipomoea pes-caprae*) 55, 57
golden orchid (*Dendrobium*
 discolor) 56, 57, 58
Goldsmith Island 142, 160-1,
 177
Gondwana 32, 52
Googaburra 126
Gordon, Donald Coutts 145,
 146, 172
Gorringe, J.A. 164
Gould, Ron and Elain 178
Grammatorcynus bicarinatus 91
Grant, Bill 150, 173
grass sweetlip (*Lethrinus fletus*)
 90
grass tree (*Xanthorrhoea* sp.)
 58, 59, 155, 171
Grassy Island 161, 167
Great Barrier Reef
 complex of coral reefs 41
 Marine Park 23, 25
 Marine Park Authority
 (GBRMPA) 23
 origin of name 41
Great Dividing Range *see* Great
 Escarpment
Great Escarpment 37
great southern continent 137
Grey, Zane 167
Guettarda 55
Gull, silver (*Larus*
 novaehollandiae) 65, 175
Gulnare inlet (Whitsunday I.)
 58, 167, 175, 180, 181
Gumbrell, Edward James 161
Gumbrell Island 161
Gymnothorax sp. 183

H

Haemotopis longirostris 63
Haemotopus fuliginosus 63
Haliaeetus lecogaster 62, 159,
 165
Haliastur indus 63
Hallam, Bert and Bob 150, 167
Hamilton harbour 164, 165
Hamilton Island 57,146, 158,
 159, 164-5, 167, 173
Hamilton Island Enterprises
 165
Hannah Point (N. Molle I.) 143,
 174
Happy Bay (Long I.) 141, 151,
 173
Hardy, Norman 49
Hardy Reef 27, 49, 110–11,
 112

Haslewood Island 46, 143, 157, 165-6, 166, 173
Haslewood, Sublt Frank 165
Hayman Island 36, 46, 139, 143, 147, 150, 151, 161, 166-7, 169
Hayman, Thomas 167
Hemiscylium ocellatum 122
Henning Island 167-8
Henning, William H. 167
Hill Inlet (Whitsunday I.) 39, 181
Hill, Wills 138
Hillsborough, Cape see Cape Hillsborough
Hillsborough, Viscount 138
Holiday Inns 165
Holothuria atra 121
Holothuria spilota 121
Holothuridae 121
Homestead Bay (Cid I.) 156
Hook Island 34, 106, 107, 108, 168-9, 175, 180
Hook Island underwater observatory 169
Hook Peak (Hook I.) 168
Hook Reef 27, 47, 49
hoop pine (Araucaria cunninghamii) 17, 54, 55, 58, 59, 155, 156, 166, 167, 168, 171, 174, 175, 177, 179, 180
Horn, The 130, 177
Hurford, Tom 173
hussar (Lutjanus adetii) 90
hydroid, stinging
 white (Lytocarpus philippinus) 182 187
 fern (Alaphenia cupressinia) 182

I
ice age 51
Indian head (Pentecost I.) 37, 175
Ingot Islets 177
inner route 140, 142
Investigator, HMS 140, 155
Ipomoea pes-caprae 55, 57
irukandji (Carukia barnesi) 186

J
Jeffreys, Lt Charles 142, 146, 178
Jeffreys, Mount 177, 178, 179
jellyfish 41, 185, 186
Jennings Industries Ltd. 157
Jewel Hotel Group 178
Jillett, Katy 177
Joe's Beach (Whitsunday I.) 181
Johnson, F.C. 178
Johnson, John 134
Johnson, Samuel 134
Jubilee Pocket 168

K
Kangaroo, HM Brig 142, 178
Kean, Hugh Percival (Percy) 146, 164, 172, 178
Kennedy Sound 131, 136, 171
Kennedy, Jim 157, 178
Kent, Duke and Duchess of 171
King George III 160
King George VI 167
King, Lt Philip Parker 142, 143, 159, 169, 172, 173, 174, 175, 176, 177
kite, brahminy (Haliastur indus) 63
Kookaburra, laughing (Dacelo

novaeguineae) 65, 179

L
L Island 139, 153
L1 Island 139, 153
L2 Island 139
Lady Nelson, HMS 140, 141, 142, 155, 177
Laguna Quays 176
Lambis lambis 121
Lamond Hill 177, 179
Lamond, Henry 149, 151, 157, 178
landscape, Whitsunday 51–60
Langford Island 108, 169-70
Langford, J.E. 177
Langford, William 169
large mouth nannygai (Lutjanus malabaricus) 90
Larus novaehollandiae 65
Laurence, Peter 157
Lee, A.F.E. (Boyd) 150, 154, 161, 166, 167
leopard fish (Bahadschia argus) 121
Lethrinus fletus 90
Lethrinus miniatus 90
Lethrinus nebulosus 90
Lethrinus schoenleinii 90
Lighthouse
 Dent I. 159
 Eshelby I. 160
Linckia laevigata 121
Lindeman, Dr Henry 170
Lindeman, Sublt George S. 170
Lindeman Island 126, 132, 133, 146, 148, 170-1, 174
Lindeman Wine Company 170
Line Reef 27, 47, 49, 111
Linnaeus see Linné, Carl von
Linné, Carl von 172, 177
Linné, Island 142, 172, 177
Linné, Peak 172, 177
Linnéan Society 177
lionfish see butterfly cod
Little Grassy Island 161
Littler, A.B. 164
lizard, Burton legless (Lialis burtonis) 69
lolly fish (Holothuria atra) 121
Long Island 145, 146, 172-3
Louisa Maria 127, 132, 133, 134-5, 136, 181
Luncheon Bay (Hook I.) 106, 169
Lupton Island 141, 165, 166, 173
Lutjanus adetii 90
Lutjanus argentimaculatus 90
Lutjanus bohar 95, 183
Lutjanus carponotatus 90
Lutjanus erythropterus 90
Lutjanus gibbus 95, 183
Lutjanus johnii 90
Lutjanus russeli 90
Lutjanus sebae 90
Lytocarpus philippinus 182, 187

M
McCulkin, Vern 166
Macdonald, Dr John 164, 166, 167
Mackay 9, 51, 79, 83, 131, 136, 137, 144, 156, 180
Mackay Tours Ltd 170
mackerel
 broad-barred (grey) (Scomberomorus

semifasciatus) 91
 school (Scomberomorus queenslandicus) 91
 sharkey (Grammatorcynus bicarinatus) 91
 Spanish (Scomberomorus commerson) 91
 spotted (Scomberomorus munroi) 91
Mackerel Bay (Hook I.) 106
McIvor, Alexander 134
McLean, Tom 156
Maclear, Capt J. 143
Macona Inlet (Hook I.) 54, 58, 169, 175
Macquarie, Governor Lachlan 142
Mandalay Point 75
mangrove Jack (Lutjanus argentimaculatus) 90
mangroves 59-60
Mansell Island 36, 143
 geological origin 36
Manta Ray Bay (Hook I.) 107, 169
Manta Ray Drop-off (Bait Reef) 109
mantles 119, 120
Maori wrasse (Chelinus undulatus) 90
marina, see boating facilities
marine park
 Great Barrier Reef 23, 24-5
 State 23
 zones 25
Maryport Bay 156
Matthews-Frederick, Tom 170
Maureen's Cove (Hook I.) 107, 169
Mausoleum Island 174
May's Bay (Whitsunday I.) 60
Megapodius reinwardt 64, 168, 171, 181
Megaptera novaengliae 66
Melomys cervinipes 67
melomys, fawn-footed (Melomys cervinipes) 67
Merkara, Mount 143
Mermaid, HMS 142, 143, 159, 160, 173, 174, 175, 176, 177
Michener, James 154
Mid Molle Island 156, 178
Midge Point 143
Millepora sp. 187
Minstrel Rocks 158
mistletoe 70, 171
mistletoe bird (Dicaeum hirundinaceum) 70
Molle Group 156, 174, 177
Molle Island 146, 178
 see also South Molle Island
Molle Islands 178
Molle, Col George James 142, 178
Molle, Port see Port Molle
molluscs 118-19
 baler (bailer) shell (Neki anogira) 120
 clams
 burrowing (Tridacna crocea) 118
 giant (T. maxima) 118
 catseye turban (Turbo petholatus) 120
 cone shell
 geography (Conus geographus) 120
 marble (Conus mamoreus) 120

textile (Conus textilis) 120
 spider shell (Lambis lambis) 121
 triton, giant (Charonia tritonis) 120
 trochus 119, 121, 136, 179
 (Trochus niloticus) 121
monitor, Lace (Varanus varius) 69
Moody, Skip 157, 164
moorings 157, 159, 165, 169, 161, 173, 178
moray eel (Gymnothorax sp.) 183
Moresby, HMAS 49, 141, 169
Morgan brothers 144
Morgan, Mount 144
Morrison, John 134
Moses perch (Lutjanus russeli) 90
Mosstroper Peak 155
Motels of Australia 156
Mount Jeffreys 177, 178, 179
Mount Merkara 143
Mount Morgan 144
Mount Oldfield 170, 171
Mount Pelée 34
Mount Pinatubo 36
Mount St Helens 34, 36
Mountney, John 173
Mountneys, the 151, 173
mulloway (Argyrosomus hololepidotus) 91
Murray, Connie 150, 156
Murray, Lt John 140, 142, 155, 177
Murray, Maj Lee (Paddy) 150, 156, 157
mushroom coral, see coral
Mytarc Pty Ltd 173

N
Nara Inlet (Hook I.) 58, 126, 169
Nares, Cmdr George S. 143, 154, 156, 157, 158, 160, 161, 164, 167, 169, 174, 175, 176
Native Mounted Police 132, 133, 135, 136, 170, 181
nautical mile, definition of 151
Neck Bay (Shaw I.) 177
needle-spined sea urchin (Diadema setosum) 121
Neki anogira 120
Nelson 138
Nelson, Lady 155
nematocyst 41
nesting
 avoid disturbance to birds when 29
 osprey 62
 sea birds 29
 sea eagle 62
 turtles 68
New Holland 137
Newry Group 83, 174
Newry Island 174
Ngalangi 126
Ngaro 125, 126
Nibea soldado 90
Nicklin, Billy 170
Nicklin, Frank 170
Nicolson, Angus 149, 170, 174
Nicolson, Archie 170
Nicolson, Betty 170
Nicolson, Elizabeth 149, 170
Nicolson, Frank 170
Nicolson Island 143, 174
Nicolson, Lachlan 148, 170

Nicolson, Thora 149, 170
North Molle Island 74, 157, 174
North Queensland Register 145

O

Oak Bay (Brampton I.) 156
observatory, Hook Island underwater 169
O'Connell River 41, 47
octopus bush (*Argusia argenta*) 55, 56, 57
Ocypode ceratophthalma 122
Ogyris zosine zolivia 70
O'Hara, John James 158, 159
Olden Island 174-5
Olden, Henry 174
Oldfield, Mount 170, 171
One Foot Island 169
Operculum 120
Ophiaracachnella gorgonia 122
Ophiomastix sp. 122
orange-footed scrub fowl (*Megapodius reinwardt*) 168, 181
osprey (*Pandion haliaetus*) 63, 159, 168
Otolithes ruber 91
Outer Newry Island 146, 174
outer reefs
visiting the 113
oyster-catcher
pied (*Haemotopis longirostris*) 63, 154
sooty (*Haemotopus fuliginosus*) 63
oyster cuts, treatment of 183
oyster gathering 27–8

P

paddle tail (*Lutjanus gibbus*) 95
Page McGeary Holdings 173
Pagrus auratus 91
Palm Bay (Long I.) 151, 173
Palm Bay Hideaway 173
Paluma, HMS 143, 175
Pandanus 55, 57, 130, 171
Pandion haliaetus 63, 159
Pangaea 32
Paradise Bay (Long I.) 173
Park
Great Barrier Reef Marine 23, 25
Queensland marine 23
Queensland national 23
Passage Island 158, 164
Passage Peak 164, 165
pearl perch (*Glaucosoma scapulare*) 90
pelicans 168
Pentcost
meaning of 138, 175
feast of 175
festival of 138
Pentecost Island 13, 35-6, 37, 137, 175
geological origin 35-6
Indian head 37
peppermint gum (*Eucalyptus exserta*) 166
perch
Moses (*Lutjanus russeli*) 90
pearl (*Glaucosoma scapulare*) 90
peregrine falcon 154
periostracum 120
permits, camping 26
Petrogale inornata 67
Petrogale persephone 67
Physalia physalis 186

pigeon
Torresian imperial *see* Torresian imperial pigeon
Torres Strait *see* Torresian imperial pigeon
pigs, wild 166
Pine Head 142, 143, 175
Pine Island 174, 175
Pinnacles, The 107, 169
Pioneer River 41, 47
Pioneer River Farmers and Graziers Association 176
Pisonia forest 160
Pivot Group 157
plankton 120
Plantation Beach (Lindeman I.) 171
Planton Island 156, 175, 178, 189
plate tectonics 31-2
Plectropomus sp. 86, 87, 90
Pleigynium timorense 55, 56
P&O 170, 171
Point Slade 138, 139
poisoning
fish 94, 183, 184
see also ciguatera
Polglass, S.E. 166
polyp, coral, *see* coral
poplar gum (*Eucalyptus platyphylla*) 55, 171
Porcher, Edwin Augustus 128, 129
Porites cylindrica 179
Port Denison 132, 180
Port Denison Times 135
Port Jackson 139, 140, 172
Port Molle 142, 146, 172, 178
Port Newry 73, 83, 137
possum, brushtail (*Trichosurus vulpecula*) 67
potato cod (*Epinephelus tukula*) 90
Powell, William 180
prickly red fish (*Thelonota ananas*) 121
Preservation Zone 160
see also zones, marine park
Princess Alexandra Bay 171
Princess Margaret 167
Pristipomoides sp. 91
Proserpine 9, 136, 158
Proserpine River 41, 47, 126
protected animal species 93
Protonibea diacanthus 91
Proud Rock (Macona Inlet) 175
Proudfoot, George 145, 146
Pteropus alecto 67
Ptychosperma elegans 58
puffers 184
purple tusk fish (*Choerodon cephalotes*) 90

Q

Q.DEH, *see* Queensland Department of Environment and Heritage
Qantas 156, 157
quarry, Aboriginal 130, 178, 179
Queen Elizabeth 167, 176
Queensland Department of Environment and Heritage 23, 79, 171
Whitsunday Information Centre 23-24
Queensland groper (*Epinephelus lanceolatus*) 90
Queensland State Government Insurance Office (SGIO) 171

R

RAAF Flight 101 141
Rabbit Island 146, 174
Rachycentron canadus 91
Radisson Long Island Resort 173
rainbow lorikeet (*Trichoglossus haematodus*) 171
rainfall
along the Whitsunday coast 53
among the islands 51
annual in the Whitsundays 15
see also weather
Raleigh Beach (Hook I.) 169
raptors 61, 62, 63
Rasmussen, Peter 173
Rattray Island 175
Rattray, Alexander, MD 175
red bream (*Lutjanus sebae*) 90
red emperor (*Lutjanus sebae*) 90
red throat emperor (*Lethrinus miniatus*) 90
reef *see* coral reefs
reefwalking 116-7
reindeer 164
Reliance 161
Repair Island 175
Repulse Bay 137, 176
Repulse Islands 38, 142, 176
geological origin 38
resorts, island
history of 147-151
Brampton Island 156
Club Med Lindeman Island Resort 171
Daydream Island Travelodge Resort 157
Hamilton Holiday Inn Crown Plaza Resort 165
Hayman 167
Palm Bay Hideaway 173
South Molle Island 178
Whitsunday Long Island Resort 173
Rhizophora stylosa 60
Richards, Lt G.E. 143
Riser 135
Rock-wallaby
Proserpine (*Petrogale persephone*) 67, 160
unadorned (*Petrogale inornata*) 67, 181
Rocky Island 174
Rooney & Co 180
Rooper Inlet 143
rosy job fish (*Pristipomoides* sp.) 91
Rowan, John 166
Royal Australian Navy 141, 156, 175, 179
Royal Hayman 167
Royal Navy 131, 137, 141, 142
Royal Seaforth Island *see* Royal Seaforth Island
Roylen Cruises 155
rubbish
removal from parks 26

S

Saba Bay (Hook I.) 107
Saddleback Island 176
St Bees Island 156
Salamander, HMS 143, 154, 156, 158, 159, 161, 164, 167, 169, 174, 175, 176
San Andreas Fault 31
Santa Barbara 132, 179

Sandrock, G.F. 135
Sandy Bay (Long I.) 173
Sawmill Bay (Whitsunday I.) 144
Sawmill Beach (Whitsunday I.) 180, 181
Scaevola sericea 55, 56, 57
Scawfell Island 79, 141, 155, 172
Scomberomorus commerson 91
Scomberomorus queenslandicus 91
Scomberomorus semifasciatus 91
Scott, Sir Walter 158
screw palm 55 (*see also Pandanus*)
screw pine 55 (*see also Pandanus*)
scrub fowl, orange-footed (*Megapodius reinwardt*) 64, 168, 171, 181
sea birds, avoiding disturbance to 29
see also wildlife
sea cucumber *see* echinoderms
sea eagle, white-bellied (*Haliaeetus lecogaster*) 62, 159
sea fan 41
sea star *see* starfish
sea whip 41
Seaforth 79, 174
Seaforth Island 171, 176
seagrasses 60, 181
sea stars, *see* echinoderms
sea urchin, needle-spined (*Diadema setosum*) 121
sea wasp see *box* jellyfish
seaweeds 60
Sebastian Properties 159, 164
Senix 172
Seriola ialandi 91
settler, first 144
Shardlow, Fred 166
shark 122, 185
epaulette (*Hemiscylium ocellatum*) 122
white tip (*Triaenodon obesus*) 185
black tip reef (*Carcharhinus melanopterus*) 185
hammerhead (*Sphyrna* sp.) 185
tiger (*Galeocerdo cuvier*) 185
Shark Alley 111
shark-catcher 161
Shaw Island 36, 136, 170, 176-7,
geological origin 36
Shaw Peak 136, 177
Shaw, George 177
she-oak (*Casuarina equisetifolia*) 55
shearwater, wedge-tailed 160
shell collecting, in the marine park 27
Short, Allen 177
Shute Harbour 9, 20, 82, 143, 157, 179
Shute Island 143, 177
Shutehaven 20
silver bush (*Scaevola sericea*) 55, 57
silver jew (*Nibea soldado*) 90
Silversmith Island 159, 177
silver teraglin (*Otolithes ruber*) 91
Sinclair, Capt Henry Daniel 132, 179

Sinker Reef 47, 49, 111
Sir James Smith 177
Sir James Smith Group 172
Skiddaw Peak (Carlisle I.) 155
Slade, Thomas 138
slipper coral, see coral
small mouth nannygai (Lutjanus erythropterus) 90
Smith, Rupert 166
Smith, Sir James 177
Smith, Sir James Group 172
snapper (Pagrus auratus) 91
Snapper bream 170
Snare Peak Island 13, 139
solitaire palm (Ptychosperma elegans) 58
Solway Passage 160
South Molle Island 127, 130, 144, 145, 146, 156, 157, 177-9
officially 'Molle Island' 145
Southern Pacific Hotel Corporaton 157
South Repulse Island 176
spangled emperor (Lethrinus nebulosus) 90
spear fishing
Aboriginal 130
in the marine park 27
restrictions 93
Spheroides hamiltoni 95, 182, 184
Spion Kop 74, 130, 177, 179, 189
Afrikaans for 'lookout hill' 178
Spitfire, HMS 155
spotted (black) jew (Protonibea diacanthus) 91
spring tides see tides
Spry, Edmund 155
staghorn coral, see coral
starfish see cchinoderms
Stenella longirostris 66
Stepping Stones (Bait Reef) 49, 109
Sterna anaethetus 63
Sterry, H.C. 164, 178
Stichopus chloronotus 121
Stichopus variegatus 121
Stingers see box jellyfish, irukandji, bluebottle
stinging coral (Millepora sp.) 187
Stingray
avoiding wounds 185
blue-spotted (Taeniura lymna) 122
Stockyard Beach 166
stonefish (Synanceia horrida, S. verrucosa) 182, 185
Stonehaven 108, 168, 169
Stonehaven, Lord 169
stripey (Lutjanus carponotatus) 90
Strombidae 121
Sunlovers Beach (Daydream I.) 157
sunburn 183
symbiotic algae 42, 118
see also algae, zooxanthellae
Symphorus nematophorus 95
Synanceia horrida 182, 185
Synanceia verrucosa 185

T

Taeniura lymna 122
Tancred Island 179
Tancred, Lt George Dalton 179
tanjong tree (Mumusops elengi) 55, 56

Telford Property Fund 178
teraglin jew (Atractoscion aequidens) 91
tern
black-naped 160, 174
bridled (Sterna anaethetus) 63, 160
common noddy 160
tetrodotoxin 184
Tethys Sea 32
textile cone (Conus textilis) 120
The Island 173
Thalimata sp. 122, 123
Thelonota ananas 121
thick-knee
beach (Burhinus mangirostris) 64, 159, 161
bush (Burhinus neglectus) 64
Thomas Island 130, 179–80
Thomas, Lt James C. 179
tides
effects on activities 19
effects on sea conditions 74
maximum range in Broad Sound 18
range in the Whitsundays 18, 74-5
spring 19
timber-cutting 180
timber-getters 144
Eugene Fitzalan 144
John Withnall 144
Tinsmith Island 177
toadfish
common (Spheroides hamiltoni) 95, 182, 184
giant (Lagocephalus scleratus) 182, 184
stars and stripes (Arothron hispidus) 182
Torres Strait 140, 142
Torres Strait pigeon see Torresian imperial pigeon
Torresian imperial pigeon (Ducula spilorrhoa) 65 154, 159, 175, 176
Tourist Resort Promotions Ltd 177
tracks, walking
Brampton I. 156
Hamilton I. 165
Hayman I. 167
Lindeman I. 171
Long I. 173
South Molle I. 179
trade winds
effects on Whitsunday waters 17
trade winds
origin of 18, 73
season in the Whitsundays 18, 19, 74
Trammel Bay 143
tramway, logging 181
Trans Australia Airlines 156
transportation, to the Whitsundays 20-21
Travelodge 157
trepang (bêche-de-mer) 121
Trichosurus vulpecula 67
Tridacna crocea 118
Tridacna maxima 120
Tridacna crocea 120
Tripcony, J.C. 155
triton shells, see molluscs
clam shells, see molluscs
trochus shell 136, 173
Trochus niloticus 121
Tronson, Walter 150, 173
'tropical ear' 183

Turban shell 120
Turbo petholatus 120
Tursiops truncatus 66
turtle
green (Chelonia midas) 68
hawksbill (Eretmochelys imbricata) 68
Turtle Bay (Brampton I.) 156
turtle grass 60
turtle weed (Chlorodesmis fastigiata) 60

U

Underwater observatory, Hook I. 169
US-Australian task force 181
US Pacific Fleet 181

V

Vagellas, Peter 178
Valetta 141, 144, 172
vegetation, Whitsunday 55-60
Venus tusk fish (Choerodon venustus) 90
Venus, transit of 137
Veranus varius 69
Victor Creek 83
Victory 136
Vigar, R.W. 159, 164
Virago, HMS 125, 143, 170, 176, 179
volcanic origins of the Whitsundays 34-7
volcanoes
Hawaiian islands 33
'slow motion' 32-3
'soda pop' 33

W

wahoo (Acanthocybium solandri) 91
Waite Bay (Haslewood Island) 165, 166, 174
Walker, Andrew 134
walking
tips 84
see also tracks
wallaby, rock-
Proserpine (Petrogale persephone) 67, 160
unadorned (Petrogale inornata) 67, 181
Wallace, Bill and Leen 151, 159
Walmsley, T.A. 164
water
colour of in the Whitsundays 9, 14
temperature in the Whitsundays 14
watercraft, Aboriginal 128
weather in the Whitsundays 5
see also rainfall
Wegener, Alfred 32
West Molle Island 150, 156, 157, 178
see also Daydream Island
whale, humpback (megaptera novaengliae) 66
whalers 140
Whit Sunday 138, 139, 142, 175
White Bay see Waite Bay
White Rock 143
'White Sunday' 138
white-bellied sea eagle (Haliaeetus leucogaster) 62, 159
Whitehaven Bay 166
Whitehaven Beach 38, 39, 160, 166, 180, 181

Whitehaven Beach
geological origin 38-9
Whitsunday airstrip 21
Whitsunday azure, see butterflies
Whitsunday Group 159
Whitsunday Information Centre 26
Whitsunday Island 16, 34, 108, 144, 156, 165, 166, 167, 175, 180–1
Whitsundy islands
geological origins 34
number of 13
what constitutes the 13
'Whitsunday 100' 173
Whitsunday Passage 156, 158, 159, 166, 177
Whitsunday Peak 180
Whitsunday, Town of 20
Whitsunday Long Island Resort 173
'Whitsunday's Passage' 13, 138, 180
Whyribba (stone axe) 178
Wilding, Harry and Francis 173
wildlife in the Whitsundays 61-7
William of Deloraine 158
Williams, Keith 159, 164, 165
wind in the Whitsundays 18
see also trade winds
Windy Bay 165, 166
Withnall, John 144, 180
Woller, Albert 166
Wood Pile, the
dive site 108
geological origin 35
Wood, Ian 149
Workington Island see Worthington Island
Worthington Island 143, 173
wounds (coral), treatment of 183

X

Xanthorrhoea sp. 58, 59, 155, 171

Y

Yarrakimba 170
yellowtail kingfish (Seriola ialandi) 91

Z

Zebra, HMS 172
zebrafish see butterfly cod
zones, marine ark 25
Zooplankton 115
Zooxanthellae 42